OUTSIZE
LARGE SCALE GRAPHIC DESIGN

CHRIS FOGES

RotoVision

SIZE

OUTSIZE
LARGE SCALE
GRAPHIC DESIGN

A ROTOVISION BOOK
PUBLISHED AND DISTRIBUTED
BY ROTOVISION SA,
ROUTE SUISSE 9,
CH-1295 MIES, SWITZERLAND

ROTOVISION SA,
SALES AND PRODUCTION OFFICE
SHERIDAN HOUSE,
112/116A WESTERN ROAD
HOVE, EAST SUSSEX
BN3 1DD, UK

TEL: +44 (0)1273 72 72 68
FAX: +44 (0)1273 72 72 69
EMAIL: SALES@ROTOVISION.COM
WEB: WWW.ROTOVISION.COM

10 9 8 7 6 5 4 3 2 1

ISBN 2-88046-702-0

BOOK DESIGN BY NB:STUDIO

PRODUCTION AND SEPARATION BY
PROVISION PTE. LTD., SINGAPORE
TEL: +65 334 7720
FAX: +65 334 7721

This book is about large scale graphic design. The term needs some clarification, or at least qualification. First, one might ask, when does a piece of graphic design become 'big'? Is a large format magazine big? An A0 poster sheet? The totality of a 200 page book? For the purposes of this book, the distinction is made between two types of graphic design. The first is those pieces which are designed to be held in the hand – such as this book, a magazine or soap powder packet, or viewed from close up, like the A0 poster or a subway map. The second type of graphic design is that which exists on a scale where we might define our position in relation to it – a shop front or the graphic environment of an exhibition stand – or physically move around it in order to view its entirety – a vehicle livery or the construction barriers around a building site.

And having established what is meant by scale in this context, what do we mean by graphics? The boundaries are blurred – as one might expect at the point where graphic design meets other disciplines such as architecture, environmental design, engineering and even art, in the case of such figures as Jenny Holzer, Lawrence Weiner and Barbara Kruger. First, we might say that while all design has the potential to communicate – the glass dome on top of Norman Foster's Reichstag parliament building in Berlin lets light into the debating chamber and in doing so symbolises the 'transparency' of the processes of government – graphic design is usually concerned with the communication of specific and quite precise messages from one party to another. Further, this is usually achieved with the use of text and image, and the arrangement and ordering of information. So, while the work of Saurbruch Hutton architects is strongly graphic – building facades covered in coloured panels – it is not graphic design in the generally accepted sense of the term.

This book includes a wide variety of work, from shop fronts and advertising billboards to vehicle liveries, lighting and projections, building interiors and exteriors. The function of the work varies just as widely: to inform or entertain, to claim ownership of a space or promote a product, to identify a route, to impress or awe, to cover up or transform. Some are permanent – or as close to it as modern building or hard landscaping comes. Others, such as projections, can be removed at the flick of a switch. But if the examples are diverse, there are aspects of their design, production and application that place them together, and make them distinct from the bulk of graphic design production.

The things that most people think of as graphic design; books and magazines, packaging, brochures and leaflets, bills, timetables and directories, websites and CD-ROMs are not designed to be viewed in any particular context. In editorial design of books and magazines concessions are made to make publications fit on the average shelf, and a cover is designed on the understanding that it has to look more attractive than the one next to it. Once the magazine is bought, however, it can be taken wherever and remain a self-contained graphic experience. Graphics of scale are part of an environment – whether that be architectural, as an interior or exterior; part of the streetscape in vehicle liveries; or the landscape, as in the case of the black bull silhouettes, advertising Osborne sherry, that dot the hills of Spain.

Likewise, most graphic designs – from soap powder packaging to annual reports or bus timetables – are not static fixed objects, but have some movement designed into them: they open and close, pages turn, they must be manipulated to be read. With some exceptions (such as vehicle liveries), large scale or environmental graphics are usually fixed in one place. Instead of turning the pages or holding the brochure closer for a better look, the reader must physically move themselves in relation to the piece of graphics. This fundamentally changes the nature of the relationship between the audience and a piece of communication.

Most graphic design is applied to paper or card via printing processes. As is discussed in the final chapter of this book, much environmental graphic design involves the use of other substrates, either as part of the building fabric, such as brick or glass; or vinyls and other such materials with appropriate weather-proofing and structural properties. This is unfamiliar territory for many graphic designers, and again leads to collaborations with practitioners from other disciplines, from sign painters to product designers and engineers.

There are also parallels between large scale graphic design and the more general kind. Just as a designer might create a narrative over a series of magazine spreads or web pages, so too might they on a much larger scale in an exhibition or other graphic environment in which a person passes through distinct areas. But the exhibition allows for other possibilities too, especially if the graphic designer begins to think not only in terms of two-dimensional representation in type and image, but to consider the possibilities of form, structure, and even lighting, film or performance.

As suggested above, designing graphics for these types of application may require the graphic designer to collaborate with those from other disciplines whose normal remit touches with graphics at this point – architects, for example – but it may also require graphic designers themselves to learn new skills. These might be in printing, in representation of concepts to clients, in imagining three- as opposed to two-dimensional space, and in thinking differently about audiences and the business of communication.

Today there is perhaps more demand, and more opportunities for large scale graphics than ever before. Media owners – and that includes the owners of buildings, landscapes and so on – are recognising the value of their real estate, and making it available to brand owners and their designers. As the market for corporate identity and branding continues to expand, there are also more assets to cover, from the corporate HQ to the company's delivery vehicles. Further, the growth of the experiential communications market means that graphics and the idea of storytelling within environments such as brand stores or museums is on the increase. These opportunities come with particular responsibilities for designers – in questioning what might be regarded as visual pollution of public space, for example – as graphic design moves off the page and into our shared environment.

A final note on the classification of projects in this book: by their nature, many of these large scale graphic design projects are complex and perform more than one function. A single piece or work may be used for wayfinding and for promotion, or be made through a combination of printing, fabrication and lighting design techniques. In many cases work is included to merely show one interesting aspect of a multi-faceted scheme.

THE GRAPHIC LANDSCAPE

'Ads,' said Marshal McLuhan, social scientist and media theorist, 'are the cave art of the twentieth century.' Cave paintings, like those at Lascaux in France, dating from 20,000 BC, are the earliest surviving forms of human artistic expression. 'Advertising,' as McLuhan also said, is 'the greatest art form of the twentieth century.' And they do have much in common. Both, arguably, illustrate the wants and desires of the society that created them, whether that be successful hunting or whiter teeth and glossier hair. And further, they are both examples of the ways in which human beings have, from the earliest times, made marks on the landscape – communication designed to be read as part of the landscape in which it sits. Environmental 'graphics' mark out claims to territory, or map and interpret geography, as in the case of the Nazca lines in Peru, or imbue a landscape with extra emotional resonance, as in the case of the men and animals carved at huge scale into chalk cliffs in the South of England. Today, we continue to mark the landscape in similar ways, as projects in this book demonstrate, from Selbert Perkins Design's LAX Gateway (p.77) to Peter Anderson's Poles of Influence (p.80–81).

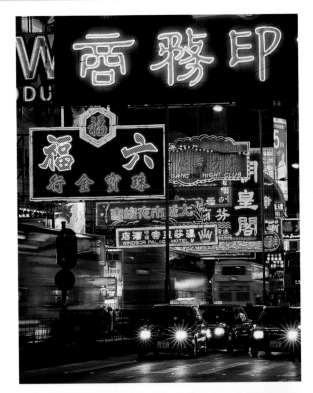

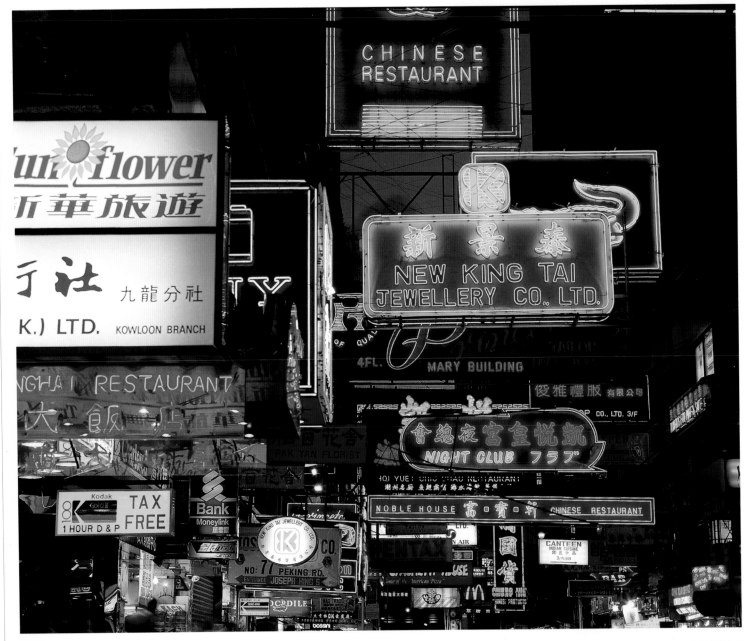

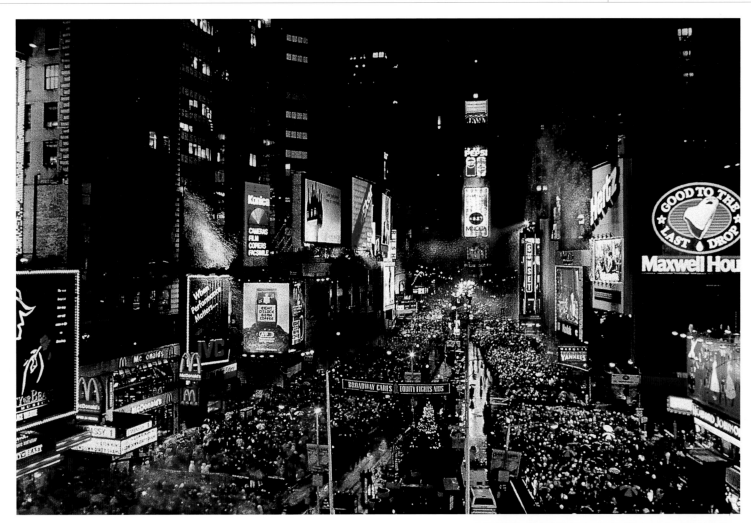

As well as the natural landscape, we mark the built environment too. In their book 'Learning from Las Vegas'[1], the architects Robert Venturi and Denise Scott Brown analysed the importance of signs in identifying and attracting customers to the casinos, set in the context of 'urban sprawl', and in guiding visitors, travelling at speed in cars, around the city as a whole. This new type of city, they suggested, is made up of signs before it is composed of buildings. The signs, not the architecture, are what creates a sense of place in Las Vegas. 'This architecture of style and signs is antispatial,' they wrote. 'Communication dominates space as an element in the architecture and in the landscape.' But while the condition of urban sprawl, and the vernacular response to it in Las Vegas may be new, as the authors observed, the integration of architecture and sign is not: 'Modern architecture,' they suggested, 'abandoned a tradition of iconology in which painting, sculpture and graphics were combined with architecture. The delicate hieroglyphics on a bold pylon... the ubiquitous tattoos over a Giotto chapel... all contain messages beyond their ornamental contribution to architecture.'

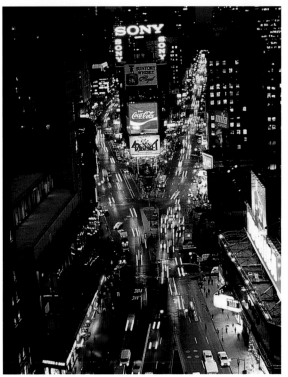

1, 2. NEON STREETSCAPES;
HONG KONG

3, 4. TIMES SQUARE;
NEW YORK, USA

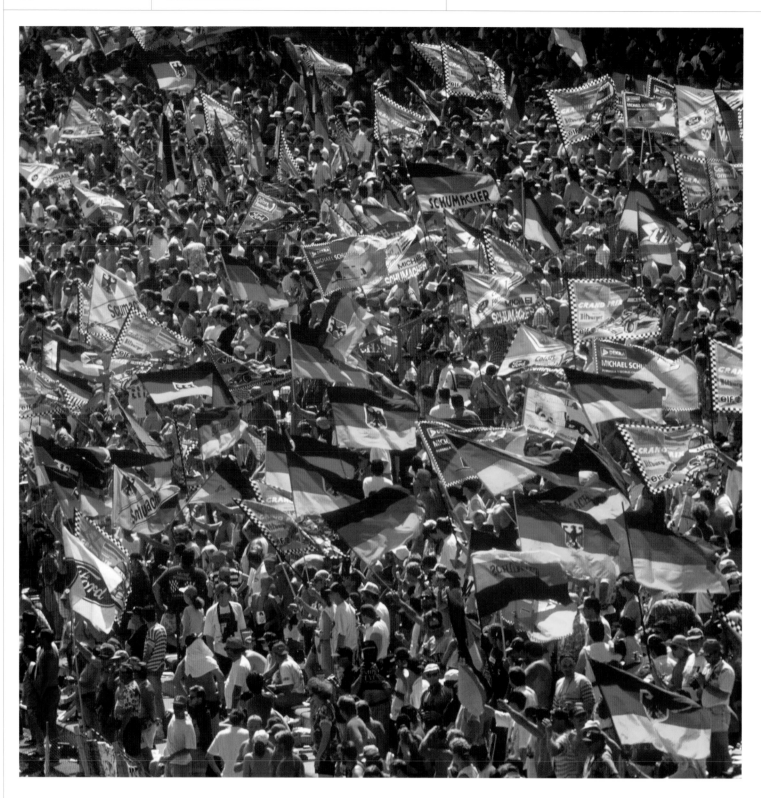

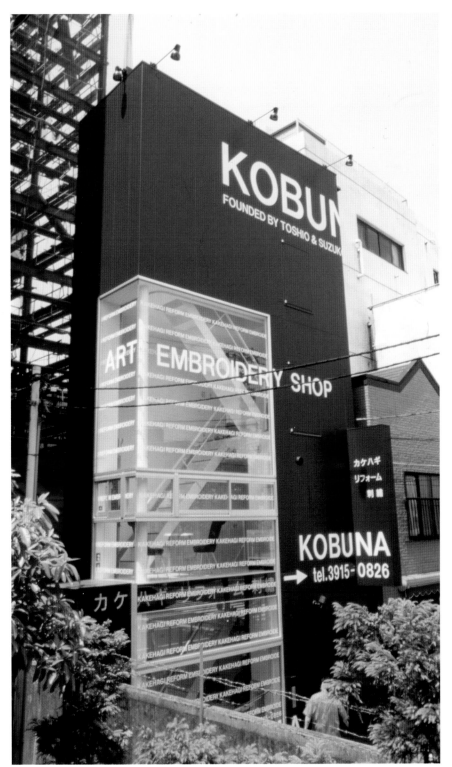

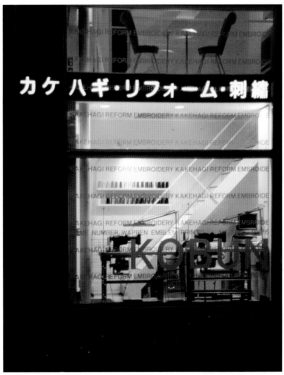

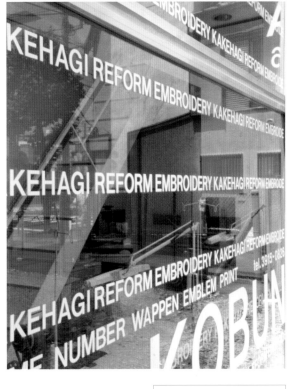

1. BANNERS OF FERRARI FANS
AT A GERMAN FORMULA ONE
GRAND PRIX RACE.

2, 3, 4. KOBUNA EMBROIDERY
SHOP; TOKYO, JAPAN
TOSHIAKI ISHIDA A & A
(ARCHITECTURE AND
GRAPHIC DESIGN)

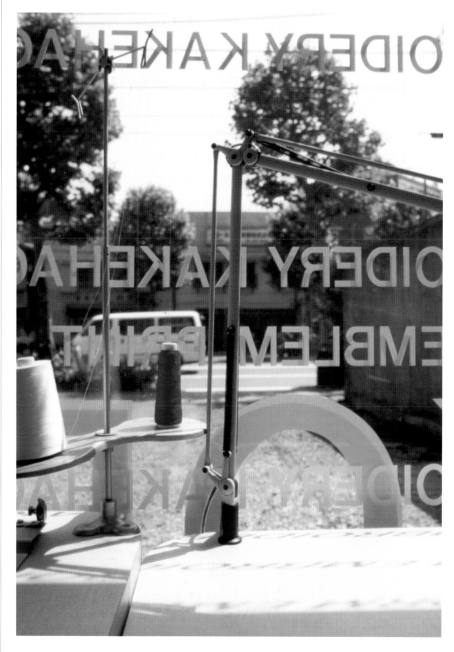

But even in the Modern era, architects and graphic designers have incorporated graphic communication in built form, from Herbert Bayer's Bauhaus design for a newspaper kiosk (1924) to J.J.P. Oud's Café de Unie in Rotterdam (1924), which put into built form some of the graphic concerns of the De Stijl movement, from vertical type to the primary colour palette promoted by the painter Mondrian, among others. Today, projects such as 'Big Time', by architect Cameron McNall (p.152–153), use technology as a means to fuse graphics, moving image, and interactive capabilities with the built environment, while those such as the PTT facades by Buro Lange Haven (p.34) attempt to find a genuinely architectural expression of graphic identity.

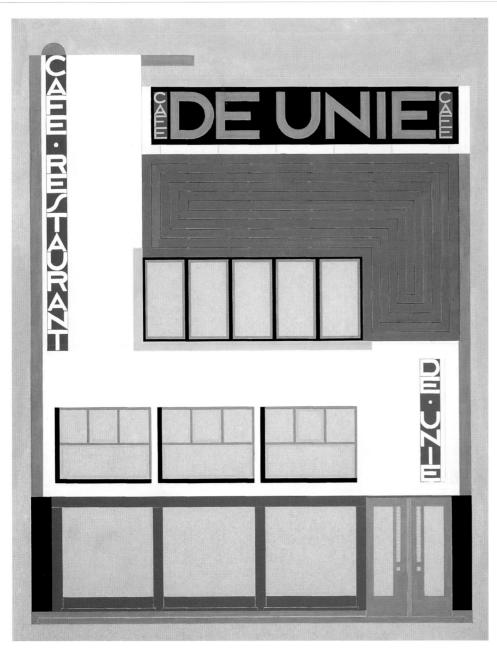

1, 2. KOBUNA EMBROIDERY SHOP; TOKYO, JAPAN
TOSHIAKI ISHIDA A & A (ARCHITECTURE AND GRAPHIC DESIGN)

3. THIS DRAWING BY THE ARCHITECT J.J.P. OUD SHOWS THE 'GRAPHIC' FACADE OF THE DE STIJL CAFE DE UNIE, WHICH WAS DEMOLISHED IN 1940.

4. CARVINGS BY GIOTTO AROUND THE BASE OF THE CAMPANILE 'CONTAIN MESSAGES BEYOND THEIR ORNAMENTAL CONTRIBUTION TO ARCHITECTURE', AS THE AUTHORS OF 'LEARNING FROM LAS VEGAS' OBSERVED.

The projects in this book are for the most part the products of professional design consultancies. Such work, however, constitutes a comparatively small proportion of the total graphic landscape, just as, at a smaller scale, the books, magazines, food and product packaging that are the output of the design studios represent a fraction of the graphic materials in circulation, from the lost dog notice on the tree to the sports team sheet pinned to the school noticeboard. But all are part of this environment of written words and images in which we live, and all serve the same ultimate purpose. In their essay 'Critical Way Finding'[2], the design critics Ellen Lupton and J. Abbott Miller came up with as good a definition of the job of graphic design as might be achieved. 'Like an over-eager, pimply-faced younger sibling, graphic design is what architecture never wants to be: namely, packaging, ornament, frame and sign... Yet graphic design is a frame that makes spaces, places and objects legible. Graphic design continually mediates contact with the environment... Environmental signage is simultaneously there and not there – not really a "part of" the architecture, yet indispensable to its functions, its lived use... Graphic design – signage in particular – is largely a framing activity. Graphic design occupies the space between a product, building, or text and its user. Graphic design is the margins of a book, the buttons of a boom box, the friendliness of a computer interface, or the label wrapping a tin can. By creating a graphic landscape, that lies on top of the physical landscape, we make the world readable.'

1, 2, 3. LAS VEGAS, NEVADA, USA. FREMONT STREET (2, 3) IS PERHAPS THE MOST INTENSE GRAPHIC EXPERIENCE IN A CITY CHARACTERISED BY ITS SIGNS AND OUTSIZED SYMBOLS.

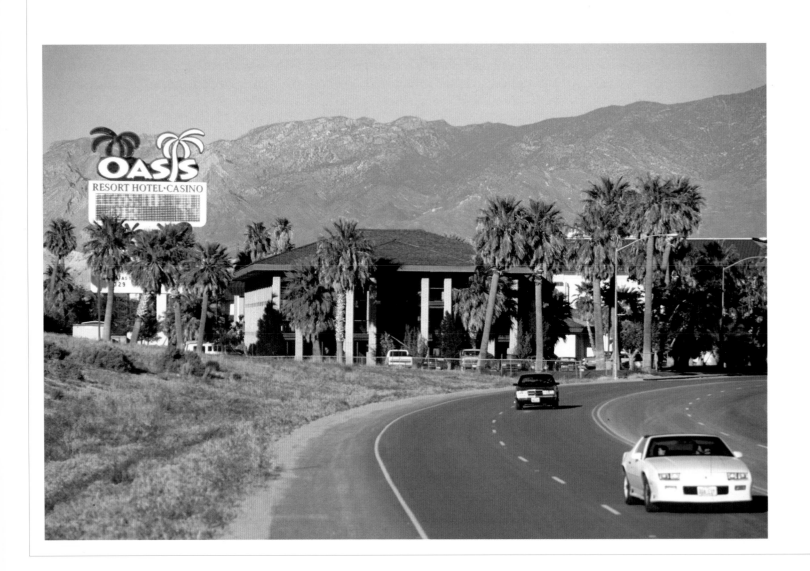

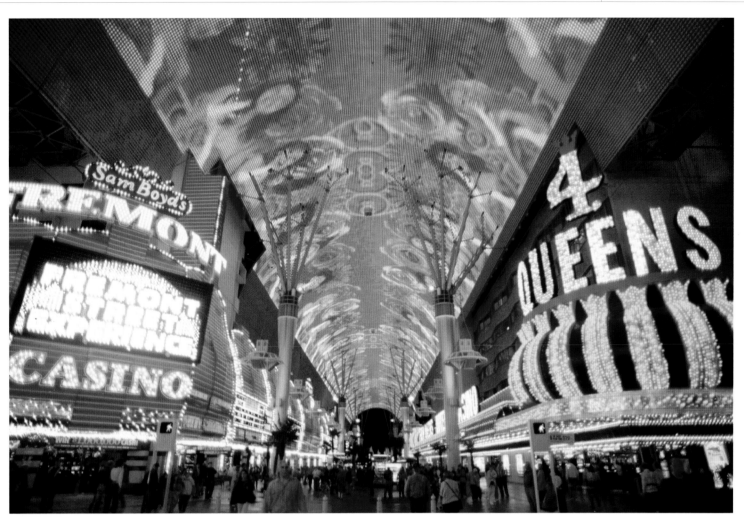

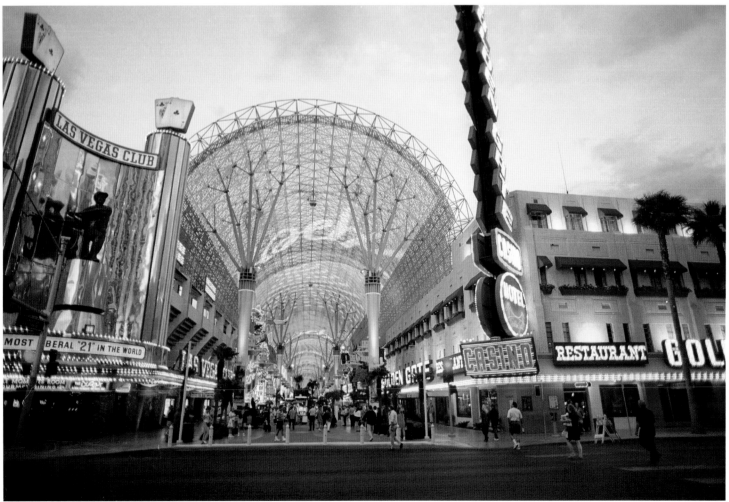

FUNCTION
PROMOTION
IDENTITY
WAYFINDING
INFORMATION
EXPERIENCE

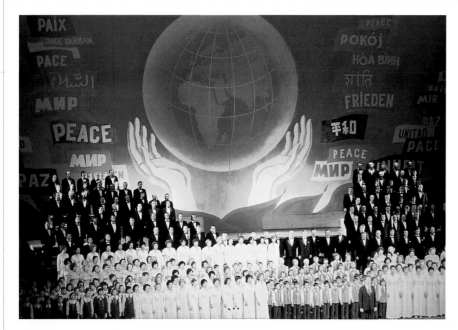

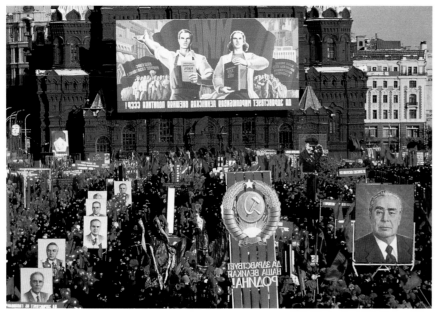

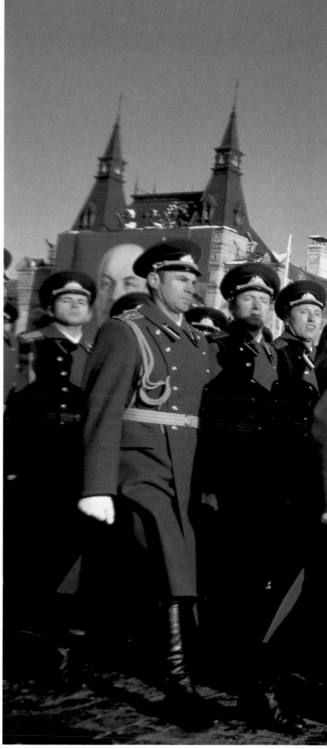

INTRODUCTION

Rulers throughout the ages have known that the significance of major physical statements – ostentatious palaces, triumphal arches and monumental statuary leave a mark on the world for a time after power has gone, but more important, such exercises are a statement of power at the time. Any human activity conducted on a large scale is inherently awe-inspiring, but environmental graphic design is not just about impressing people through scale. It is a response made in specific circumstances to the usual demands from graphic design – that it should organise and convey information, should present a product or service in an attractive way, and should give a unique identity to one thing to distinguish it from competitors. Issues of physical context, and distance between object and viewer are covered in a later chapter.

The projects on the following pages are instances where the appropriate response to the requirement has been to design graphics on a large scale, whether this be to guide people round a building, for example, or to attract visitors to a particular shop. The responses have been to make environments from the graphics, or to mediate the existing environment through them in such a way as to adjust it to a new purpose.

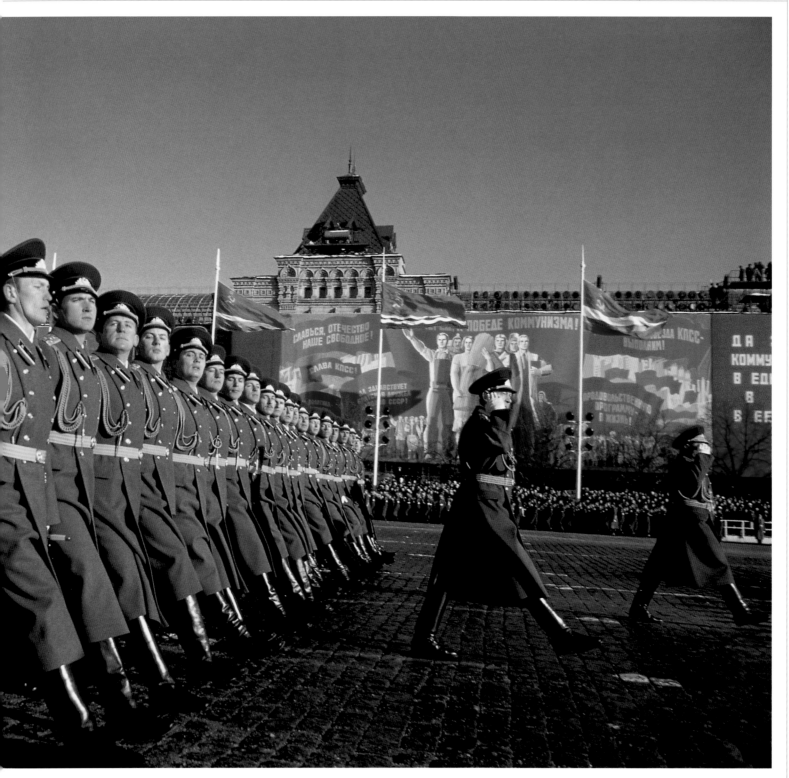

1. BACKDROP FOR A MEETING
COMMEMORATING THE 60TH
ANNIVERSARY OF THE 1917
RUSSIAN REVOLUTION (1977).

2, 3. ENVIRONMENTAL DESIGN
FOR NOVEMBER 7TH PARADE,
RED SQUARE, MOSCOW (1982).

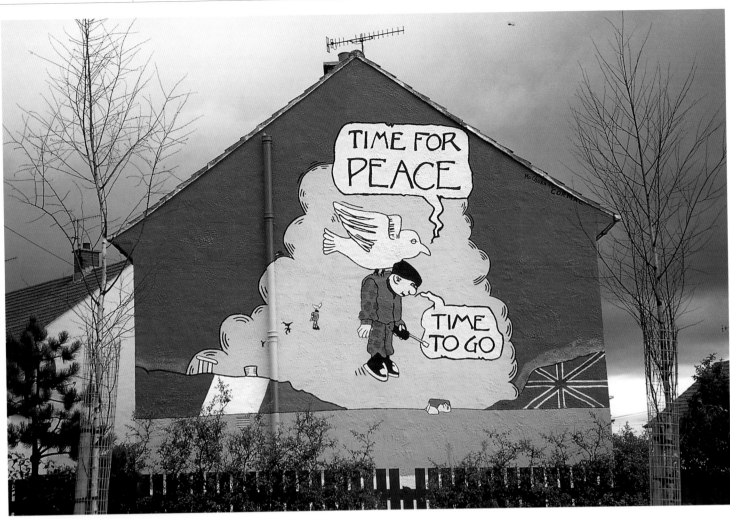

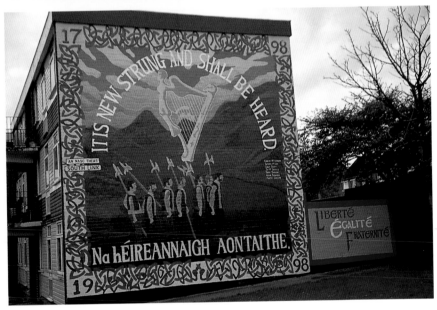

1		3
2		

1, 2, 3. SECTARIAN MURALS;
BELFAST, NORTHERN IRELAND
SINCE 1908, LARGE SCALE
GRAPHICS IN THE FORM OF MURALS
ON THE GABLE ENDS OF HOUSES IN
BELFAST HAVE BEEN USED TO CARRY
ON THE PROPAGANDA 'WAR'
BETWEEN NATIONALISTS, WHO
PREFER NORTHERN IRELAND TO BE
UNIFIED WITH THE REPUBLIC OF
IRELAND, AND UNIONISTS, WHO
WANT TO MAINTAIN THE UNION WITH
BRITAIN. THE MURALS NOT ONLY
TAKE THE DEBATE INTO THE PUBLIC
REALM, BUT MARK OUT TERRITORIES
WITHIN A CITY WHOSE 'OWNERSHIP'
IS CONTESTED. THESE
PHOTOGRAPHS, TAKEN BY
SOCIOLOGY PROFESSOR AND
AUTHOR OF TWO BOOKS ON THE
MURALS (FOOTNOTE 3), BILL
ROLSTON, SHOW EXAMPLES FROM
BOTH CAMPS. NATIONALIST MURALS
DEPICT BRITISH SOLDIERS BEING
FLOWN BACK TO BRITAIN BY DOVES
OF PEACE (1), AND COMMEMORATE
THE BICENTENARY OF THE UNITED
IRISHMEN, A REVOLUTIONARY
ORGANISATION, WITH THE SLOGAN
'IT IS NEW STRUNG AND SHALL BE
HEARD' (2). THE LOYALIST MURALS
CELEBRATE TWO PARAMILITARY
GROUPS, THE ULSTER FREEDOM
FIGHTERS AND THE ULSTER
VOLUNTEER FORCE (3)

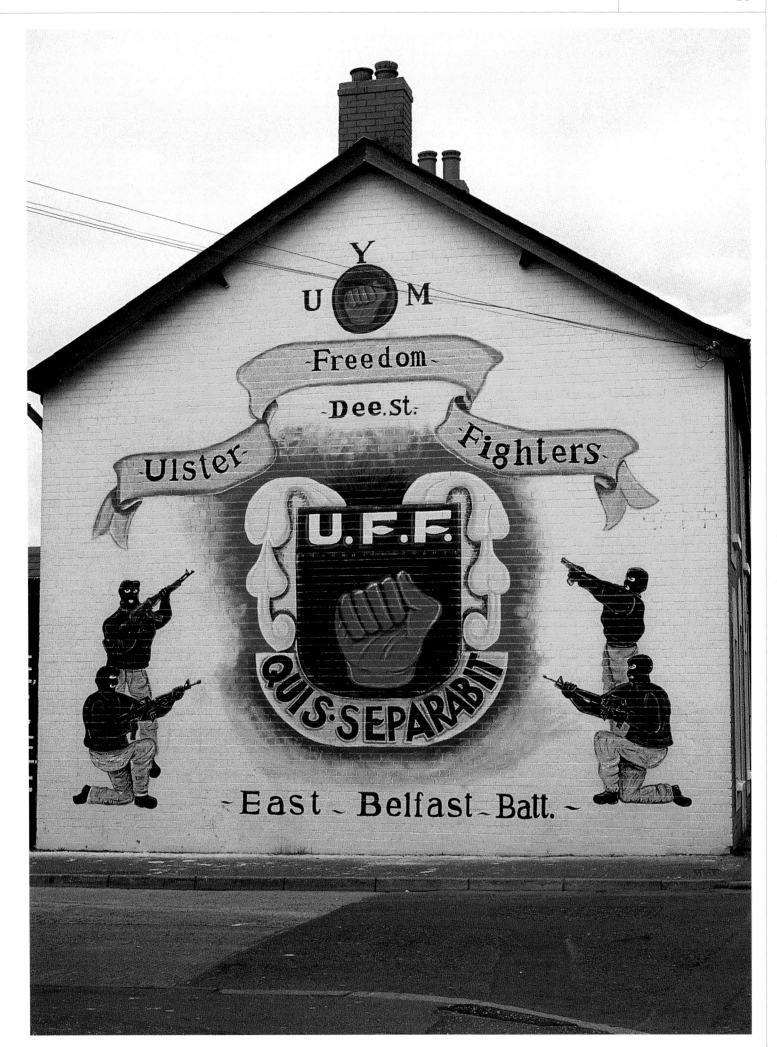

PROMOTION

The distinction between advertising and graphic design, as a profession and a practice, has always been blurred. At various times, and in various places, they have been virtually synonymous; while at others, a dividing line has been more rigorously policed. And while it is true to say that today, most companies trading as graphic designers do not work on TV ad campaigns or billboard posters (though some do), and most advertising agencies do not create textbooks or subway maps, much graphic design studio output, from brochures to retail interiors, websites and even corporate identities, is a fusion of information and promotion.

And it is in areas where the dividing line between functions is blurred that graphic designers, rather than advertising agencies, are often commissioned to produce promotional work on an environmental scale. Billboards exist to advertise, but delivery vehicles exist to make deliveries; however, they can do the job of promotion at the same time. Corporate vehicle liveries (as part of a corporate identity function), like retail interiors or window displays, involve piggy-backing promotional activities onto an object or environment that is already engaged in other business. And as 'hybrids', in that they use different media, with restrictions imposed by site and circumstance, such promotions rarely follow the conventions of billboard or television advertising, with their emphasis on the memorable strapline, for example.

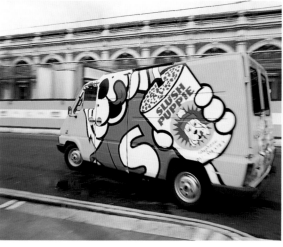

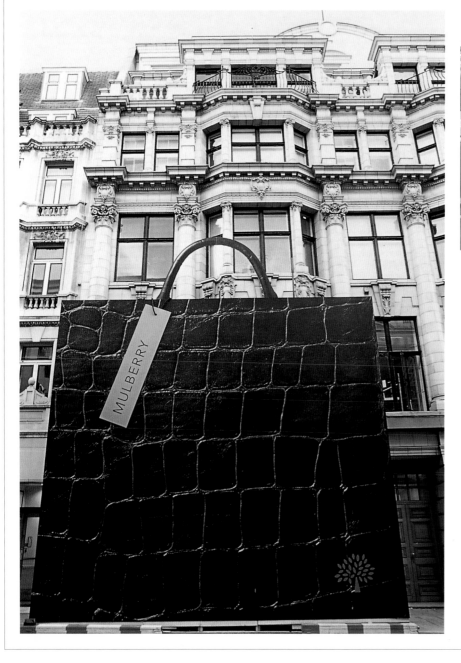

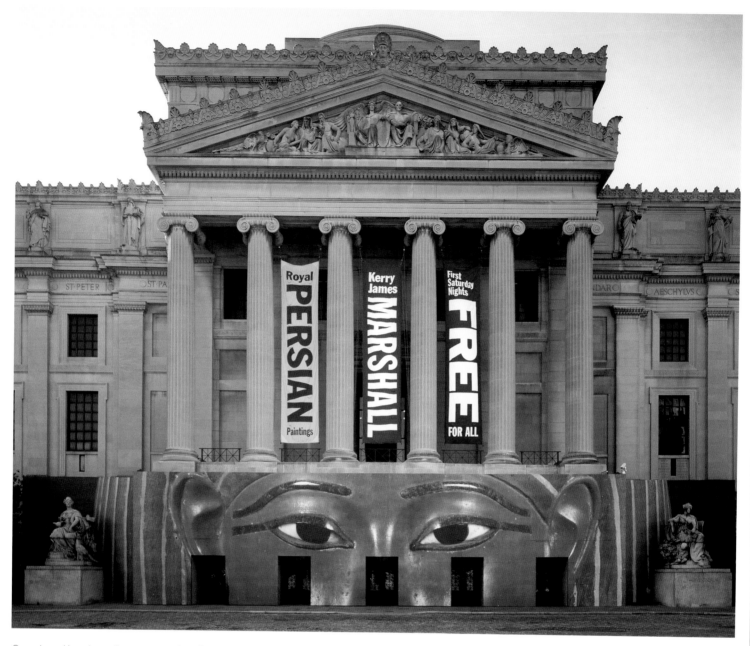

Construction barriers are a familiar sight around any city. They, of course, have a primary function which is to keep passers-by safe during building work, and the site safe from intruders. But they also present a remarkable promotional opportunity — a billboard-sized surface at street level. Design consultancy Four IV worked with Mulberry on a complete relaunch of its brand, with the aim of attracting a new generation of young, aspirational customers without losing the fashion retailer's existing customer base. The designers worked on everything from a new logo and carrier bag design to a refit of Mulberry's New Bond Street store in Central London. While building work was underway, Four IV took advantage of an opportunity to promote the new-look store by erecting construction barriers in the form of a giant Mulberry handbag. The result was a piece of promotion signalling the character of the brand in an understated, yet fun and eye-catching way. Similarly, during a two-year period of renovation, the Brooklyn Museum of Art wanted to take advantage of the presence of construction barriers to publicise the museum and its collections. The designers, Pentagram, selected an image of a sarcophagus from the museum's own collection of Egyptian antiquities, which simultaneously announced the building as a museum, and quite literally put a face to a name.

1. MULBERRY CONSTRUCTION
BARRIER; LONDON, UK
FOUR IV

2. SLUSHPUPPiE VEHICLE
LIVERY; UK
SPRINGETT ASSOCIATES
THE PRINCIPAL MEANS OF
PROMOTING THE DRINKS BRAND
SLUSHPUPPiE ARE THROUGH
GRAPHICS ON PROPERTIES SUCH AS
ITS FLEET OF VEHICLES, IN-STORE
DRINKS MACHINES AND THE PAPER
CUPS IN WHICH DRINKS ARE SOLD,
RATHER THAN THROUGH
CONVENTIONAL ADVERTISING
SPRINGETT ASSOCIATES WAS
COMMISSIONED TO 'WORK HARDER'
FOR THE BRAND AGAINST THE
BACKGROUND OF GRAPHIC NOISE
THAT EXISTS WITHIN STORES AND
ON THE STREET. THE SOLUTION, A
COMBINATION OF VIBRANT COLOURS
AND LARGE, CROPPED CARTOON
IMAGERY, IS INTENDED TO HAVE
MORE IMMEDIATE VISUAL IMPACT

3. BROOKLYN MUSEUM OF ART
CONSTRUCTION BARRIERS;
NEW YORK, USA
PENTAGRAM

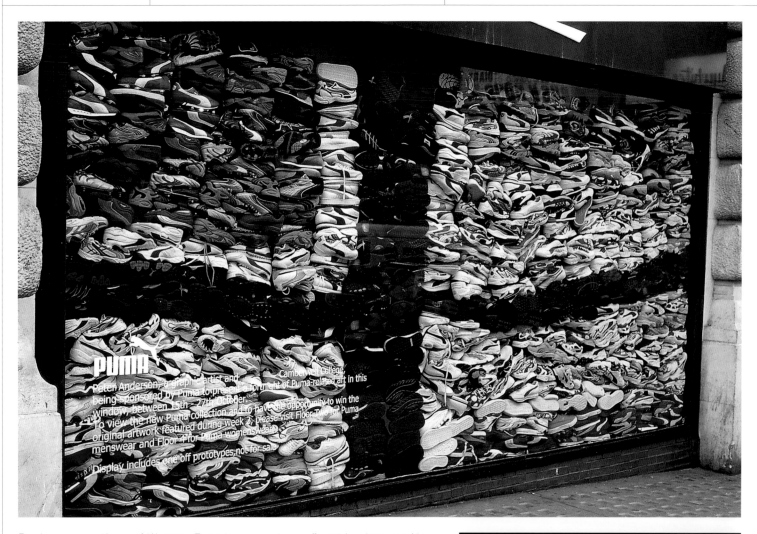

During renovations of Warner Bros.' seven-storey flagship store on New York's 5th Avenue, the opportunity arose to use the required protective screen for promotional purposes. The company briefed graphic design consultancy The Partners to create construction barriers that would not only promote the upcoming movie Space Jam to passers-by on what is one of the city's busiest streets, but that were quirky enough to ensure all-important press coverage. The design featured the distinctive ears of Warner Bros.' most famous character, Buggs Bunny, protruding from behind a newspaper which carried stories about the movie. The story of the construction barrier was itself picked up by real-world newspapers, including the New York Times, netting Space Jam an estimated $1 million dollars' worth of pre-release publicity.

Unlike the construction barriers at Mulberry and the Brooklyn Museum of Art, those at the Warner Bros. store were used to promote a 'product' which was not available immediately on the other side of the barriers; the site is, however, owned by the makers of the product. It is much less common for graphic designers to be commissioned to create promotions for spaces not owned by the company being promoted. And when it does happen, it is often through an arrangement such as sponsorship rather than the conventional advertising model, which involves buying or renting space, whether on TV, billboards or in magazines.

gge.{sole}
= 2.9mm/acc.
w {heel supp.} @
w.p: 52.6mm (incl.
leather) w (sole) @
w.p: 83.75mm • e.s 97
l=258.5mm i.d =72 ~
support = 720 – c.j/b.s
upper shoe/2{xy}.stitch.
t {sole} = 4.4mm. ~ heel
incline = 20° raised heel
56mm {a.g.l} • a {sole}
= 11400mm² / a {heel}
=170mm² is a {heel} =
{170/(170 + 11400)}%
of 100%. (t.s.a) w.heel
centre = 50.65mm @
from shoe back ~ also
105mm from ball of
foot. wt.{shoe} = 173
gms. shoes tapers ~
max {w} ball * foot to
front. sole = i.m. nyl.
{x} ▼ inj. heel « via
<2 spigots>. total
pmtr. of sole (l)
= 506 mm.

relaxing
awhile, briefly
conversing-fleet
afoot, base balancing
head-striding along,
beating quick rhythms,
dextrously controlling,
powerfully projecting,
softly ensconced, phalanges
smooching-dawdling slowly,
free form, lazy, syncopation
naked, brazen displays,
signalling intent-arching
gracefully, supporting
ambition-hiding desire,
caressing ever discreetly
sheathed synthetically,
skin u von skin upon skin
stubbing nocturnally,
fibulaic pogoing-tapping
subconsciously, mind
tempted by the beat
entwined in passion,
on parade in repose
witness to momentum,
carriers of all of
our lives

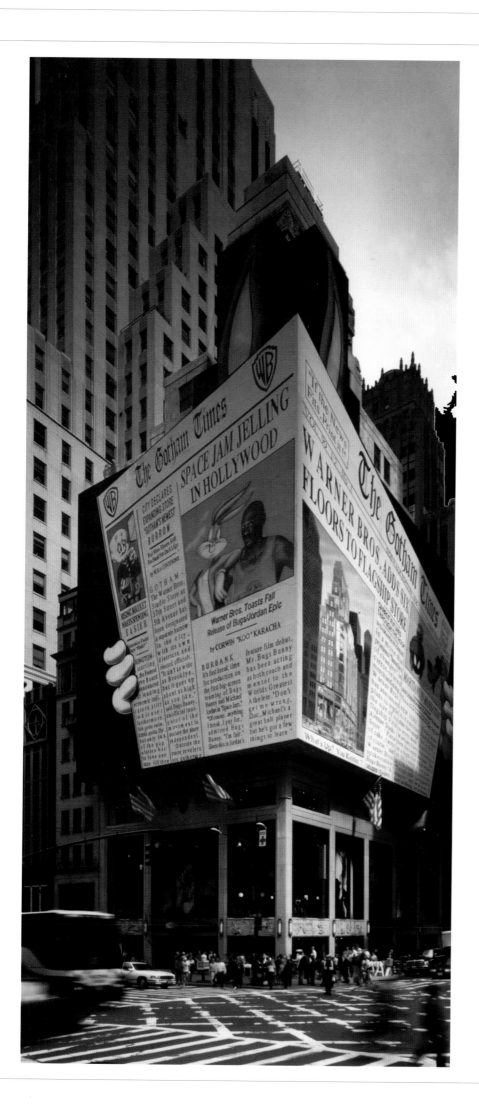

1. PUMA WINDOW DISPLAY;
LONDON, UK
PETER ANDERSON
THE WINDOW OF THE SPORTING
GOODS DEPARTMENT STORE
LILLYWHITES WAS CHOSEN FOR
ITS PROMINENT LOCATION ON
LONDON'S PICCADILLY CIRCUS
WHEN PUMA WANTED TO DO SOME
STREET-LEVEL MARKETING.

2. AUDLEY SHOE
ADVERTISEMENTS; LONDON, UK
LIPPA PEARCE DESIGN
THE DESIGNS WORK AS BOTH
ADVERTISING AND WINDOW DISPLAY.

3. WARNER BROS. CONSTRUCTION
BARRIER; NEW YORK, USA
THE PARTNERS

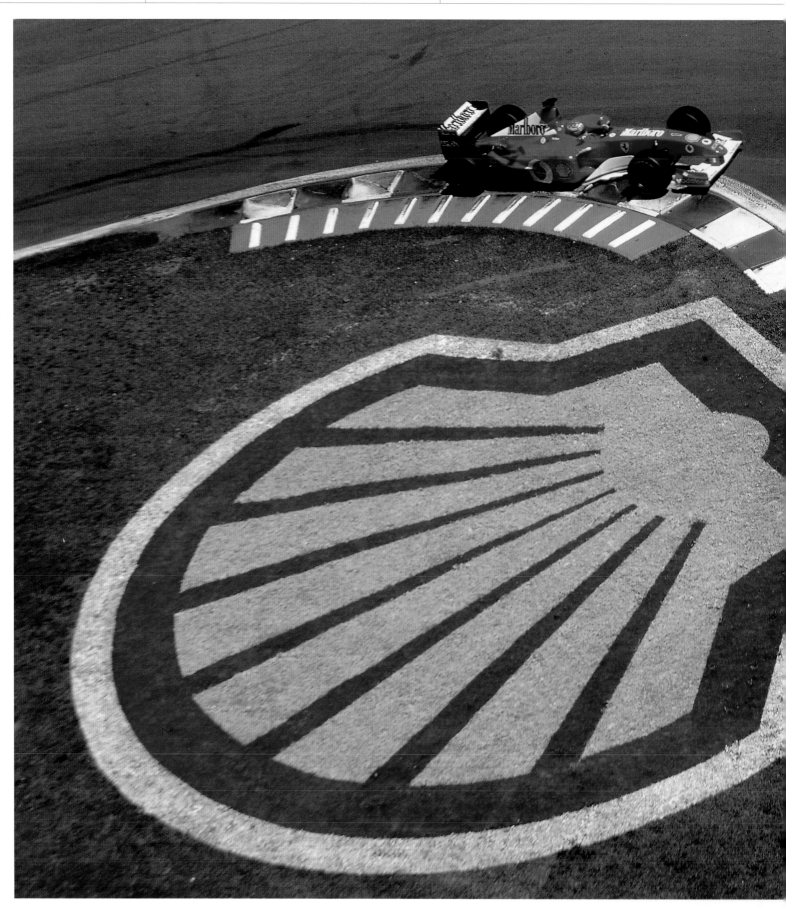

1. SHELL GRAND PRIX TRACKSIDE BRANDING; CANADA

WHILE ALL CIRCUIT OR TRACK ADVERTISING IS USED BY COMPANIES TO GIVE THEM BRAND EXPOSURE – THE MAIN BENEFIT FOR SHELL, ACCORDING TO ITS GLOBAL PROMOTIONS MANAGER JACKIE IRELAND, IS THAT TRACK SIGNAGE AT FORMULA ONE GRAND PRIX RACES IS USED TO PROMOTE THE BRAND AND PRODUCTS IN AN ENVIRONMENT WHERE PEOPLE ARE ALREADY RECEPTIVE AND SYMPATHETIC TO THE COMMUNICATION MESSAGE. FURTHERMORE, IRELAND SAYS, 'PICTURES AND FILM OF RACES WITH FERRARI CARS AND TRACK SIGNAGE ARE USED AS CORE MATERIALS FOR MUCH OF OUR BRAND AND PRODUCT COMMUNICATION PORTFOLIO IN ALL MEDIA; THIS HELPS US TO SHOW OUR CUSTOMERS HOW THE SHELL/FERRARI PARTNERSHIP BENEFITS THEM IN TERMS OF THE ADVANCEMENT OF THE PRODUCTS FOR THEIR CARS. FOR EXAMPLE, PRODUCTS SUCH AS SHELL OPTIMAX, THE SHELL HIGH-PERFORMANCE FUEL AND SHELL HELIX LUBRICANTS ARE A DIRECT RESULT OF WORK AND RESEARCH WE DO WITH FERRARI – SO THE CAR AND TRACK SIGNAGE BRANDING HELPS US TO PROMOTE THIS ASSOCIATION AND PARTNERSHIP AND GIVE EVIDENCE OF IT'

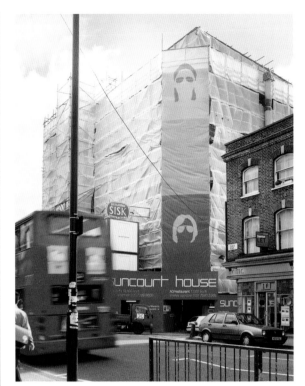

**2. SUNCOURT HOUSE
CONSTRUCTION BARRIER;
LONDON, UK
STUDIO MYERSCOUGH**

'GOOD ADVERTISING,' SAID
INTERNATIONALLY RENOWNED
AD MAN LEO BURNETT, 'DOES NOT
JUST CIRCULATE INFORMATION, IT
PENETRATES THE PUBLIC MIND WITH
DESIRES AND BELIEF' WHEN THERE
IS NO PRODUCT TO SHOW, THE NEED

FOR BELIEF, AS WELL AS DESIRE,
BECOMES EVEN GREATER. THE
CONSTRUCTION BARRIERS FOR
SUNCOURT HOUSE, A COMMERCIAL
AND RESIDENTIAL REDEVELOPMENT
IN LONDON, ARE A CASE IN POINT
THEY DID CIRCULATE INFORMATION
ON THE PROPERTIES BECOMING
AVAILABLE AND CONTACT DETAILS
FOR THE DEVELOPER, BUT WITH
JUST THE SIMPLEST OF MEANS

– A CHIC TYPEFACE, A VIBRANT
ORANGE AND RED COLOUR
SCHEME, AND BOLD GRAPHIC
IMAGES OF TWO ANONYMOUS,
ANDROGYNOUS FIGURES
IN SUNGLASSES. WITH THIS
APPROACH, STUDIO MYERSCOUGH
ALSO TURNED THE BARRIERS INTO
AN UNDERSTATED EXPRESSION
OF FASHIONABLE LIVING.

Sponsorship

Sponsorship is a form of 'stealth' advertising. As well as associating their product with a particular activity or organisation, the aim of many sponsors is to have their name appear in a context, such as the editorial pages of a newspaper or the TV coverage of a sporting event, that viewers do not immediately associate with advertising. This makes the viewers more receptive to the commercial messages they receive. Even the smallest glimpse will do, it seems: certainly, there is no shortage of sponsors willing to pay large sums to get very small logos onto the clothing of top sports stars, who are seen on television by hundreds of millions of people around the world. The Italian yacht Luna Rossa (Red Moon) competes in the top tier of international sailing races, such as the Luis Vuitton Cup and the Americas Cup (2000 and 2003). Sponsored by Prada and dressed in its corporate livery, the boat is a floating billboard for the Italian fashion company, seen by the thousands

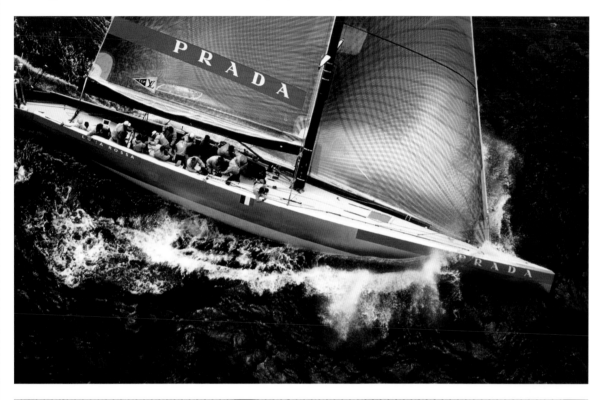

of spectators who turn up to watch the start and finish of each leg of a major race as well as many millions more on television. And it's a big billboard: under full sail, the Luna Rossa presents nearly 1,000 square metres of canvas and hull.

Richard Branson, founder of the Virgin corporation and serial entrepreneur, is almost as well known for his sporting exploits and great talent for self-publicity as for his business activities. A number of world record attempts, first in power boats and later in balloons, have brought publicity to the company and its figurehead, not least through the large and prominent display of the Virgin logo on each of these vehicles. Never one to miss a trick, Branson has turned his hobby into another business opportunity, renting customised balloons to other companies to promote themselves. According to Virgin Balloons, one such UK tour by a balloon in the shape of an RAC van gathered the breakdown service '38 million verified audience impacts through 152 press articles and 34 news clips, all for less than the cost of two 30-second prime-time TV spots.'

Since 1925, when the first helium-filled model, the Pilgrim, took to the skies with the company logo painted on the side, the Goodyear Blimp has become one of America's best-known corporate symbols. Today, the tyre company's three remaining airships – the Spirit of Goodyear, based in Akron, Ohio; the Eagle, based in Carson, California; and the Stars & Stripes, in Pompano Beach, Florida – travel more than 100,000 miles across the country every year. But while its primary function may still be to tour the United States as an 'ambassador' for Goodyear, the Blimp has not only worked its way into coverage of sporting events and the like, but has had cameo roles in feature films and television programmes such as The Simpsons, and has even entered common parlance (as a synonym for big things).

Yachts, airships and balloons come at a price, of course. But a simple vehicle livery for a bus, van, car or even train, can cost less than the monthly rental on a prominent billboard site. And even when such vehicles are not distinctive enough to appear on television, their champions assert they claim the best recall of any 'out-of-home' advertising media – that is to say, viewers are more likely to remember an image seen on the side of a train than on a billboard or banner.

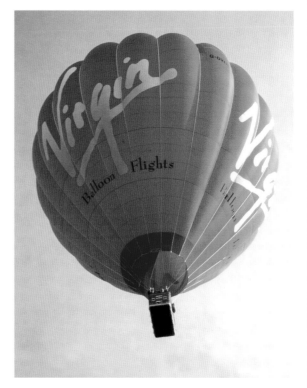

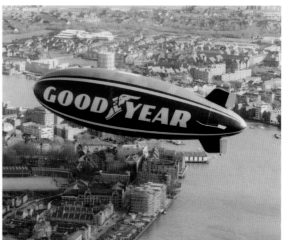

1, 2. THE LUNA ROSSA; ITALY
WHEN THE RACING YACHT IS UNDER
FULL SAIL, THE PRADA GRAPHICS
COVER NEARLY 1,000 SQUARE
METRES OF CANVAS AND HULL.

3. VIRGIN BALLOON; UK

4. THE GOODYEAR BLIMP; USA

IDENTITY

In what is generally regarded as the first 'modern' corporate identity programme, the German architect Peter Behrens was invited by the German electrical company Allgemeine Elektricitaets Gesellschaft (AEG) to take control of all of the company's visual properties, from its logo and printed promotional materials to the architecture of its factories and the design of its products. But while Behrens' work for AEG, which began in 1907 and emphasised consistency of application across media, became the prototype for much of the corporate identity work that has followed, the buildings and facilities owned by a company have not always come within the remit of the company's identity designer.

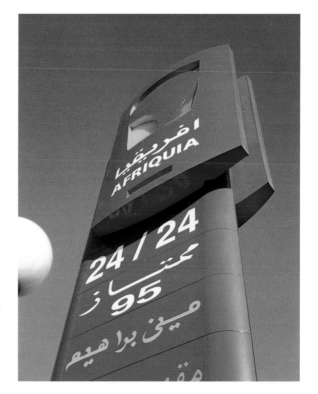

The reasons for this, of course, are multiple: not all companies, for example, get to design and build their own headquarters, they rent premises from developers and others. Furthermore, the graphic elements of a company's identity are changed, or at least updated, more regularly than it is possible to commission new buildings, even if the desire existed. But in recent years companies have expressed increasing interest in having their buildings manifest some element or aspect of their identity, and the way this is achieved is often graphic rather than strictly architectural. In the offices of interior design consultancy 20/20, its own logo becomes an interior design feature, and stamps the identity of the company on its premises. And at the Madejski Stadium, the new home of Reading Football Club, designers Alan Cotterell Practice took advantage of the free rein offered by a new building to inscribe the name of the club's chairman, John Madejski, in the banked seating in white and blue, the club's colours.

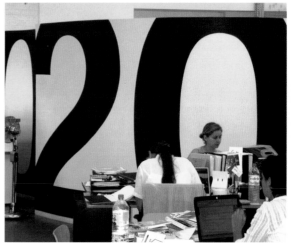

It is, of course, easier to incorporate elements of an essentially graphic identity into architecture when the graphic designer and architect are able to communicate and collaborate at the start of the design process. Of all building types, the petrol station is probably the one in which a company's corporate identity – in the strict sense of its logo, corporate colour palette and so on – are most clearly manifested. In architectural terms they are largely functional, providing merely a roof for shelter from sun and rain, pumps and underground tanks, and a place to pay. It is the graphics that do all of the work, first in persuading the driver to pull off the road at that particular point, and second, increasingly, by advertising the extended offer – mini-supermarket shopping and on-site eating facilities. Afriquia is Morocco's leading petrol company. Its stations, designed by Minale Tattersfield Design Strategy, take their visual cues, including shape and colour scheme, from a new identity also designed by Minale Tattersfield.

The most straightforward way of applying an identity to a building, of course, is just to blow the logo up until it seems proportionate to the scale of the building on which it is to sit, and apply it as an illuminated sign, or a banner. But this is not a method that is particularly sensitive either to the wider environment or the requirements of the job in hand. A logo designed to be used primarily in print does not necessarily work well as a piece of environmental graphic design due to the particular complications involved in working with architecture, and within a wider environment.

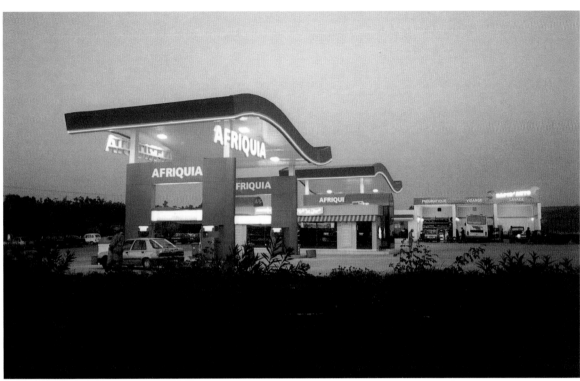

1, 3. AFRIQUIA PETROL STATION;
MOROCCO
MINALE TATTERSFIELD
DESIGN STRATEGY

2. 20/20 OFFICE SIGNAGE;
LONDON, UK
20/20

4. MADEJSKI STADIUM;
READING, UK
ALAN COTTERELL PRACTICE

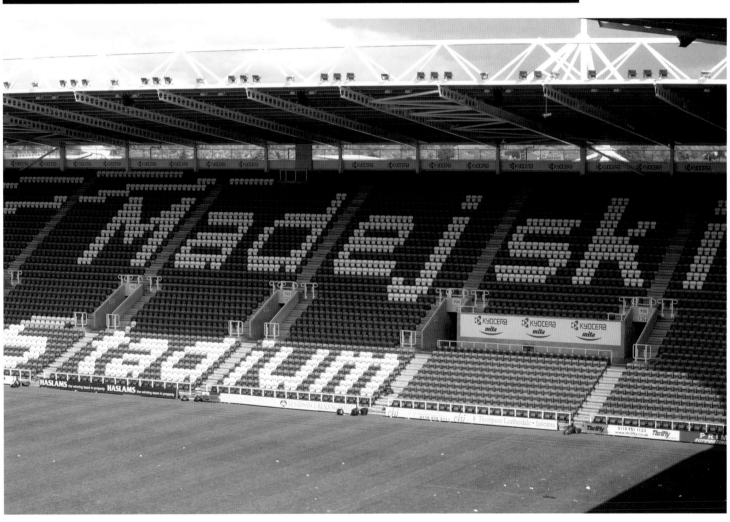

1,2. PTT BUILDING
INTERIOR LED WALL CONCEPTS
AND THE FINISHED RESULT;
LEEUWARDEN WEST,
THE NETHERLANDS
BURO LANGE HAVEN

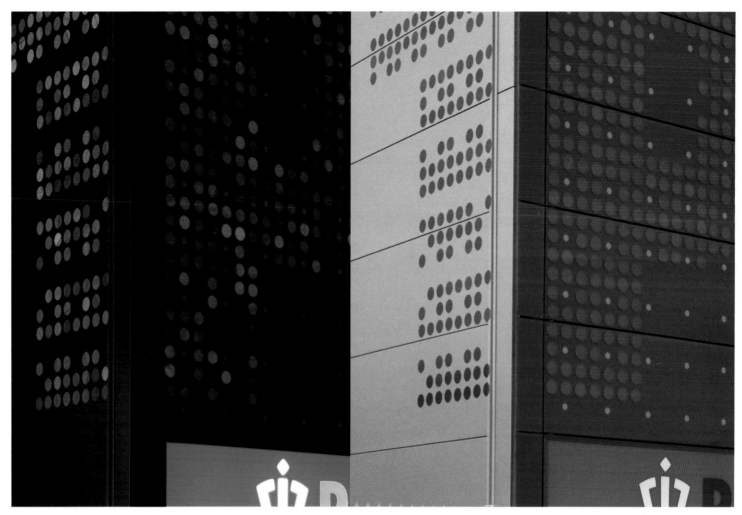

When the Dutch post office, the PTT, commissioned a new identity for its buildings, the designers Buro Lange Haven attempted to fully integrate graphic design and architecture on what the company's founder, Gerard Hadders, refers to as a 'monumental' scale. The PTT had commissioned a number of new buildings from the Delft-based architectural practice CPZ, and these were the first to receive the all-encompassing dot-matrix veneer, derived from the existing PTT identity. But the designers also developed a database of variations to be applied to the facades of other buildings and properties, making this a genuinely flexible identity system which is ideally suited to the complexities of applying graphics to architecture and environmental installations rather than letterheads and brochures. The 75mm 'dots' were cut from a reflective prismatic foil of the sort normally used for road signs, which is intended to reflect light from sources external to the building, such as street lamps in the car park. At close range the dots form a pleasant abstract image, but at a greater distance – from nearby roads, for example – the entire logo is clearly visible.

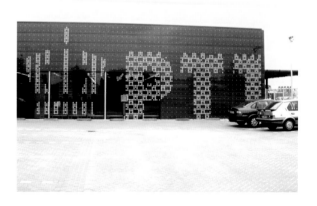

Temporary transformations

Just as companies may take up residence in a building, and want
it to express the fact of their residence as well as other, more abstract
qualities, so too other forms of organisation may temporarily occupy
an environment, and wish it to manifest elements of their identity.
The Winter Olympic Games of 2000, held in Salt Lake City, Utah,
represented a significant graphic design undertaking. In addition to
bespoke scoreboards, vehicle liveries and course markings, 25,000
purpose-built directional signs were installed for the event. But perhaps
the most striking contribution to the city's overall transformation into the
temporary home of the Olympics was made by twelve vast banners,
suspended from eleven downtown office buildings and the University
of Utah.

The banners – the largest of which measured 339 feet tall by 158 feet
wide – were produced by ProGrafix International and installed and
later demounted by the Young Electric Sign Company (YESCO) – a
process that took 12,000 hours in total. They feature photographs
by John Huet of athletes participating in winter sports such as figure-
skating, snowboarding, luge and ice hockey. In order to ensure that the
city's temporary 'identity scheme' was not compromised, the Salt Lake
Organising Committee reached agreement with other buildings in the
downtown area that they would not display commercial banners for
the duration of the event.

As a temporary scheme, special consideration had to be given to the
long-term impact of the banners on the fabric of the city's buildings,
and to the avoidance of unnecessary disturbance to the normal working
of the city before, during and after the games. In order to preserve the
buildings, the structural engineers devised scaffolds and other temporary
fixings unique to each of the buildings, designed to cause the minimum
possible damage to their facades, yet withstand winds of up to 70mph.
The banners themselves were made of netting, which looks opaque at a
distance, but permits light into the offices, allowing their inhabitants to
see out. The Salt Lake City banners, along with the 25,000 signs, came
down at the end of the 2000 Olympics, their job done, and the city
reverted to its former identity.

The Hollywood sign

What starts out as a temporary superimposition on a place, can
sometimes end up defining that place permanently. Standing 50 feet tall
and stretching 450 feet across the side of Mt. Cahuenga, overlooking
Los Angeles, the Hollywood sign has come to represent not only the
place in which it is located, but the world of entertainment. But while it is
now one of the world's best-known landmarks, the identities of the town
and its sign took many years to fuse. The $21,000 dollar sign was first
erected in 1923 by a local property developer called The Hollywoodland
Real Estate Group, and originally read 'Hollywoodland'. 4,000 blinking
bulbs ensured that the sign remained visible day and night, from a
distance of up to 25 miles.

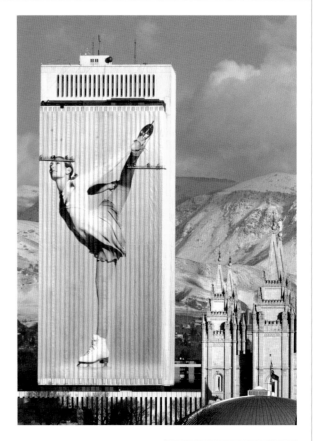

1, 2, 3. PTT BUILDING EXTERIORS;
LEEUWARDEN WEST,
THE NETHERLANDS
BURO LANGE HAVEN
CAREFUL RENDERINGS OF
THIS GRAPHICALLY AMBITIOUS
PROJECT (1, 2) PRODUCED A
REALITY (3) THAT WAS CLOSE TO
THE ORIGINAL VERSION.

4. OLYMPIC CITYSCAPE;
SALT LAKE CITY, UTAH, USA
PROGRAFIX INTERNATIONAL
THE BANNER SHOWN HERE
WAS SUSPENDED FROM THE
HEADQUARTERS OF THE MORMON
CHURCH, BASED IN THE CITY
BECAUSE HOLES COULD NOT
BE DRILLED INTO THE FACE
OF THE BUILDING, THE BANNER
WAS SUSPENDED FROM 1,500
CUSTOM-ENGINEERED AND
MANUFACTURED CLAMPS

THE HOLLYWOOD SIGN; LOS
ANGELES, CALIFORNIA, USA

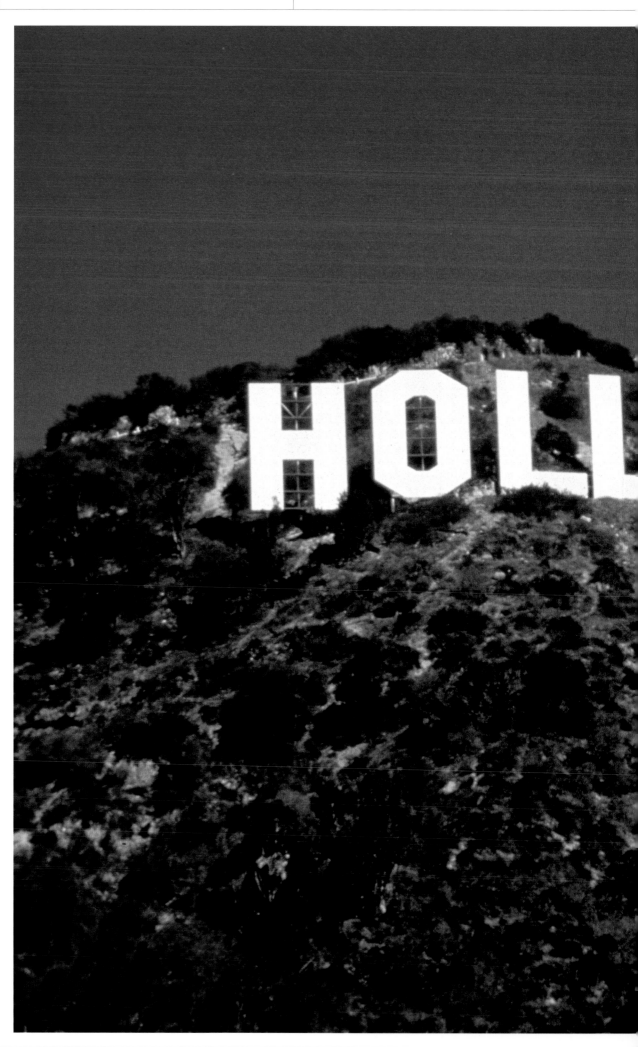

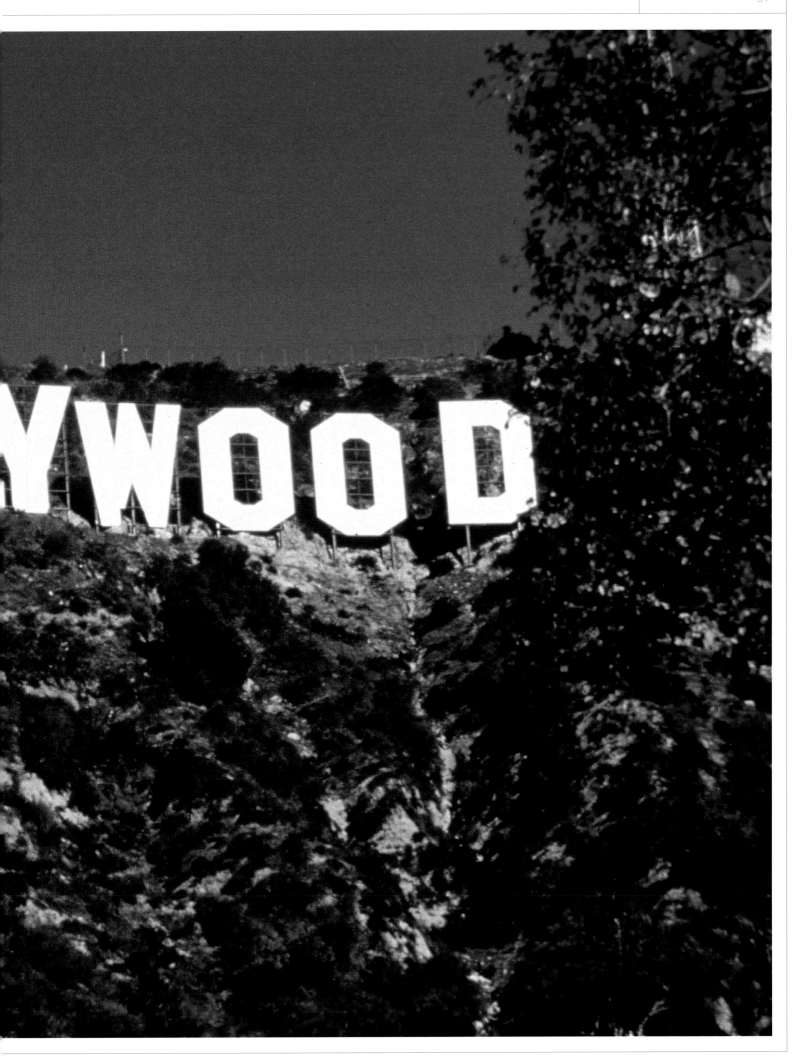

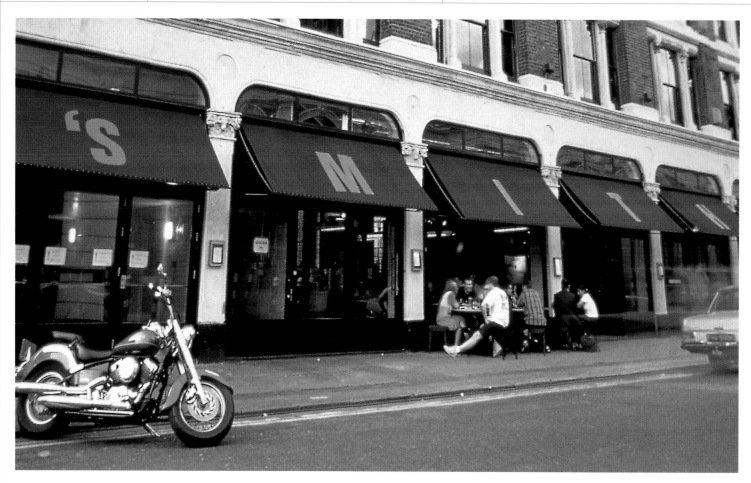

The sign was intended to last for just 18 months but remained in place through turbulent times. The developer went bankrupt, the sign was vandalised, the bulbs were stolen and winds blew the 'H' down. The future looked brighter in 1949, when the land and the sign were acquired by the City Council, which removed the word 'land' to leave the now famous 'Hollywood' sign. But despite being given landmark status by the Cultural Heritage Board in 1973 the sign continued to fall into disrepair: an 'L' was set fire to; the double 'O' was changed to double 'E' by pro-marijuana campaigners and once restored, all three 'O's fell down, along with the 'D'; and salvation attempts by Gloria Swanson, Fleetwood Mac and others came to nothing. The sign was eventually saved by the industry it represents: various stars each bought a letter, and the sign was rebuilt from scratch in 1978. In perfect health today, the Hollywood sign is unlikely to fall into dereliction again. Indeed, it has become the focal point of any large scale local celebration, from the Olympics in 1984 to the millennium, when it was illuminated by more than two million watts of light – considerably more than the 80,000 watts that did the job in the 1920s.

By an accident of history, the Hollywood sign has become the unofficial logotype of one of the world's richest industries. Using the same measures by which the Coca-Cola or Microsoft 'brand equity' is assessed, it would have to be one of the most valuable properties in the world.

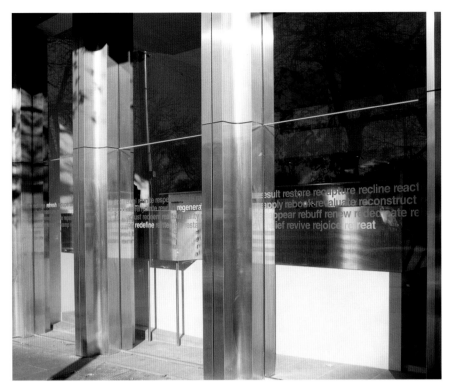

1, 2. SMITHS OF SMITHFIELD;
LONDON, UK
RODNEY FITCH
THE CHUNKY LETTERING ON THE
AWNING OF SMITH'S OF SMITHFIELD
NOT ONLY IDENTIFIES THE
RESTAURANT TO PASSING TRADE,
BUT TIES IN WITH ITS OVERALL
IDENTITY, AS APPLIED TO MENUS,
BEER MATS (2) AND OTHER
RESTAURANT STAPLES

3, 4. RETREAT; MELBOURNE,
AUSTRALIA
FABIO ONGARATO DESIGN
RETREAT IS A CONCEPT STORE
COMBINING A SPA AND JUICE
BAR (JUICETTERIA). THE DESIGN
OF ITS IDENTITY, BY FABIO
ONGARATO DESIGN, ENCOMPASSED
EVERYTHING FROM STATIONERY
AND MARKETING MATERIALS TO
THE INTERIOR OF THE STORE
ITSELF, WHERE LARGE SCALE
TYPOGRAPHY ACTS AS BOTH A
SIGNAGE AND BRAND MESSAGING
SYSTEM. THE STORE INTERIOR
WAS DESIGNED IN CONJUNCTION
WITH ARCHITECTS CARR DESIGN

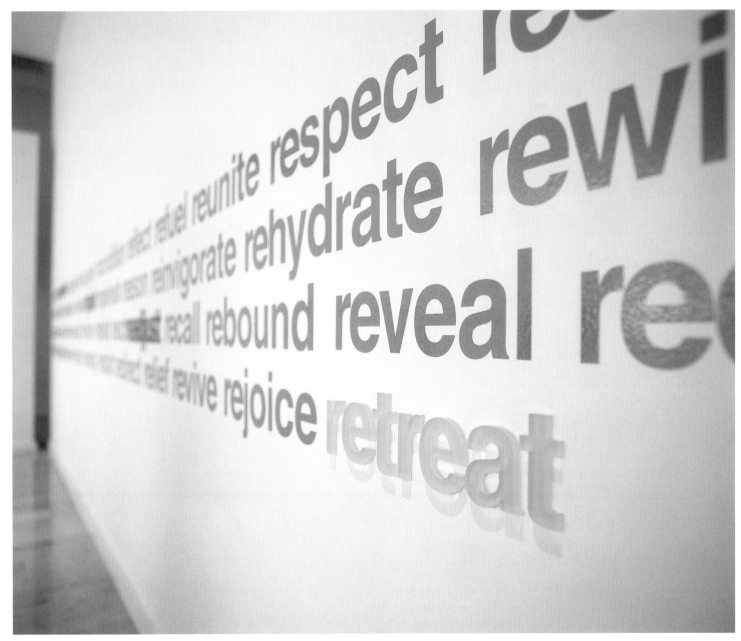

WAYFINDING

Wayfinding is a broad term – used to describe the provision of information that is more than purely directional. As in the case of exhibition design elements, or the design of retail spaces that lure shoppers to a particular part of the shop as much as point them in the right direction.

But the term is normally understood to mean the system by which we find our way around buildings and the built environment, and although it is often thought to be synonymous with 'signage' it is about more than just this. It is the complete system of clues that people use to navigate around unfamiliar and even familiar spaces, in as pleasant and uncomplicated a way as possible. Components of the system can include audible and tactile elements (such as elevator announcements arriving at the correct floor, or a supermarket public address system, or simply a different floor finish in different departments of the same store) as well as visual ones, the most obvious of which is signage. But visual cues are also found in the way a building is lit, for example, and in the nature of the arrangement of the space itself. Many architects believe that if a building is sufficiently well-planned, a sign system should be almost redundant. In practice, of course, this does not happen. We cannot see around corners, and we instinctively want to read signs if only to reassure us that we have made the correct decision about which way to go.

1, 2, 3, 4. DUKE THEATER 42ND
STREET STUDIOS; NEW YORK, USA
PENTAGRAM

5. STANSTED AIRPORT
SIGNAGE; LONDON, UK
PENTAGRAM

While designers will almost always want a design to be readable –
whether it is a record sleeve or a catalogue – this is of paramount
importance with wayfinding, overriding aesthetic considerations. Because
readability is the priority, attention to typographic detail is essential: at a
distance, the thin strokes of some typefaces will become invisible, even if
the letters themselves are reproduced at what might seem an adequate
size. Likewise, letterforms that are not sufficiently spaced may blur
together. It is possible to render signs in modelling software such as
Form Z, to simulate how they would appear at a distance, but many
designers feel that there is no substitute for printing out scale copies
and making observations on site, even if it is more time-consuming.

The Dukes Theater's rehearsal studios

Wayfinding specialists often caution against providing too much information, or dividing it into such formidable order that the hierarchy of signs can only be understood on paper. The wayfinding system designed by Pentagram partner Paula Scher for Duke Theater's 42nd Street rehearsal studios on New York's 42nd Street covers virtually every surface within the building. The colours of walls and floors are recognisably part of the wayfinding system, and large scale numbers, words and pictograms are used throughout, running across doors, walls and floors to create a truly graphic environment that almost competes in scale and intensity with nearby Times Square. But while the wayfinding system at the Duke Theater studios is monumental and all-pervasive, it is not overwhelming. The actual quantity of information imparted is as much as is needed and no more. While a room number may cover an entire door, it is still just a single room number, and is therefore immediately comprehensible. The entire environment has been turned into a description of its composite elements.

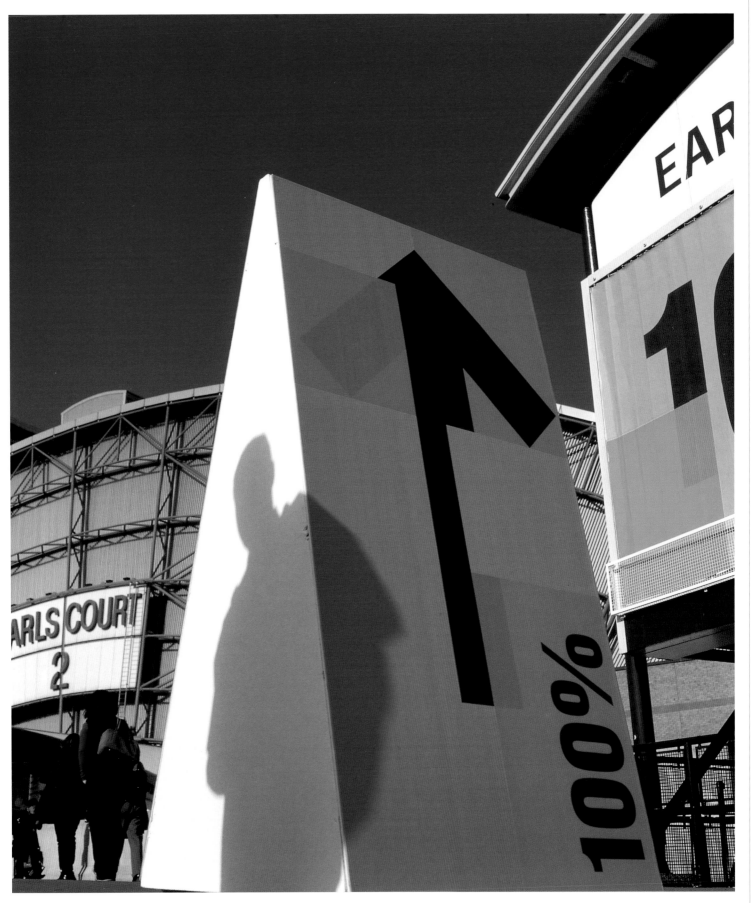

1. MILLENNIUM POINT SIGNAGE;
BIRMINGHAM, UK
CARTLIDGE LEVINE

2, 3. 100% DESIGN SIGN SYSTEM;
LONDON, UK
LIPPA PEARCE
THE SCALE OF THE PYRAMID SIGN
PROVIDED AN EASY POINT OF
ORIENTATION FOR VISITORS
ARRIVING AT THE 100% DESIGN
EXHIBITION. THE TWO- AND THREE-
DIMENSIONAL ELEMENTS OF THE
DESIGN OF THE EXHIBITION AND
WAYFINDING WERE CONSIDERED

TOGETHER, IN A COLLABORATION
BETWEEN THE GRAPHIC DESIGN
CONSULTANCY LIPPA PEARCE DESIGN
AND THE INTERIOR DESIGN
CONSULTANCY BEN KELLY DESIGN

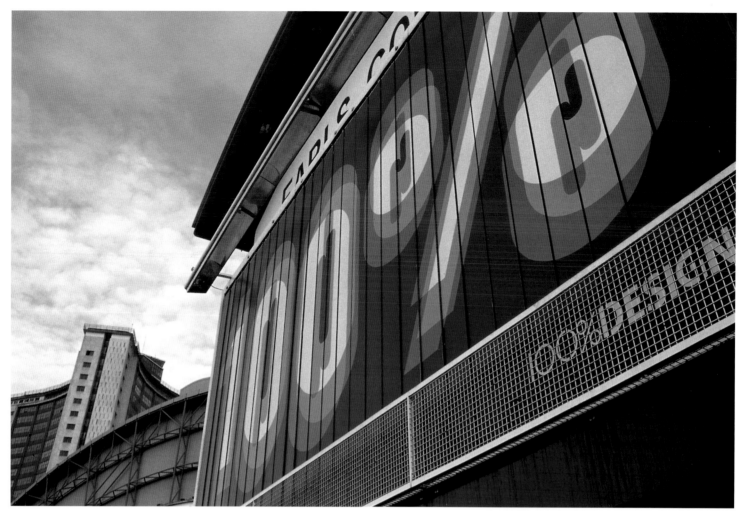

Large scale graphics are used in wayfinding both in- and outdoors for a variety of reasons. First, and most obviously, they can be easier to see, if for example the area in which the sign is placed is liable to get crowded or the distances from which signs must be read is great. In other circumstances, large signs are on an appropriate scale to the environment. Alan Fletcher, as a partner at design consultancy Pentagram, was asked to create a signage system for London's new Stansted Airport terminal designed by the architect Norman Foster. The scale of his original proposals reflected the fact that Foster's innovative design – which buried the mechanics of airport services under the floor allowing for high ceilings and a light, airy space – represented a new departure in airport design. Previously, the convention of housing services in the roof had resulted in low-ceilinged, dark spaces within airport terminals. Pentagram's signage proposals revelled in the volume of the space, and practically, allowed signs even for such 'minor' conveniences as toilets and money-changing facilities to be read from across the terminal building.

Colour contrast in the sign itself is useful to viewers attempting to distinguish type from a distance, but colour can also be useful in helping to identify the sign. The yellow colouring and distinctive cube forms of the sign system created by graphic design consultancy Cartlidge Levine for the Millennium Point development in Birmingham, UK, is a good example. As brightly coloured, free-standing objects, the signs are easy to distinguish against the grey backdrop of the environment.

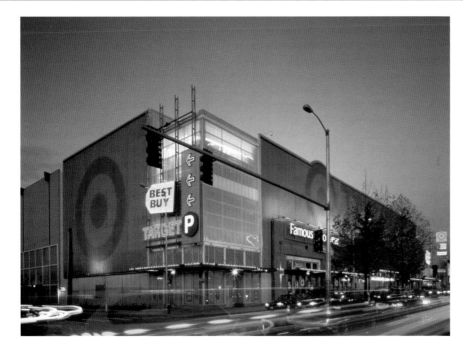

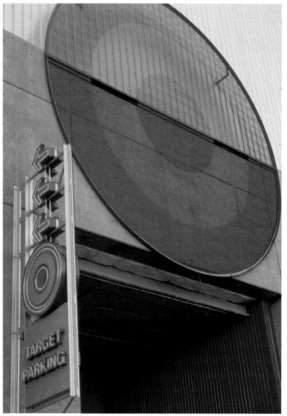

Designing systems

Another important aspect of wayfinding systems is that they are systems. Consistency is important – not just a consistent use of typography, naming and symbols between individual signs, but between signs and all of the other elements of the wayfinding system. Consistency of placement is also important. If visitors to a building find a sign facing the elevator doors on the first two floors of a building, they will rely on finding one on the third as well. Romedi Passini, an architect with a doctorate in environmental psychology, has produced many publications based on his research into wayfinding and spatial orientation, most recently concentrating on the particular problems faced by those with visual or cognitive impairments. His studies of wayfinding problems in urban Montreal in the 1970s led to a conceptualisation of wayfinding as a two-stage activity: decision-making – deciding what to do, and decision executing – doing it[4]. Signage and the other components of a wayfinding system must both furnish the user with enough information about where they are and the options available to enable a decision, and then support them in actually carrying it out. It is no good knowing in principle where you are going if you can't find it in practice. Generally speaking, signs should be placed at all decision-making areas – where visitors enter the environment, where they must decide to turn right or left and so on. To do this effectively, the designer must first understand all of the possible routes that a visitor may take through an environment, and create a system that not only lets them know where they are at any particular time, but also how to get to another destination from there. This can be problematic: a sign visible throughout 95 percent of an exhibition hall may be obscured by a column in front of a critical entrance-way, for example.

1, 2. 100% DESIGN SIGN SYSTEM;
LONDON, UK
LIPPA PEARCE

3, 4. NORTHGATE NORTH
SIGNAGE; SEATTLE,
WASHINGTON, USA
WPA, INC.
NORTHGATE NORTH IS UNUSUAL FOR AN AMERICAN SHOPPING CENTRE. WHILE MOST ARE LOW LEVEL, WITH ACCESS TO INDIVIDUAL RETAILERS FROM A LARGE SURROUNDING PARKING LOT, NORTHGATE NORTH IS STACKED VERTICALLY WITH AN EIGHT-LEVEL GARAGE OPPOSITE. DESIGN CONSULTANCY WPA, INC. EXPRESSED THIS BY PERSUADING EACH OF THE RETAILERS TO FORGO THEIR OWN SIGNS IN FAVOUR OF A CONSISTENT, COMPREHENSIVE SYSTEM OF

INTERNALLY ILLUMINATED SIGNS ATTACHED TO THE BUILDING. PRIMARY TENANTS ARE IDENTIFIED BY CHAIN-LINK MESH SIGNS WHICH FORM THE FACADES TO THE PARTS OF THE BUILDING THAT THEY OCCUPY. THE SMALLER TENANTS WERE IDENTIFIED BY SMALLER-SCALF METAL AND NEON SIGNS. THE DESIGNERS ALSO DEVISED A COLOUR SCHEME FOR BOTH SIGNAGE AND ARCHITECTURE TO ENSURE CONSISTENCY ACROSS THE BUILDING

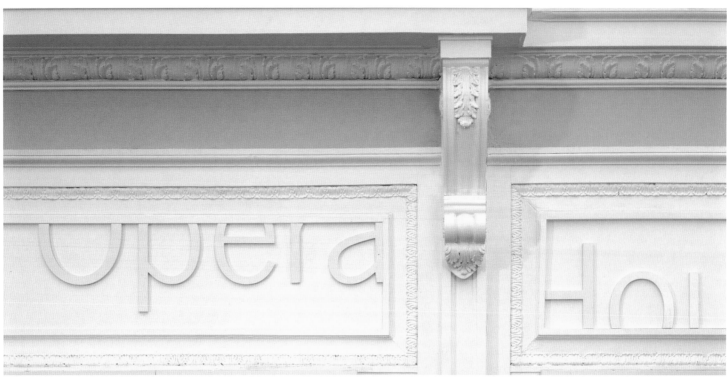

Supporting visual communication

As unlikely as it may seem, a significant proportion of the population of even the most developed countries have difficulty reading basic texts, or interpreting graphical information, whether in book format or in signage systems. Estimates for the incidence of 'functional illiteracy' in some Western countries reach as high as 25 percent. It is therefore desirable to support any principally text-based wayfinding system not only with other visual clues – such as the use of colour, or standard pictograms for facilities such as toilets – but with 'signs' which can be read by other senses.

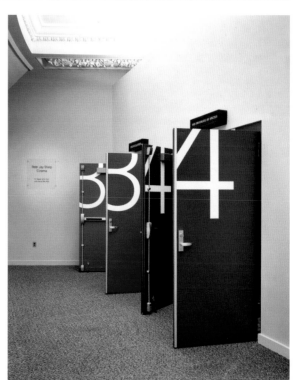

One such method is the use of audible 'signs'. These can range from the elevator that speaks out loud the number of the floor at which it has arrived to the presence of attendants who can answer directional queries in person. Tactile signs, too, are frequently used, ranging from Braille copies of the signage system itself to the use of different floor finishes to denote different departments within a store. While the responsibility for provision of audible and even tactile clues may not fall to the graphic designer, it is still important to discover what provision will be made, and adapt the visual elements of the wayfinding system to fit in with these other elements.

Wayfinding systems, of course, do not have to rely on large scale signs. By exploiting new technologies such as interactive kiosks and mobile phones, for example, designers could theoretically make some of the most complex environments navigable without the need for signs at all. In many situations, however, especially where the environment itself is large or complex, and the visitor may find themselves within sight but some distance from where they want to be, large scale wayfinding graphics are the most effective solution.

1, 2, 3. BROOKLYN ACADEMY OF
MUSIC; NEW YORK, USA
PENTAGRAM

THE HALF-HIDDEN TYPE THAT
FORMED THE SIGNAGE AT THE
BROOKLYN ACADEMY OF MUSIC
(BAM) WAS INTENDED AS A
METAPHOR, THE TYPE IS 'COMING
OVER THE HORIZON', A REFERENCE
TO THE EMERGING TALENTS WHOSE
WORK IS SHOWCASED IN THIS
PERFORMING ARTS VENUE
ALTHOUGH THE DESIGNERS USED
THE WAYFINDING TO COMMUNICATE
SOMETHING OTHER THAN
NAVIGATIONAL INFORMATION,
ITS FUNCTION AS DIRECTIONAL
SIGNAGE IS NOT IMPEDED

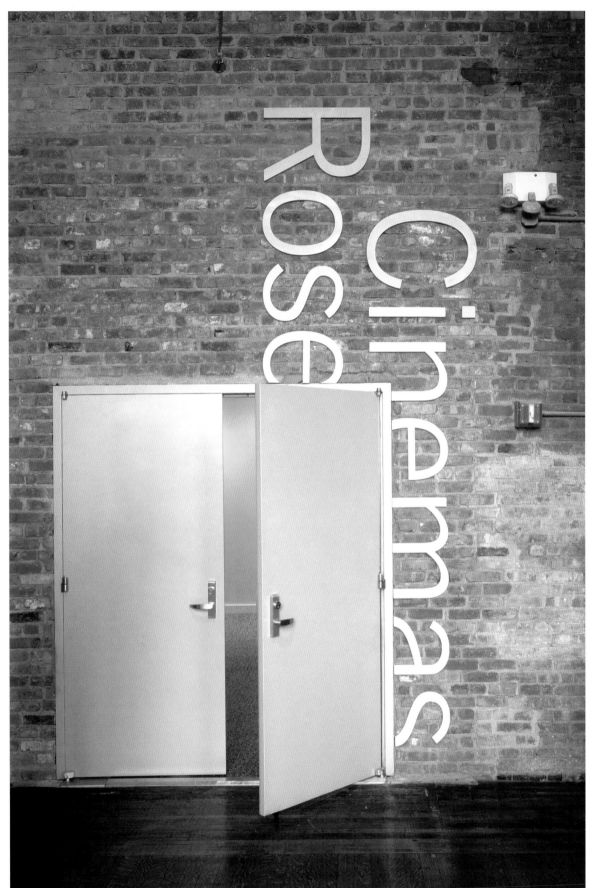

INFORMATION

The book, the brochure, the catalogue, the magazine; we are used to receiving our non-commercial information in these editorial formats — and understand them to be printed documents which we can hold in our hands. But moderate levels of information are not always provided in this way. If a space the size of a billboard can be used for advertising purposes, it can be used for editorial purposes too. That said, the way we read information on walls is very different to the way we read from the page: reading from a book is a solitary activity; reading from a wall is potentially done by many people simultaneously. Therefore, while the reader can control pace by turning pages, or skip backwards and forwards between index and contents in a hand-held book, this is not possible with a book printed on a wall. Likewise, the book, magazine or brochure is a portable object; the environmental graphic is not. The book can be referred to again later in a different location — the wall cannot. And further, the book can be read in a place of our own choosing — in a comfortable chair, or to kill time waiting for a train; the wall cannot. But there are things that the designer of the book or brochure on a wall can be sure of that the designer of a printed, bound magazine cannot — context, for example. They know exactly where the reader is standing, and what is likely to be happening around them.

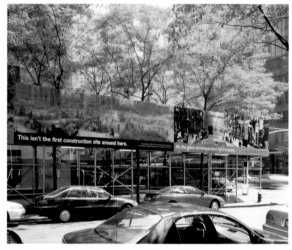

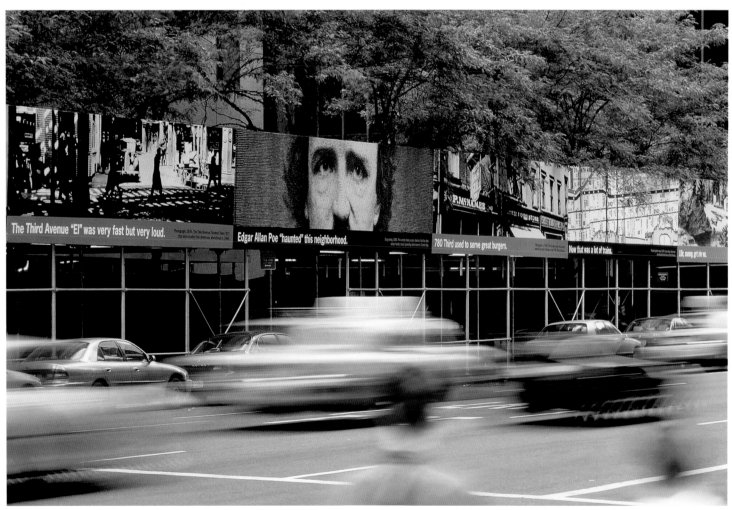

In designing 'History in the Making', a public exhibition installed on construction barriers at 780 Third Avenue, New York, Chermayeff & Geismar's designers knew that the subject of the exhibition – the surrounding Turtle Bay neighbourhood – would be in view at all times. The client's objective was to encourage tenants of the building to renew their leases, so they were one of the primary audiences for the exhibition, along with passers-by on foot and those using public and private transport. While the construction barrier had both a practical and commercial purpose, the exhibition was designed in the same spirit as if it were housed in a museum, and came complete with supplementary information such as a bibliography.

Of course there are precedents suggesting that people will take the time to stop and view an exhibition that interests them – although not many for exhibitions mounted in the street. There are even fewer indicators that people want to read the editorial content of books or magazines at large scale in an environmental context. And yet that is what Müller + Hess created. Grenzwert is a self-initiated magazine project, emanating from the studio of the Zürich-based design consultancy, whose launch issue was intended to promote a bar of the same name. It exists primarily in printed form but the designers also produced it as an installation at the bar, in which the text, set in Scala – a typeface created by Müller + Hess – was silkscreened in black onto clear plexiglas. The individual letterform tiles were mounted on the wall of the bar, and periodically reconfigured by a journalist to form the new text of the next edition.

1, 2. 'HISTORY IN THE MAKING'; NEW YORK, USA CHERMAYEFF & GEISMAR

3. BAR GRENZWERT; ZÜRICH, SWITZERLAND MÜLLER + HESS

BAR GRENZWERT; ZÜRICH,
SWITZERLAND
MÜLLER + HESS

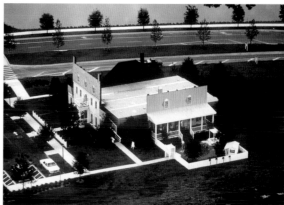

Celebration town preview center

Celebration in Florida has become famous as the town started by the Disney corporation. Despite its parentage, however, Celebration is a real town rather than a theme park, which aims to resurrect the aesthetics and community values of small-town America in a bygone age. While Celebration has its critics, it is its residents' idea of Utopia. But when the town was being constructed, its developers needed to convince potential residents that such a place could be found.

Pentagram was responsible for all of Celebration's graphic design, from the 'tree girl' logo, street signs, commercial signage and even sewer caps to a range of Celebration-branded products, such as watches and golf clubs. In addition to this Pentagram also designed the Celebration Preview Center to show potential purchasers what their dream homes would be like. As the Preview Center was to be used before any actual homes were built, Pentagram created a graphic 'simulation' of a typical Celebration house. Four ready-made trailers were clad in flat facades, wrapped in large scale prints showing watercolour paintings of a house. The three flats – a front and two sides – represented to scale three of the six approved styles of domestic architecture in Celebration (paradise is strictly controlled). The addition of a porch helped to create the illusion of a real, three-dimensional house when the Preview Center was viewed from a nearby highway. Inside, the floor was covered in a 1:1 scale architect's blueprint of a typical Celebration house (with white lines out of blue), and dressed with props to suggest a real home. In the Preview Center, the designers not only explained on a technical level what a Celebration house might consist of, but gave potential purchasers the opportunity to experience a town that did not yet exist.

One of the principal tasks undertaken by the designers of graphics on an environmental scale is what might be described as the shaping of the sense of place. This goes beyond purely informational functions such as wayfinding, and even beyond 'identity' in the sense of applying a 'corporate' graphic consistency to architecture or environments. It is more to do with character, and atmosphere, and association.

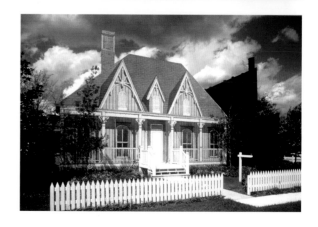

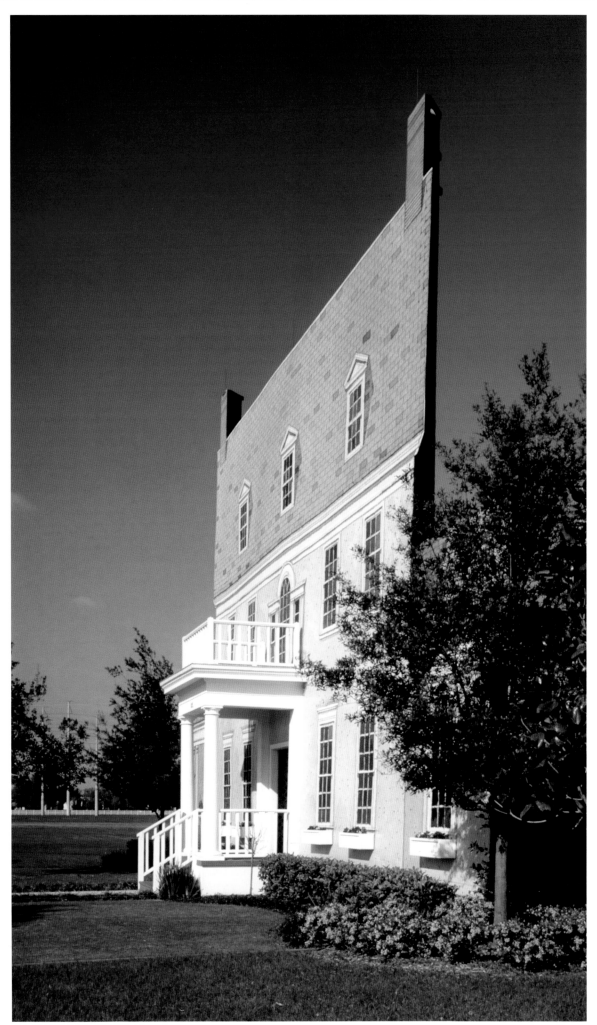

1, 2, 3, 4, 5. CELEBRATION
PREVIEW CENTER; FLORIDA, USA
PENTAGRAM

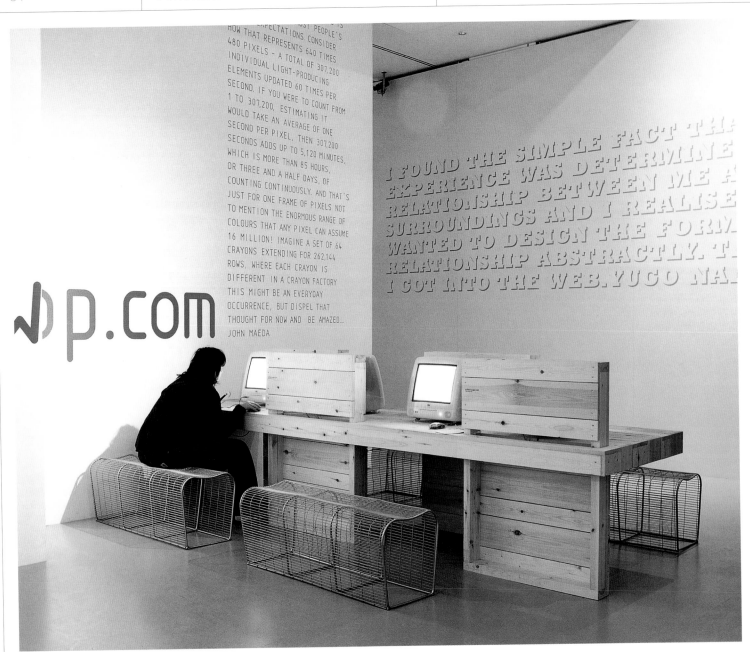

EXPECTATIONS, MOST PEOPLE'S
HOW THAT REPRESENTS 640 TIMES
480 PIXELS - A TOTAL OF 307,200
INDIVIDUAL LIGHT-PRODUCING
ELEMENTS UPDATED 60 TIMES PER
SECOND, IF YOU WERE TO COUNT FROM
1 TO 307,200, ESTIMATING IT
WOULD TAKE AN AVERAGE OF ONE
SECOND PER PIXEL, THEN 307,200
SECONDS ADDS UP TO 5,120 MINUTES,
WHICH IS MORE THAN 85 HOURS,
OR THREE AND A HALF DAYS, OF
COUNTING CONTINUOUSLY. AND THAT'S
JUST FOR ONE FRAME OF PIXELS NOT
TO MENTION THE ENORMOUS RANGE OF
COLOURS THAT ANY PIXEL CAN ASSUME
16 MILLION! IMAGINE A SET OF 64
CRAYONS EXTENDING FOR 262,144
ROWS, WHERE EACH CRAYON IS
DIFFERENT IN A CRAYON FACTORY
THIS MIGHT BE AN EVERYDAY
OCCURRENCE, BUT DISPEL THAT
THOUGHT FOR NOW AND BE AMAZED...
JOHN MAEDA

I FOUND THE SIMPLE FACT THA
EXPERIENCE WAS DETERMINE
RELATIONSHIP BETWEEN ME A
SURROUNDINGS AND I REALISE
WANTED TO DESIGN THE FORM
RELATIONSHIP ABSTRACTLY. T
I GOT INTO THE WEB. YUGO NA

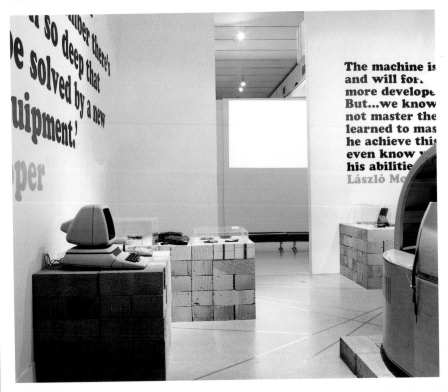

...mber there's
...o deep that
...e solved by a new
...uipment.'
...per

The machine is
and will for...
more develope...
But...we know...
not master the...
learned to mas...
he achieve this...
even know ...
his abilitie...
László Mo...

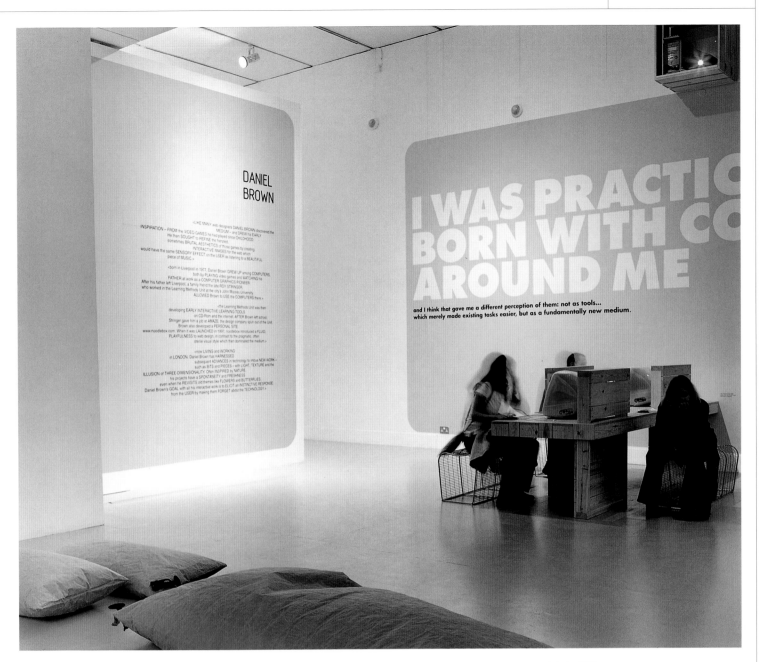

DANIEL
BROWN

«LIKE MANY web designers DANIEL BROWN discovered the
MEDIUM – and DREW his EARLY
INSPIRATION – FROM the VIDEO GAMES he had played since CHILDHOOD.
He then SOUGHT to REFINE the transient,
sometimes BRUTAL AESTHETICS of those games by creating
INTERACTIVE IMAGES for the web which
would have the same SENSORY EFFECT on the USER as listening to a BEAUTIFUL
piece of MUSIC.»

«born in Liverpool in 1977, Daniel Brown GREW UP among COMPUTERS,
both by PLAYING video games and WATCHING his
FATHER at work as a COMPUTER GRAPHICS PIONEER.
After his father left Liverpool, a family friend, the late ROY STRINGER,
who worked in the Learning Methods Unit at the city's John Moores University,
ALLOWED Brown to USE the COMPUTERS there.»

«the Learning Methods Unit was then
developing EARLY INTERACTIVE LEARNING TOOLS
on CD-Rom and the internet. AFTER Brown left school,
Stringer gave him a job at AMAZE, the design company spun out of the Unit.
Brown also developed a PERSONAL SITE,
www.noodlebox.com. When it was LAUNCHED in 1997, noodlebox introduced a FLUID
PLAYFULNESS to web design, in contrast to the pragmatic, often
sterile visual style which then dominated the medium.»

«now LIVING and WORKING
in LONDON, Daniel Brown has HARNESSED
subsequent ADVANCES in technology to imbue NEW WORK –
both in BITS and PIECES – with LIGHT, TEXTURE and the
ILLUSION of THREE-DIMENSIONALITY. Often INSPIRED by NATURE,
his projects have a SPONTANEITY and FRESHNESS
even when he REVISITS old themes like FLOWERS and BUTTERFLIES.
Daniel Brown's GOAL with all his interactive work is to ELICIT an INSTINCTIVE RESPONSE
from the USER by making them FORGET about the TECHNOLOGY.»

I WAS PRACTIC
BORN WITH CO
AROUND ME

and I think that gave me a different perception of them: not as tools...
which merely made existing tasks easier, but as a fundamentally new medium.

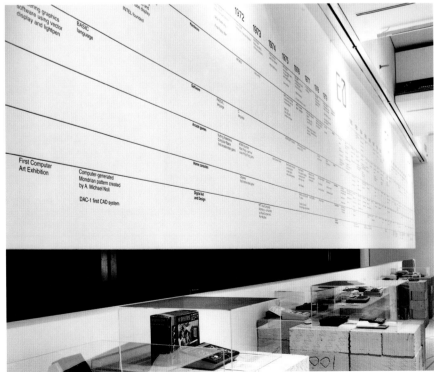

| 1 | 3 |
| 2 | 4 |

**1, 2, 3, 4. 'WEB WIZARDS';
LONDON, UK
STUDIO MYERSCOUGH**

'WEB WIZARDS' WAS AN
EXHIBITION AT LONDON'S
DESIGN MUSEUM, PRESENTING
SOME OF THE MOST INNOVATIVE
CONTEMPORARY ONLINE ART AND
DESIGN WORK. THE EXHIBITION
DESIGN, BY STUDIO MYERSCOUGH,
WORKED ON A NUMBER OF LEVELS.
FIRST, THE LARGE SCALE GRAPHICS
VISUALLY CONTEXTUALISED
THE PHYSICAL EXHIBITS (THE
MONITORS REQUIRED TO SHOW
SCREEN-BASED WORK ARE NOT
THEMSELVES VERY EXCITING), AS
WELL AS EXPLAINING THEM AND
SUPPLYING SUPPLEMENTARY
INFORMATION ON THE HISTORY
OF DIGITAL CREATIVITY AND THE
NATURE OF THE MEDIUM. BUT
MORE IMPORTANTLY, THE GRAPHICS
EXPRESSED THE NATURE OF THE
WORK ON SHOW BY ACTING AS A

NETWORK, ADOPTING THE MOST
SIGNIFICANT CHARACTERISTIC OF
THE WEB ITSELF. LINES RUNNING
ACROSS THE FLOOR LINKED LARGE
SCALE PAGES OF TEXT ON THE WALLS
– INSPIRED BY THE HYPERTEXT
PAGES OF THE WEB – TO OTHER
GRAPHIC COMPONENTS OF THE
EXHIBITION SUCH AS A TIMELINE
HISTORY OF THE INTERNET WHICH
OCCUPIED AN ENTIRE WALL OF THE
GALLERY. THE INFORMATION ON
THE WALLS, WHICH LED VISITORS
AROUND THE EXHIBITION AND
EXPLAINED THE WORK ON SHOW,
COULD BE READ AT A DISTANCE,
WHICH CONTRASTED WITH THE
CLOSER PROXIMITY REQUIRED TO
VIEW THE SCREEN-BASED EXHIBITS.

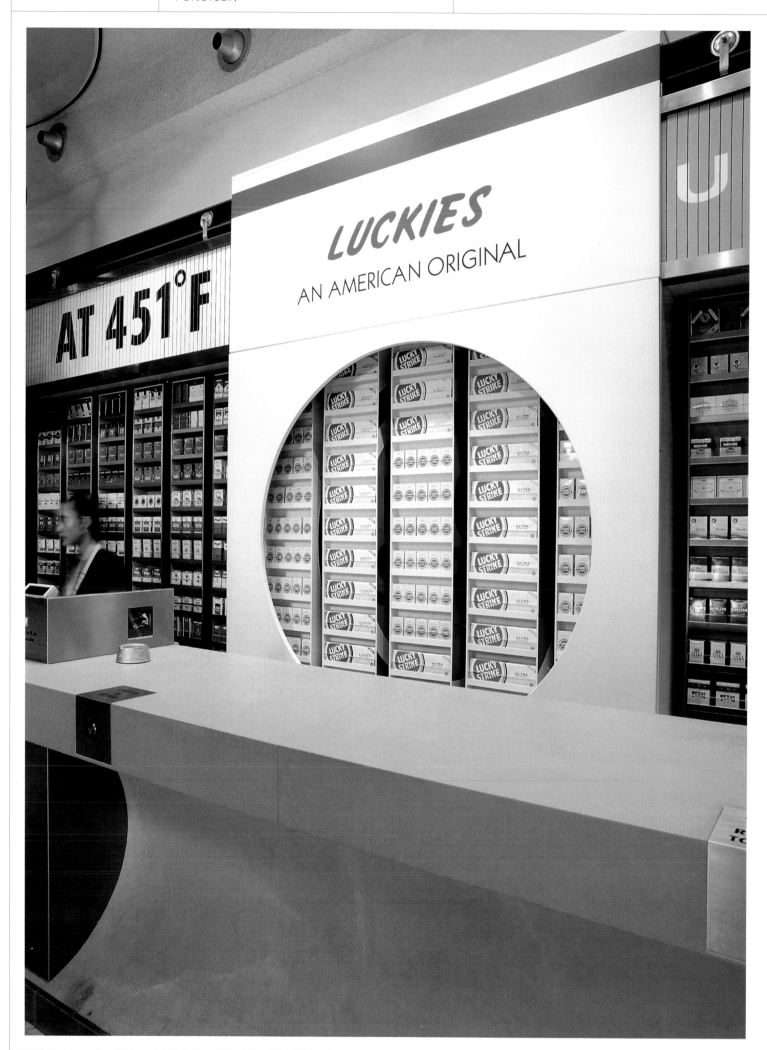

EXPERIENCE

Retailers and entertainment venues alike are keen to be thought of not so much as product vendors or service providers but as destinations in their own right – places that people remember, and want to spend time in. This has led to a greater fusion of retailing with traditional leisure activities over recent years and contributed to the emergence of a loose new design discipline known as Experience Design.

Designing experience

What is experience design? There is no straightforward answer. The term is used to cover a number of interrelated areas of design, and developments in both retailing and marketing. Theme park designers, for example, are sometimes referred to as experience designers, as, increasingly, are the designers of exhibitions, brand stores and even websites. In general, the term when applied to retail suggests that the store is providing more than the product or service that it ostensibly exists to provide, whether that be a coffee shop within a bank, or a set of record decks for the use of the customers in a tobacconist, as in the case of Amsterdam's 451ºF, designed by Fitch. Shopping may be the dominant leisure activity in many western countries, but it faces competition from TV, eating out and simply meeting up with friends for a chat. If a brand can provide all or some of these things on its own premises, its consumers will reward it with loyalty and affection, so the thinking goes. Design, of course, is central to the creation of such environments, but in design terms, the word 'experience' can imply something slightly different – usually a multi-disciplinary approach to communication that may fuse architecture, film-making, graphics and digital media with live performance or audience participation in a single product, exhibition or retail space. The desired objective, however, is often the same: predicated on the idea that we experience much more than we ever consciously think about, and that our experiences, more than our rational cognitive processes, determine our views on the outside world. Thus experience design is intended to produce an emotional reaction, and an emotional – rather than intellectual – connection to the provider of the experience, or the subject matter presented in such a way.

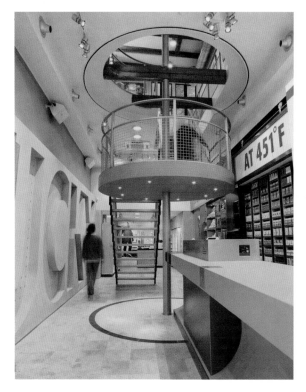

1, 2. 451ºF; AMSTERDAM, THE NETHERLANDS
FITCH
IN MANY COUNTRIES OF THE WORLD THERE ARE LEGAL LIMITS RESTRICTING WHERE TOBACCO CAN BE ADVERTISED. IN THE UK, FOR EXAMPLE, THERE IS NO TOBACCO ADVERTISING IN MAGAZINES, ON TV, ON BILLBOARDS OR AT MOST SPORTING EVENTS TOBACCO COMPANIES STILL WANT TO ADVERTISE, THOUGH, AND BRITISH AMERICAN TOBACCO (BAT) HAS FOUND A WAY OF COMMUNICATING WITH CUSTOMERS WHILE STAYING WITHIN THE LAW AT A TOBACCONIST'S ON LEIDSESTRAAT IN AMSTERDAM

451ºF (THE NAME, LIKE THAT OF THE RAY BRADBURY NOVEL, REFERS TO THE TEMPERATURE AT WHICH PAPER BURNS) IS NOT JUST A STORE, HOWEVER. INDEED, ITS DESIGNERS, FITCH, REFER TO IT AS A THREE-DIMENSIONAL BILLBOARD. UPSTAIRS, IN THE 'DECOMPRESSION ZONE', CUSTOMERS CAN RELAX WITH THE NEWSPAPERS AND FREE COFFEE IN COMFORTABLE SEATING, OR TAKE A TURN PLAYING RECORDS ON THE DJ'S DECKS. THE DECOMPRESSION ZONE IS AN EXPERIENCE PROVIDED BY BAT FOR ITS CUSTOMERS, BUT THE COMPANY AND ITS PRODUCTS ARE NOT PROMOTED INTENSIVELY WITHIN THE SPACE – INSTEAD, LARGE SCALE DECONSTRUCTED GRAPHICS DERIVED FROM LUCKY STRIKE PACKAGING FORM THE CONNECTION WITH THE SHOP DOWNSTAIRS, WHICH SELLS A RANGE OF UNRELATED PRODUCTS, FROM GUIDEBOOKS TO BAGS, AS WELL AS CIGARETTES

SENSITIVE TO THE REASONS OF WHY TOBACCO COMPANIES CANNOT ADVERTISE CONVENTIONALLY, BAT INSISTS THAT THE STORE IS NOT DESIGNED TO ATTRACT NEW SMOKERS BUT RATHER TO PERSUADE EXISTING SMOKERS OF OTHER BRANDS TO SWITCH TO THOSE BELONGING TO BAT.

3. HERON CITY; MADRID, SPAIN
FITCH
WORKING IN COLLABORATION WITH HOK, DESIGN CONSULTANCY FITCH CREATED THE FIRST HERON CITY IN MADRID. THE COMPLEX, WHICH CONTAINS OFFERINGS SUCH AS CINEMA, RESTAURANTS AND RETAIL IS DESCRIBED BY THE COMPANY AS AN EXAMPLE OF 'DESTINATION ENTERTAINMENT' – AN INTEGRATED LIFESTYLE AND ENTERTAINMENT EXPERIENCE. FURTHER HERON CITIES WILL BE LAUNCHED IN CITIES ACROSS EUROPE

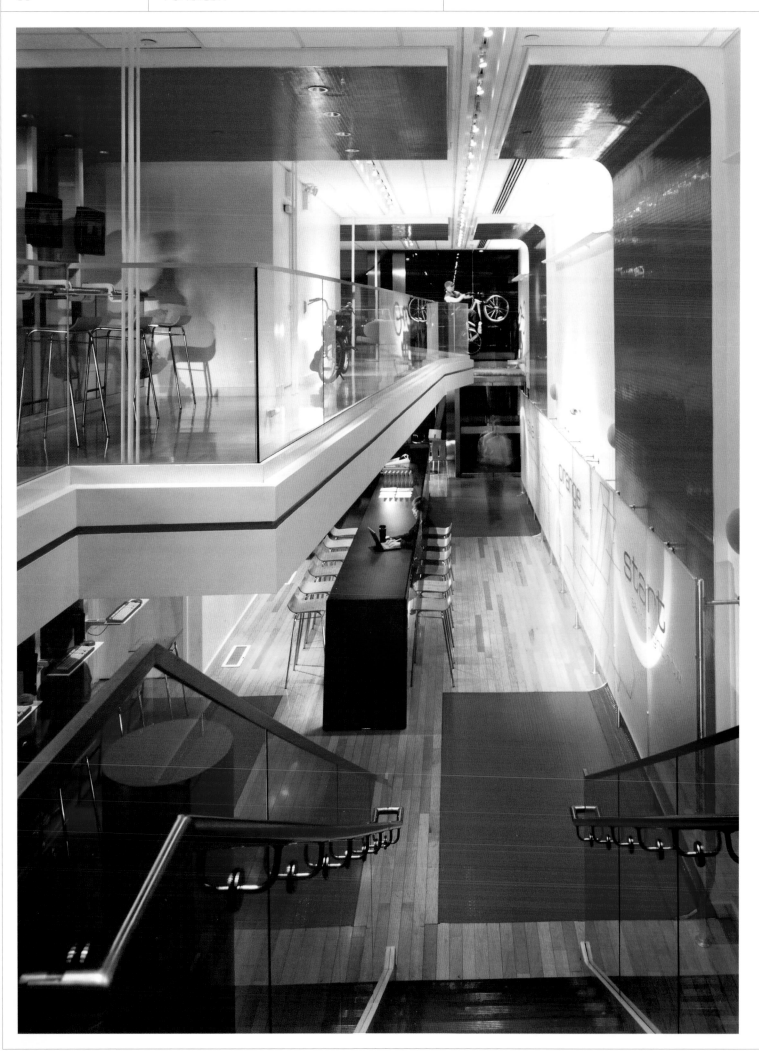

Experience design is currently a fashionable way of thinking about
retailing and brand communication, but in itself it is nothing new.
Even if one discounts the idea that the cup of coffee and conversation
that regular visitors to their local store were greeted with might be
considered experience design, one might argue that the communications
of the Heinz company at the start of the twentieth century, for example,
were the forerunners of many of today's brand experiences. In their book
'Design Writing Research'[5], the critics Ellen Lupton and J. Abbott Miller
note that shortly after 1900, the pre-packed groceries magnate Henry
John Heinz was among the first businessmen in America to commission
a large electric sign to promote his wares. Below the six-storey billboard,
complete with a 40 feet pickle, a window allowed passers-by a glimpse
of the processes by which food was 'industrially' prepared and packed.
The women working behind the window were purely for show while the
real processes took place elsewhere, but the curious could tour these
places as well if they wished. At the Heinz plant in Pittsburgh, paintings
and drawings were also used for public relations purposes. Later,
Walt Disney's original vision for the EPCOT (Environmental Prototype
Community of Tomorrow) Center was a place where the public could
come and be entertained by watching real scientists and technologists
at work in what was ultimately an artificial environment. Today, ventures
such as VW's Autostadt in Germany fuse entertainment, industry and
sales in what might be described as a corporate theme park.

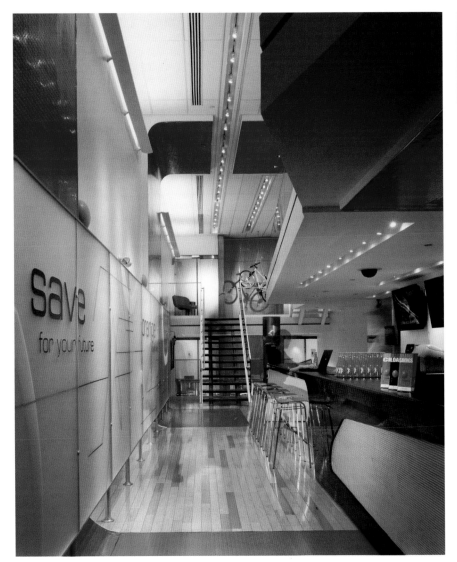

**1, 2. ING DIRECT; NEW YORK, USA
GENSLER**
MANY OF THE ONLINE BUSINESSES
THAT SPRANG UP IN THE DOTCOM
BOOM WERE INITIALLY WARY OF
BEING ASSOCIATED WITH ANY
OLD-ECONOMY, OFF-LINE BUSINESS
PRACTICES. SUCH WAS THE FAITH
IN THE IDEALS OF THE NEW
ECONOMY – THAT BITS, RATHER
THAN ATOMS, WERE THE WAY OF
THE FUTURE, TO PARAPHRASE
NICHOLAS NEGROPONTE.

IN RECENT YEARS, HOWEVER, SOME
ONLINE BUSINESSES HAVE COME TO
REALISE THE VALUE OF HAVING A
PHYSICAL PRESENCE, NOT LEAST IN
BUILDING TRUST AND IN CREATING
OPPORTUNITIES TO COMMUNICATE
WITH CUSTOMERS THROUGH
EXPERIENCES OF THE SORT THAT
ARE JUST NOT AVAILABLE IN A
VIRTUAL WORLD. THE ONLINE BANK
ING DIRECT (ITSELF A DIVISION
OF AN OFF-LINE BANKING GROUP)
TOOK JUST SUCH A STEP WHEN IT
COMMISSIONED GENSLER TO
DESIGN A REAL WORLD PRESENCE
IN THE FORM OF A NOVEL CUSTOMER
CENTRE. THE NEW YORK BUILDING
FUSES LEISURE AND RETAIL, IN
THE BROADEST SENSE, PROVIDING A
CAFÉ ENVIRONMENT WITH INTERNET
AND PHONE ACCESS POINTS AS
WELL AS GRAPHIC MESSAGING
WALLS, MERCHANDISING DISPLAYS
AND SERVICE COUNTERS.

GENSLER'S GRAPHIC TREATMENT
OF THE INTERIOR WAS BASED ON
A FLEXIBLE SYSTEM DESIGNED TO
ALLOW APPLICATION TO FURTHER
ING DIRECT STORES IN THE FUTURE.
THE BANK'S CORPORATE IDENTITY
IS REFLECTED IN THE BANDS OF
ORANGE THAT FOLD ACROSS
CEILINGS, WALLS AND FLOORS. IT
IS ALSO REFLECTED IN THE FORM OF
RUBBER TILES. ON THE EXTERIOR, A
LARGE ORANGE CIRCLE – A FORM
ALSO DERIVED FROM THE IDENTITY
– IS COUPLED WITH ORANGE METAL
PANELLING AND AN ORANGE
METAL CANOPY.

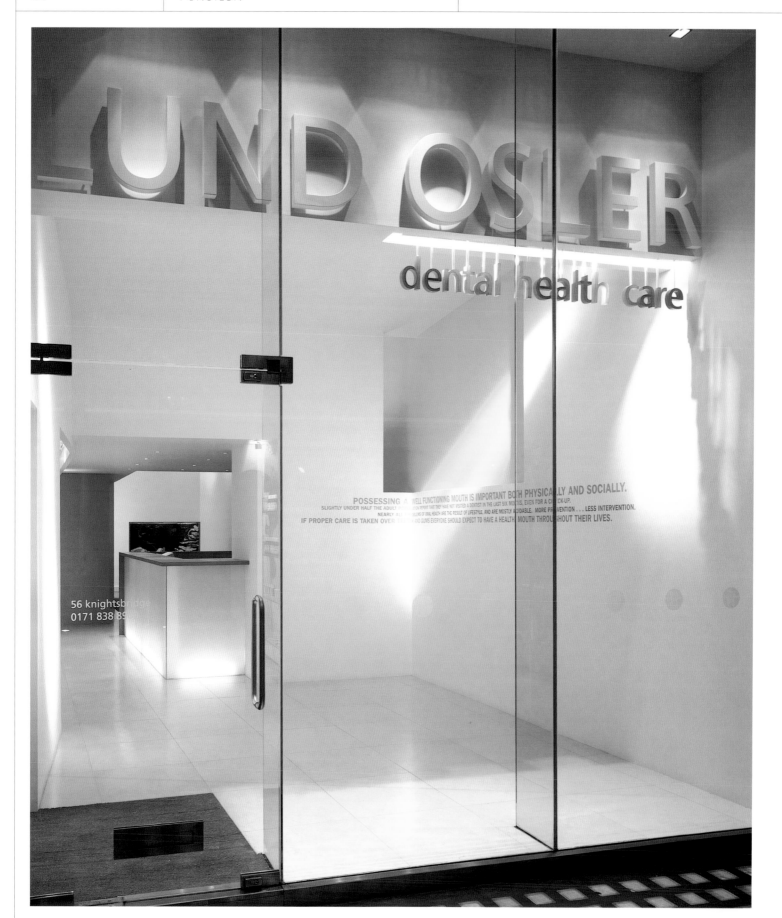

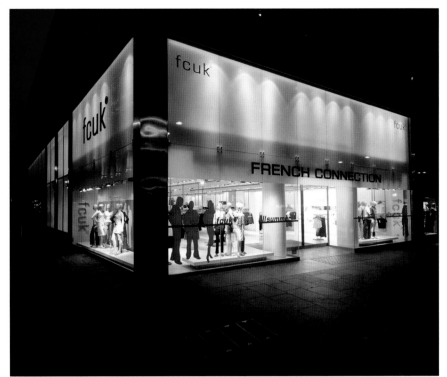

1. LUND OSLER DENTAL
SURGERY; LONDON, UK
STUDIO MYERSCOUGH
AT THE LUND OSLER DENTAL
SURGERY, STUDIO MYERSCOUGH
CREATED IDENTITY, PROMOTIONAL
MATERIALS AND ENVIRONMENTAL
GRAPHICS TO FUSE WITH ARCHITECT
POWELL TUCK'S MINIMAL INTERIOR.
THE SURGERY HAS AN AESTHETIC
UNLIKE THOSE OF TRADITIONAL
HEALTHCARE PROVIDERS, AND
IS MORE IN TUNE WITH THE
SURROUNDING SHOPS AND
GALLERIES IN UPMARKET
KNIGHTSBRIDGE. TYPE SET
IN FRUTIGER ROMAN AND
PHOTOGRAPHS BY RICHARD
LEAROYD ARE USED BOTH IN
MARKETING MATERIALS AND ON
THE WALLS OF THE SURGERY TO
EXPRESS BENEFITS OF GOOD
DENTAL HYGIENE AND CONVEY
THE AUTHORITY OF LUND OSLER
WHEN IT COMES TO DENTAL CARE.

2, 3, 4. FCUK STORE; LONDON, UK
DIN ASSOCIATES

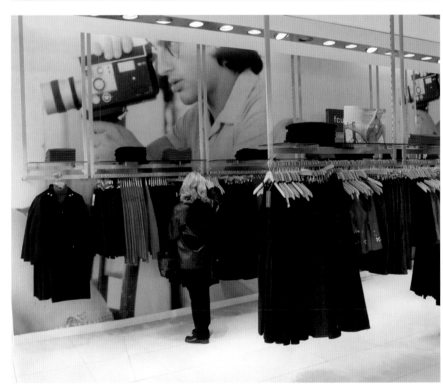

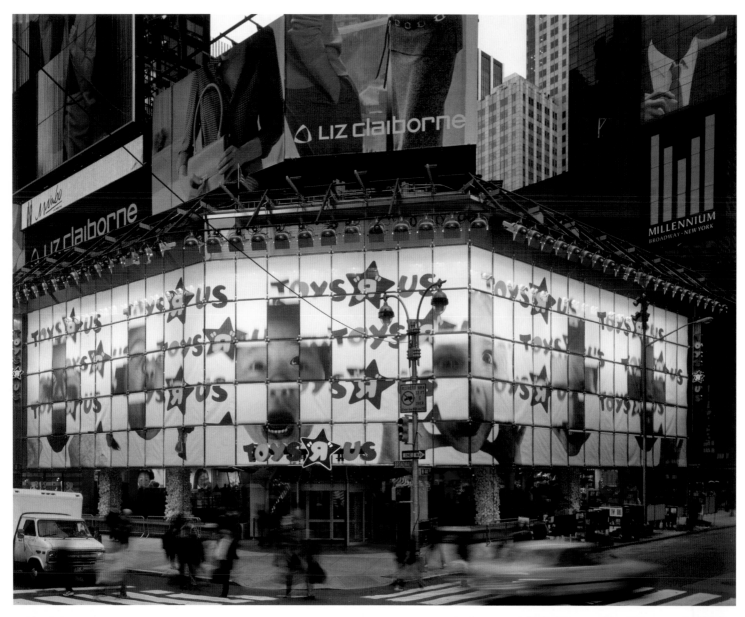

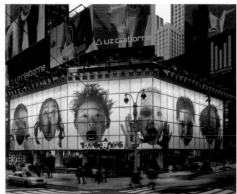
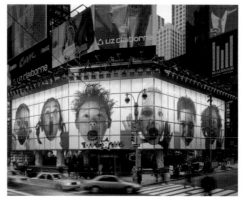
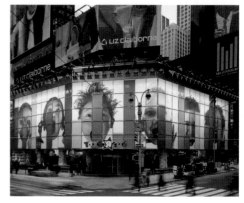

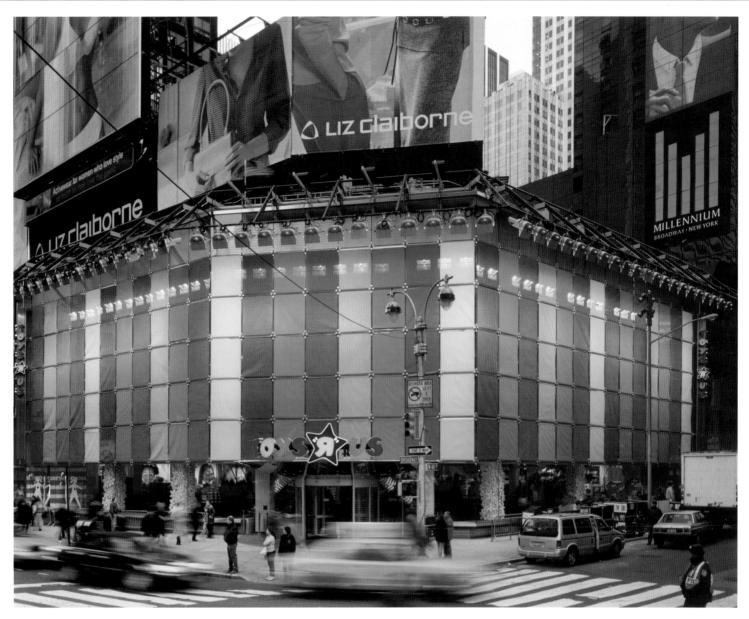

Communication, experience and sales all have a role to play in the 110,000 square feet Toys 'R' Us flagship store at 44th Street and Broadway, New York. Its owners hope that the combination of retail and entertainment offerings such as a 60 feet Ferris wheel, a lifesize, two-storey Barbie® Dollhouse and a 20 feet high, 34 feet long animatronic T-Rex dinosaur will pull in a staggering 20 million visitors a year.

But as with all such retail developments, the store is as much about communicating with customers as it is about selling products (NikeTown, a pioneer of brand experience retailing in London, New York and elsewhere, was originally run as a loss leader – its job being to communicate, not sell shoes). At Toys 'R' Us, in-store production facilities and a control centre allow the store to be used as a base for live broadcasts. The designers have also not missed the opportunity to capture the attention of passers-by at one of the busiest intersections in the city: competing with the visual noise of the Times Square district is a high-tech signage system covering the entire facade of the four-storey building. The sign is made up of 165 individual scrolling panels, mounted inside the windows. Each displays up to eight different images in a computer-controlled display allowing up to 1,320 different images to be used in an almost infinite number of permutations. When required, the panels can also be withdrawn to allow unobstructed views into the store from the street.

1, 2, 3, 4, 5. TOYS 'R' US; NEW YORK, USA
GENSLER
LIKE MANY EXPERIENTIAL ENVIRONMENTS, THE TOYS 'R' US STORE WAS A TRUE MULTI-DISCIPLINARY PROJECT. IN ADDITION TO GENSLER, INPUT WAS REQUIRED FROM J NEWBOLD ASSOCIATES, INC. (CONCEPT, THEMING, AND RETAIL DESIGN), FOCUS LIGHTING INC. (LIGHTING DESIGN), SHOW & TELL PRODUCTIONS, INC. (AUDIOVISUAL, TECHNOLOGY DESIGN) AND F.J. SCIAME CONSTRUCTION CO., INC. (CONSTRUCTION MANAGEMENT). ENTECH CREATIVE INDUSTRIES ALSO DESIGNED SOME SPECIALITY FEATURES, INCLUDING THE FERRIS WHEEL

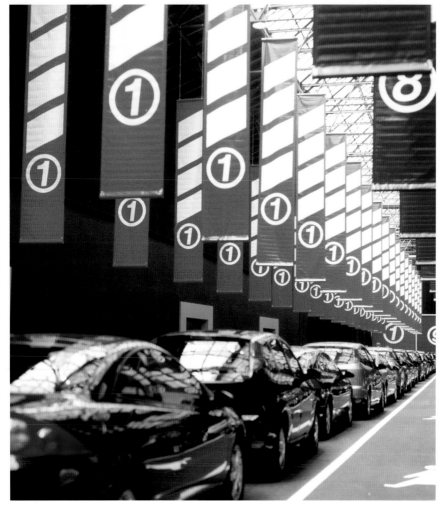

1, 2. THE AURORA CENTRE; BERLIN, GERMANY
IMAGINATION

THE AURORA CENTRE WAS USED FOR SEVEN WEEKS AS THE TEMPORARY 'BRAND HOME' OF FORD IN EUROPE DURING THAT PERIOD, 20,000 FORD DEALERS FROM AROUND EUROPE SPENT A DAY AT THE CENTRE LEARNING ABOUT THE BRAND VALUES OF 'NEW FORD' AND TEST-DRIVING A NEW MODEL. THE EVENT WAS HOUSED IN A PURPOSE-BUILT VENUE, CONSTRUCTED WITHIN A DISUSED 25,000 SQUARE METRES (269,000 SQUARE FEET) AEG ELECTRONICS FACTORY ON THE BANK OF THE RIVER SPREE IN BERLIN. WITHIN THE CENTRE, LARGE SCALE GRAPHICS COMBINED WITH FILM, PRODUCT DISPLAYS, MULTIMEDIA INTERACTIVES, HOSPITALITY FACILITIES AND LIVE PERFORMANCE TO COMMUNICATE THE ESSENCE OF FORD. (THE TEST DRIVES TOOK PLACE ON A SPECIALLY CONSTRUCTED 1.5KM (0.9 MILES) TRACK RUNNING AROUND THE CENTRE.) EACH DAY, A GROUP OF DEALERS ARRIVED AT THE CENTRE BY RIVERBOAT, AND THE SCENE WAS SET FOR THE EXPERIENCE BY THE SITE OF A LARGE STEEL BRIDGE, ON WHICH CARS WERE PLACED, EMERGING FROM A PORTAL WITHIN A 2,000 SQUARE METRE (21,500 SQUARE FEET) GRAPHIC WALL, ACROSS WHICH STRETCHED AN ABSTRACTION OF THE AURORA IDENTITY, DEVELOPED BY IMAGINATION FOR THE PROJECT

3, 4, 5. HALFORDS STORES; SHEFFIELD AND SWANSEA, UK
LIPPA PEARCE DESIGN AND BEN KELLY DESIGN

THE PRODUCT OF A COLLABORATION BETWEEN INTERIOR DESIGN SPECIALIST BEN KELLY DESIGN AND GRAPHIC DESIGN CONSULTANCY LIPPA PEARCE, THESE CONCEPT STORES FOR HALFORDS, EUROPE'S LARGEST RETAILER OF MOTOR PARTS, REPRESENT A NEW DEPARTURE IN RETAIL DESIGN IN THIS SECTOR.

APPROPRIATELY FOR AN AUTO ACCESSORIES STORE, THE DESIGNERS DEVELOPED A LANGUAGE BASED ON ROAD MARKINGS AND STREET SIGNAGE, WHICH WAS APPLIED THROUGHOUT THE STORES, FROM THE HUGE ARROWS AND CHEVRONS RUNNING AT FULL HEIGHT ACROSS EXTERIOR CLADDING TO POINT-OF-SALE DETAILS. AS ONE MIGHT EXPECT OF A GRAPHIC LANGUAGE DERIVED FROM ROAD MARKINGS, THE ARROWS FUNCTION AS PART OF A WAYFINDING SYSTEM AS WELL AS DECORATION.

THE GRAPHIC TREATMENT MAKES THE DIFFERENCE BETWEEN A NONDESCRIPT CORRUGATED STEEL SHED AND A HIGHLY DISTINCTIVE ENVIRONMENT. THIS EVOKES ASSOCIATIONS WITH MOTORING, WITH GARAGES, BODYSHOPS AND THE PARAPHERNALIA OF THE MECHANIC – AMATEUR OR PROFESSIONAL – AND WITH A KIND OF RUGGED INDUSTRIAL TRUSTWORTHINESS. WHILE THE STORE IS DELIBERATELY 'NO FRILLS' – ALLOWING FOR THE CLEAR DISPLAY OF THOUSANDS OF AUTOMOTIVE PRODUCTS – IT HAS A WELCOMING, ENERGETIC ATMOSPHERE, DUE IN NO SMALL PART TO THE VIBRANT PALETTE OF ORANGE, YELLOW AND BLACK.

WHEN LIPPA PEARCE DESIGN WAS LATER ASKED TO REVAMP THE HALFORDS IDENTITY AND PROMOTIONAL MATERIALS, THE RESULT WAS INFORMED TO A GREAT EXTENT BY THE DESIGN OF THE STORES – TESTIMONY TO THE DESIGNERS' SUCCESS IN CAPTURING AND EXPRESSING THE HALFORDS BRAND IN A PHYSICAL ENVIRONMENT.

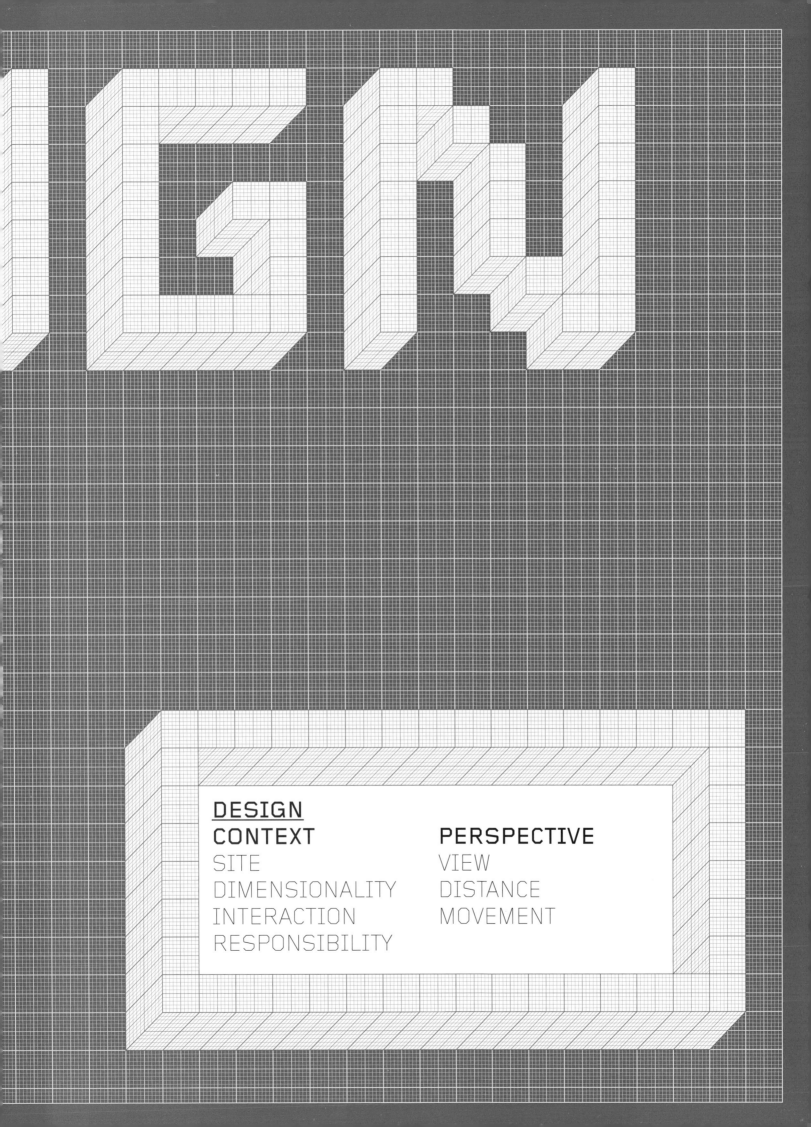

DESIGN
CONTEXT **PERSPECTIVE**
SITE VIEW
DIMENSIONALITY DISTANCE
INTERACTION MOVEMENT
RESPONSIBILITY

INTRODUCTION

While design is often thought of as an individual activity, in fact it is usually a group effort: by their nature most general design projects, from buildings to cars, require a mix of skills and experience rarely found in a single person. Exceptions can be found, however, in the case of much graphic design work. A single designer can design and supervise the production of a brochure, poster or magazine. In the case of large scale graphic design, however, this is much more problematic. First, the familiar materials of paper and ink, and the four-colour process of realising the work may be replaced by substrates and technologies of which the graphic designer has no experience and little training. Instead of the usual printer, a stone cutter, sign painter, lighting technician, software programmer or carpenter may be the actual fabricator of the object. They themselves may be more used to working with designers from other disciplines, such as architects, or to working without the input of a designer at all. Further, the nature of large scale graphics means that they come with a number of unfamiliar considerations for the graphic designer: from angle of view and legibility over great distances to the fundamentals of weather-proofing and determining how a panel will actually be suspended from a building. In addition to the requirements of the client and of the users therefore, it is likely that there will be another set of opinions and demands to factor into the design process – those of the designers from other disciplines whose input is required by the project. Furthermore, large scale graphics are often designed for environments that are due to be populated by people, and understanding people's behaviour in particular physical and social environments is important. As the designer and author Nathan Shedroff has observed, in the age of experience design, 'Incorporating in design practice the knowledge provided by ethnographers, phenomenologists (scientists of "experience"), sociologists, psychologists, historians, storytellers, and other design disciplines is another challenge facing designers.'

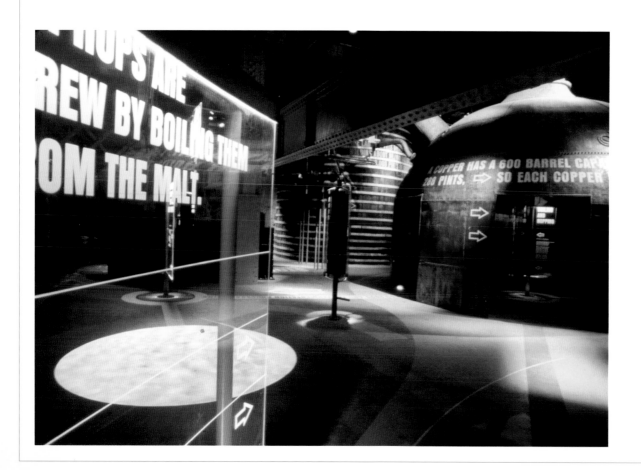

Multi-disciplinary design

There are probably as many ways of approaching multi-disciplinary teamwork as there are teams; each has to find the way of working that suits it best. Within this book, there are projects by multi-disciplinary design companies, such as WPa, Inc. or Lorenc + Yoo Design, which are effectively partnerships between graphic designers and architects or industrial designers. Another company whose work is featured, Imagination, is a multi-disciplinary company whose expertise extends from graphic design and architecture to film-making, lighting design and even choreography. On the other hand, many of the projects featured in the book are purely the work of graphic design companies who rely on specialist consultants when necessary, or who have formed close working relationships with designers in other disciplines, allowing them to work together when the occasion arises, but concentrate on their main specialisms at other times. Two collaborations between Lippa Pearce Design (graphic designers) and Ben Kelly Design (interior designers) are featured, for example.

There are, despite the diversity of individual working practices, a number of general points that can be made about teamwork, and about the specific issues facing graphic designers when working with designers in different disciplines. The first is that in teamwork, the rapport between individuals is often as critical to a successful outcome as the ideas contributed by any of them, not least because one function of the team is to challenge the ideas of the individual. Not only can it be difficult for an individual to accurately judge the merits of their own ideas, but they may also become excessively protective of them. Teams must be free to exchange views in such a way that challenging an idea is not perceived to be a personal challenge. The function of a team in refining and shaping the idea of one individual should also have a bearing on decisions about when to bring in specialists such as fabricators.

1, 2, 3, 4. THE GUINNESS STOREHOUSE; DUBLIN, IRELAND
IMAGINATION
EXHIBITS SUCH AS THE INGREDIENTS WATERFALL AND THE COOPERAGE BARREL STACK WITHIN THE GUINNESS STOREHOUSE FUSE LARGE SCALE TYPOGRAPHY WITH ARCHITECTURAL AND INTERIOR DESIGN ELEMENTS TO TELL THE STORY OF IRELAND'S BEST-KNOWN BRAND. THE BUILDING, A FORMER BREWING FACILITY ADAPTED TO ITS PRESENT USE BY IMAGINATION AND ARCHITECTS ROBINSON KEEFE DEVANE, ALSO FEATURES A SIX-STOREY CENTRAL ATRIUM IN THE SHAPE OF A GUINNESS PINT GLASS – WHAT CREATIVE DIRECTOR ADRIAN CADDY DESCRIBES AS A GRAPHIC DESIGN IDEA MADE INTO ARCHITECTURE

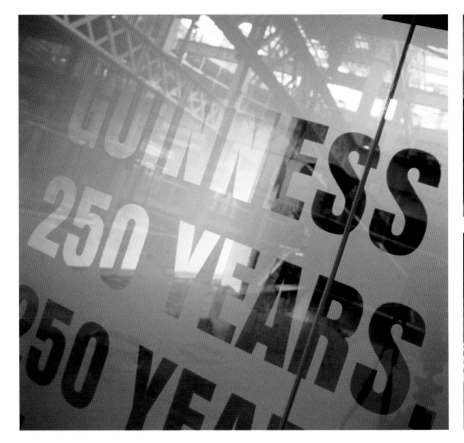

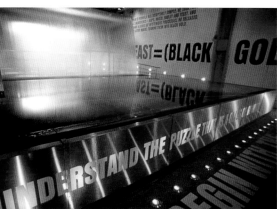

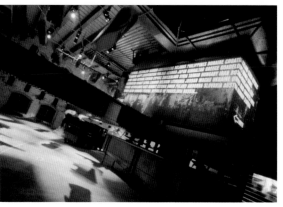

**1, 2, 3. THE JOURNEY ZONE;
LONDON, UK
IMAGINATION**

THE JOURNEY ZONE WAS AN
EXHIBITION ON THE PAST, PRESENT
AND FUTURE OF TRANSPORTATION
AT THE UK'S MILLENNIUM DOME
HOUSED IN A SPECIALLY
CONSTRUCTED PAVILION, THE
EXHIBITION TOOK THE FORM OF
A WALK-THROUGH MULTIMEDIA
EXPERIENCE, COMPRISING FILM,
AUDIO, LIGHTING, 'ELOQUENT
OBJECTS' AND GRAPHIC DESIGN
CLOSE COLLABORATION BETWEEN
THE ARCHITECT AND GRAPHIC
DESIGNER RESULTED IN A
SEAMLESS INTEGRATION OF
ARCHITECTURAL AND GRAPHIC
ELEMENTS. THE EXTENT TO WHICH
ALL DESIGN DISCIPLINES WORKED
TOGETHER TO CREATE A TRULY
IMMERSIVE EXPERIENCE IS
SUGGESTED BY THE FOLLOWING
FACT IN THE DECOMPRESSION ZONE
– A CIRCULAR CHAMBER WITH BLUE,
LIGHT-WASHED WALLS WHICH
MARKED A TRANSITIONAL POINT IN
THE EXHIBITION – NOT ONLY DID THE
ENVIRONMENT CHANGE VISUALLY,
BUT THE TEMPERATURE DROPPED

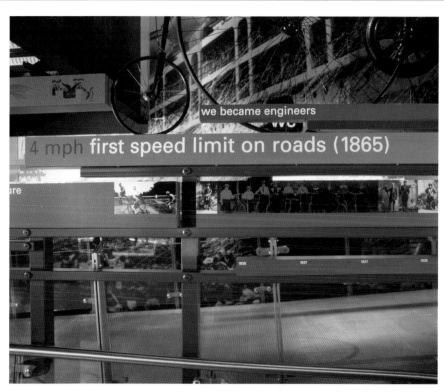

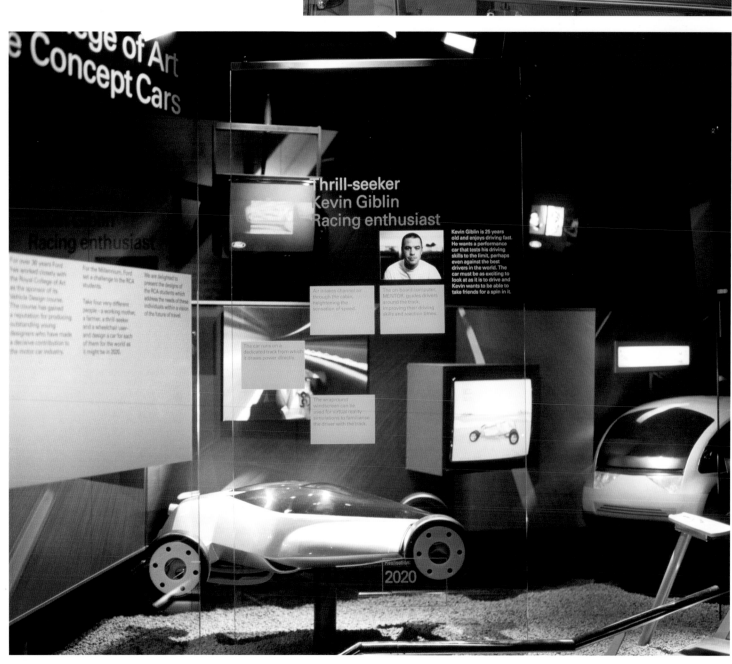

When individuals successfully work together as a team, their thinking is affected by the behaviours and structure of the group. This is because they are no longer functioning as merely a collection of individuals, but as a group, which has what is called a group dynamic. In order for this to be achieved, individuals make compromises on the ways they would ordinarily behave or express themselves.

Psychologists studying group dynamics and behaviour of groups have concluded that there are a number of common features to group activity, including structures or networks for interaction with one another. Groups also possess a set of norms – or conventions commonly understood by all members of the group – which might include the way work is discussed, or the way projects are run from day to day. One of the main challenges facing graphic designers working with those designers from other disciplines is the lack, in the first instance, of a set of norms. Terminologies vary between disciplines, as do ways of presenting ideas, and systems for tracking the progress of a project, for example. Add this to the fact that as individual designers, the members of a new group may have very different ways of understanding and tackling a brief, and the potential for misunderstanding arises. A group dynamic is in most cases something that arises spontaneously, with individuals instinctively finding their roles within the group. In order to maximise the potential benefits of teamwork, some ground rules are usually established – even at the level of clarifying word meanings. 'Symbol', for example, may ordinarily mean something quite different to an architect than to a graphic designer.

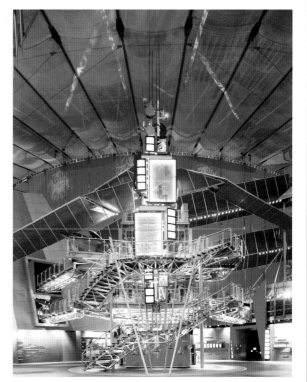

Even before the formation of the team, designers can prepare for inter-disciplinary work by keeping an eye out for developments, points of interest and crossover with other design disciplines. Globally, design is still comparatively ghettoised, with practitioners of each discipline too busy with their own work to learn much about that of others. This is not helped by the fact that there is little scope for cross-disciplinary discussion in the design press, at conferences or through design organisations, as these largely tend to cater for one or other discipline.

Finally, there must be a recognition by graphic designers that although what they bring to a team and the project is principally their skills as a graphic designer, there is also a need to unlearn some of what they know, and to develop new skills. The type of project management that requires closing a street to install a new sign, for example, requires different knowledge and skills to that of managing the workflow on a complex, studio-based project.

Adrian Caddy, formerly a graphic designer and now creative director of the multi-disciplinary design consultancy Imagination points out the following. When approaching graphic design on a large scale, graphic designers must avoid falling into the trap of thinking about it as merely the opportunity to design a very large poster, or being confined by the limitations of their own expectations. 'It pays to begin the process by learning what the potential of the technology you're about to play with is,' says Caddy. 'Ask the lighting designer or the film expert to show you what they think are the most impressive-looking projects they've found, and see whether that inspires you to think in a different way.'

When designing environmental graphics, the one key consideration that does not apply to design for print is context. This is of an entirely different magnitude to the context considerations given to, for example, packaging design, where the designers' control over context is compromised by market forces etc. When designing an installation for a specific site in the wider environment, there is a need to be acutely sensitive not only to how any intervention may impact on the environment, but also how the site might affect the reading of the installation. Considering context includes understanding how people behave in the site (where relevant), and how that will be affected by proposed alterations. For example, a wayfinding system may actually change the share of traffic experienced by differed routes through a space. This can be deliberate, or an accidental by-product of the provision of more information, putting extra strain on routes not designed to cope with large volumes of traffic. Such potential outcomes require the graphic designer to apply the type of thinking to environmental design problems more often associated with other design disciplines.

Nevertheless, Adrian Caddy, the creative director of Imagination, believes that 'context is something that all good designers understand instinctively'. And the nature of the context in which many environmental graphics are situated means that the background against which they operate is the graphic landscape described earlier in this book. The context, in essence, is information, and the task of situating new information within it is best handled by the discipline whose raw material is information – graphic design.

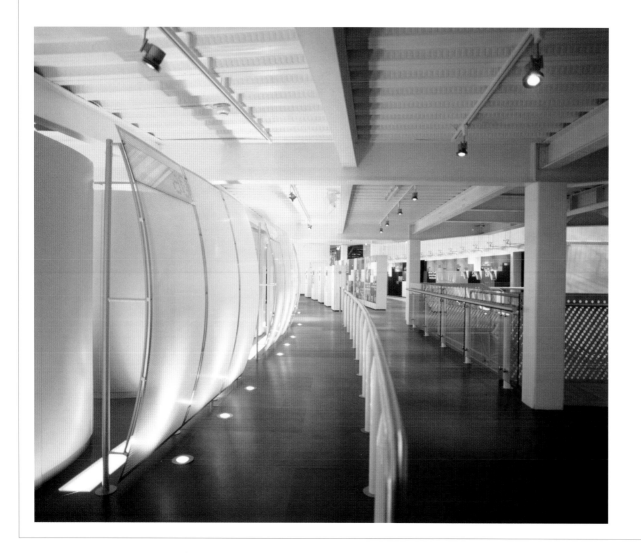

**1, 2, 3. TALK ZONE; LONDON
IMAGINATION**
AS AN EXHIBITION DEALING WITH
THE SUBJECT OF COMMUNICATION
WHICH WAS SITUATED WITHIN THE
MILLENNIUM DOME (A LARGE SCALE
ENTERTAINMENT VENUE IN WHICH
FOURTEEN ZONES COMPETED FOR
VISITORS' ATTENTION) THE TALK
ZONE ITSELF HAD TO USE A NUMBER
OF COMMUNICATION STRATEGIES,
RANGING FROM LIVE PRESENTATION
AND AUDIO – THE TWO BUILDINGS
THAT COMPOSED THE ZONE
TALKED TO ONE ANOTHER – TO
ENVIRONMENTAL GRAPHIC DESIGN.
LARGE SCALE LETTERING WAS
APPLIED TO THE EXTERIOR OF
THE BUILDING, IDENTIFYING IT
TO VISITORS IN THE WIDER
ENVIRONMENT OF THE DOME,
AND INSIDE, GRAPHICS WERE
INTEGRATED WITH ARCHITECTURE,
DIGITAL MEDIA AND FILM WITHIN
THE EXHIBITION TO CREATE A
SEAMLESS WALK-THROUGH
EXPERIENCE

SITE

As mentioned in 'Information', a principal difference between environmental graphic design and the design of printed materials such as books, magazines, record sleeves or brochures is the existence of a fixed site, and the opportunities and constraints presented by the conditions of the site.

A site in physical space, of course, has physical properties, and these have a profound impact on the nature of the graphics that can be placed there: is the existing substrate – brick? glass? steel? – sufficiently strong to support a three-dimensional installation, or suitable for the application of printed vinyls? Is there a single surface or multiple sites? Is there a flat surface, or a many-faceted one? In developing its identity and signage programme for the Minnesota Children's Museum, Pentagram looked to the architecture of the building and was inspired by its porthole windows. The idea was conceived of a red ball manipulated by hands shown in large scale images indicating floor numbers, for example. When the designers created a temporary banner for the front of the museum, featuring the hands and red balls, they were able to look back to the source of the idea, and cut out one of the balls to reveal the porthole window behind, thereby tying in the graphic and architectural elements. The banner, as much as the identity itself, is a response to the opportunities presented by the architecture.

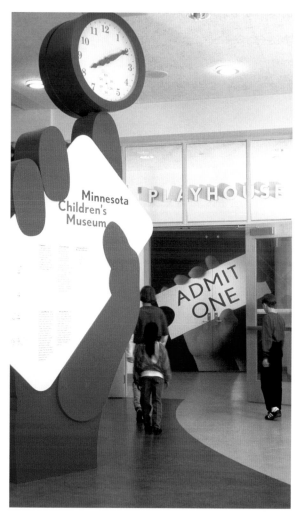

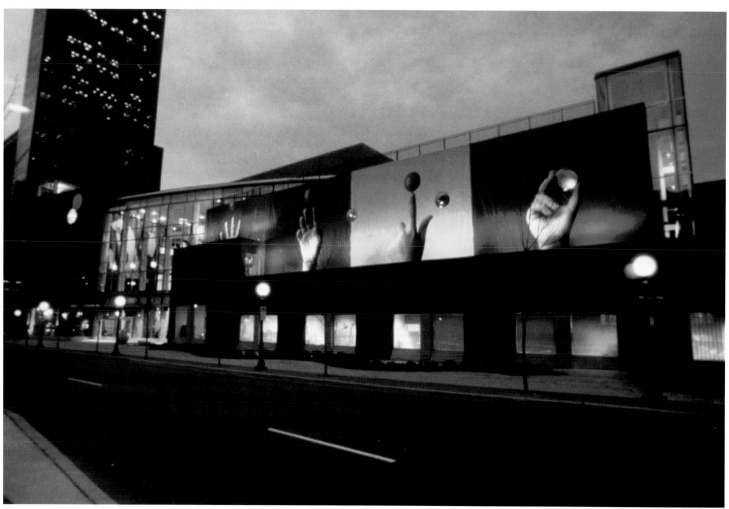

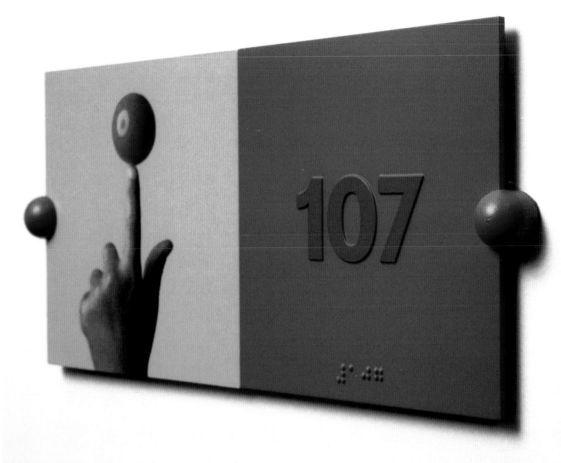

1, 2, 3, 4. MINNESOTA
CHILDREN'S MUSEUM; ST PAUL,
MINNESOTA, USA
PENTAGRAM

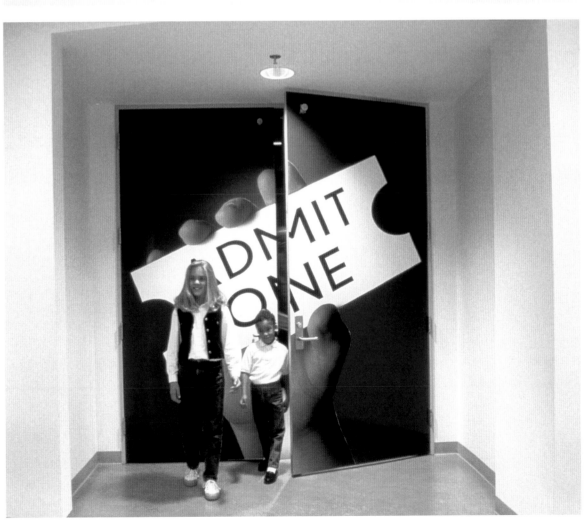

Sites also have scale, and graphics or installations placed within it must be responsive to that scale. During redevelopment works at the Barbican Centre arts complex in London, for example, Studio Myerscough took advantage of the need for construction barriers to test the effectiveness of large scale type in a large scale environment that is somewhat featureless in places, assessing its suitability for a future signage programme. The size of the type was a direct response to the conditions of the site.

Architectural scale

A wider, urban environment provides the context for an installation forming part of a larger identity programme and beautification project for the City of Los Angeles Department of Airports. Created by Selbert Perkins Design, the installation is sited in the nondescript area surrounding Los Angeles International Airport (LAX) and is intended to act as a gateway to the airport, to the city, and to the United States. The designers created a scheme that was responsive to both the scale of the site in which it was to sit, to the context presented by the airport and business of flight, to the existing roadways to it, and the way that the airport's users approach and leave it, and to the modernity of the city it serves.

1, 2. BARBICAN CENTRE
CONSTRUCTION BARRIERS;
LONDON, UK
STUDIO MYERSCOUGH

3, 4. LAX GATEWAY;
LOS ANGELES, USA
SELBERT PERKINS DESIGN
THE COMPLEXITY AND SCALE OF
THIS SCHEME REQUIRED THE
INPUT OF A WIDE RANGE OF

COLLABORATORS, INCLUDING
TED TOKIO TANAKA ARCHITECTS,
IMA DESIGN GROUP (LANDSCAPE
ARCHITECTS), LIGHTING DESIGN
ALLIANCE, ISENBERG AND
ASSOCIATES, INC. (ART), OVE ARUP
AND PARTNERS (ENGINEERING),
UCLA URBAN SIMULATION TEAM
AND AMPERSAND AND SWINERTON
WAHLBERG CO. (FABRICATORS)

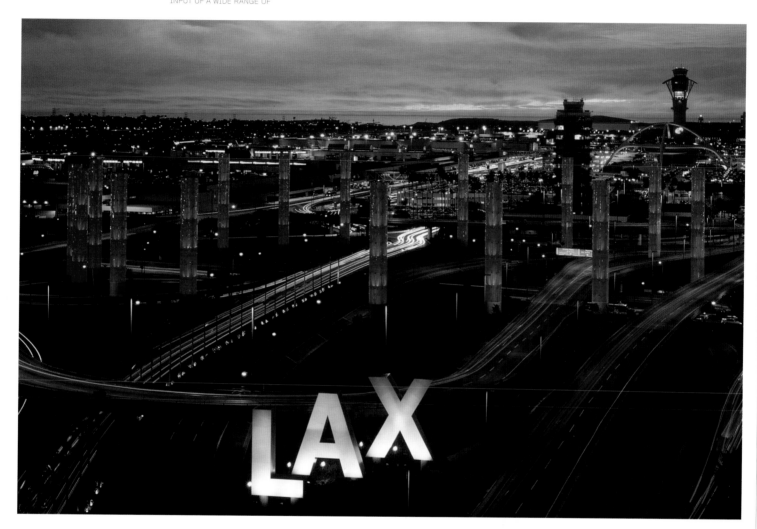

The three-dimensional, 32 feet high letterforms 'LAX' form the gateway to the airport, along with a ring of 15 illuminated pylons, each 120 feet high. Along the two-mile road that leads to the airport, the designers installed a row of equally-spaced columns that increase in height as they approach the airport, simulating take-off. At night, computer-controlled lighting sequences change the appearance of the installation. The height and verticality of the pylons and columns not only allow them to be seen from a distance, but provide a counterpoint to a flat landscape of parking lots and freeways, while the softness of the lighting scheme is in conscious contrast to the concrete surrounds.

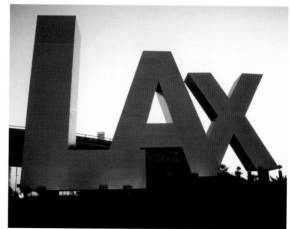

1. T-MOBILE ADVERTISING ON
THE BRANDENBURG GATE;
BERLIN, GERMANY
SPRINGER & JACOBY
IN RETURN FOR ITS FINANCIAL
SUPPORT FOR THE RENOVATION OF
BERLIN'S MOST FAMOUS LANDMARK,
THE BRANDENBURG GATE,
DEUTSCHE TELEKOM WAS GRANTED
PERMISSION TO USE THE SITE FOR
ADVERTISING PURPOSES, FOR THE
FIRST TIME EVER. AGENCY
SPRINGER & JACOBY DEVISED A
CAMPAIGN WHICH WOULD PRESERVE
THE VIEW OF THE GATE FOR THE
BENEFIT OF BERLINERS THROUGH
OPTICAL ILLUSION – AN IMAGE OF
THE GATE WAS PRINTED ONTO A
WRAP SUSPENDED OVER THE
SCAFFOLDING THAT COVERED THE
REAL GATE. AT THE SAME TIME, THE
CAMPAIGN SUGGESTED SOME OF
THE QUALITIES OF THE TELECOMS
COMPANY BY SUBTLY ALTERING THE
ARCHITECTURE OF THE GATE IN THE
IMAGES. THUS, IN THE FIRST WRAP
TO BE INSTALLED, THE MESSAGE
THAT 'THE WORLD MOVES CLOSER
TOGETHER' WAS ILLUSTRATED BY
THE PRESENCE OF OTHER WORLD
MONUMENTS SUCH AS PARIS'
EIFFEL TOWER AND MOSCOW'S ST.
BASIL'S CATHEDRAL BEHIND THE
GATE'S PILLARS. THIS WAS
FOLLOWED BY WRAPS DESCRIBING
THE BENEFITS OF THE INTERNET BY
SHOWING A HAND ICON
POSITIONING ONE OF THE PILLARS.
THERE WAS ALSO 'SPORT PORTAL' –
IN WHICH A GOAL NET APPEARED
TO BE SUSPENDED BEHIND A
PILLAR-LESS GATE, AND 'BE NICE
TO ONE ANOTHER', IN WHICH THE
PILLARS WERE WRAPPED AROUND
EACH OTHER IN AN INTIMATE
EMBRACE. TO COINCIDE WITH THE
WORLD CUP IN 2002, THE PILLARS
APPEARED TO BE WEARING
FOOTBALL SOCKS.

2. SMASHED TO PIECES
(IN THE STILL OF THE NIGHT);
ESTERHÁZYPARK, VIENNA,
AUSTRIA
LAWRENCE WEINER

Environmental conditions

Furthermore, there are environmental conditions to take account of: birds and insects nest in outdoor signs, for example, and weather conditions impact both on materials and the visibility of environmental graphics. Cold conditions can affect the workings of some lights, while wind load can exert huge forces on structures such as sign mounts or billboard frames. The rain can wash dirt down the face of a graphic, just as it does with buildings, resulting in the need for regular, and expensive, maintenance. And it's not just 'poor' conditions that can present problems: ultraviolet (UV) exposure – radiation from the sun – can cause problems, not just by fading colours, but by yellowing substrates such as uPVC and polycarbonate, and by causing adhesives to fail. In early 2002, the world's largest billboard, listed in the Guinness Book of Records as measuring 2,700 feet by 405 feet, was taken down, having failed to attract a single ad in the three years that it had stood on the banks of China's Yangtze river. The reason for this poor record was its owners' failure to foresee that due to local foggy conditions, the billboard would be invisible to passing traffic for most of the year.

Sites also have individual patterns of use; these are significant not just in assessing who will see the graphic and when, but in determining how often and how easily the graphic might be updated or maintained for example. And in most public spaces, there are of course legal parameters to what can be done; planning and zoning authorities have to approve many such schemes, and will be acutely conscious of potential safety hazards caused by the installation of any scheme, as well as its aesthetic merits.

Context and meaning

But equally importantly, sites have an intellectual or associative context; the location of a piece of graphic design has the potential to alter its meaning, or to underline it. Likewise, the design itself may change the way that the surrounding environment is read. The artist Lawrence Weiner is well known for his use of typography and the written word in his work. In 1991, he created a piece called 'SMASHED TO PIECES (IN THE STILL OF THE NIGHT)', in which those words on a white background were painted onto the sides of an anti-aircraft tower in Vienna, Austria. The work is essentially concerned with the way that things heard in the day and night sound different, but the work is given another embodied meaning by its sitting on the Flakturm (anti-aircraft tower). For the viewer, it becomes irresistible to make the connection between the word 'smashed' and its location on a World War II military installation in a city torn apart by the conflict. As Weiner told interviewer

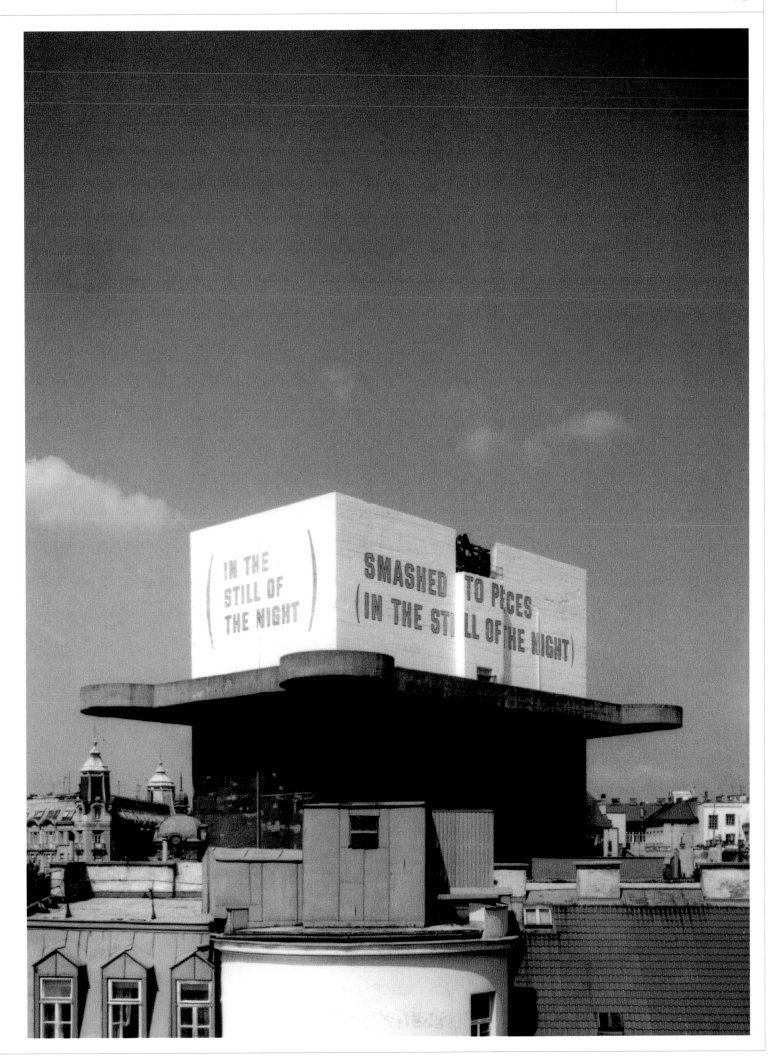

Benjamin H. D. Buchloh[6], 'They offered me this Flakturm... I chose this piece to put on it. I knew damn well it had a metaphor. Art is fabulous because it starts off as one thing and becomes something else for somebody... In fact this is not the metaphor of this particular work. If I put it in another context, which I often do as you know, it has a totally different metaphor. You put that piece in the South Pacific and all night you will hear coconuts falling, all day you hear coconuts falling.'

On St Lucia, the graphic artist Peter Anderson used banana poles – employed throughout the island to support washing lines or fence off gardens – to create an installation that stretched around the entire coastline of the Caribbean island. Anderson had been invited to exhibit by the island's new museum of modern art, and as visiting artist wanted to create a work that mixed elements of his own culture with that of St Lucia. He therefore painted a series of numbers onto the poles, whose significance – known only to him – ranged from credit card numbers and phone numbers to friends' birthdays. Numbers are both a universal language, and a means of encapsulating data that had a specific meaning to the artist in Britain, but was open to interpretation elsewhere. 'I thought numbers were an international language from which I could create a storytelling system that wasn't forced down your throat,' explains Anderson. People did make up their own stories around the coloured, numbered poles with their hidden logic, identifying them as everything from voodoo icons to off-shore racing markers. A documentary and news coverage on the project, says Anderson, only fuelled a growing folklore about the purpose of the poles – created 'just by the simple displacement of the everyday materials.' The familiar symbols, drawn from the site, provided access to the work, and allowed viewers to read a familiar site in a different way.

The final and most obvious consideration of context is that sites are occupied by people. Sensitivity to context includes appreciating how people feel as they pass through the area. Are they relaxed and happy or anxious and frustrated? During the renovations of New York's Grand Central Terminal, design consultancy Two Twelve was commissioned by the architects to design temporary construction barricades. Recognising that the works were a necessary inconvenience, Two Twelve commissioned illustrator Maira Kalman to create humorous, colourful illustrations to lighten the mood of weary commuters as they passed through the station.

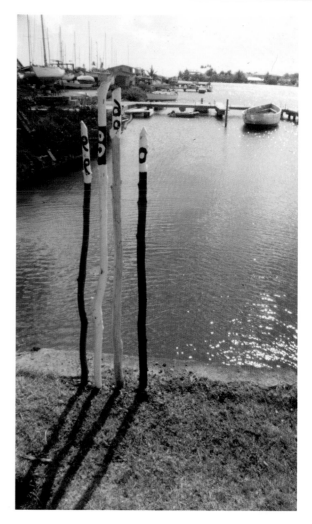

1, 3, 4. POLES OF INFLUENCE;
ST LUCIA
PETER BOYD JOINES ANDERSON

2. GRAND CENTRAL TERMINAL
CONSTRUCTION BARRIERS;
NEW YORK, USA
TWO TWELVE HARAKAWA

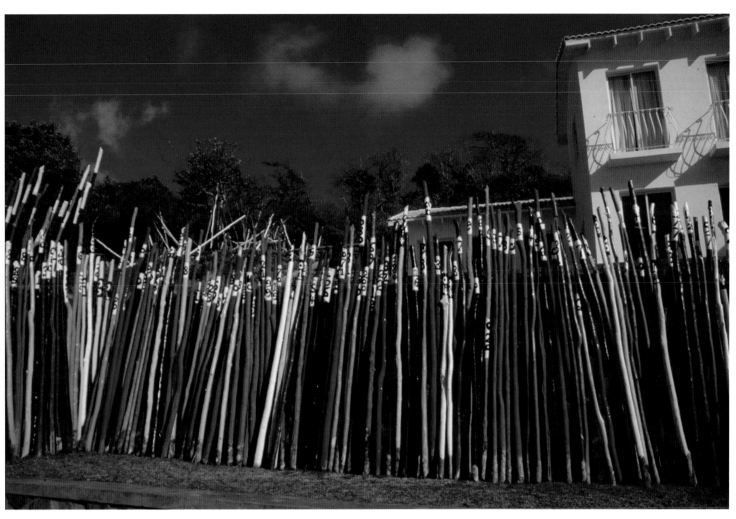

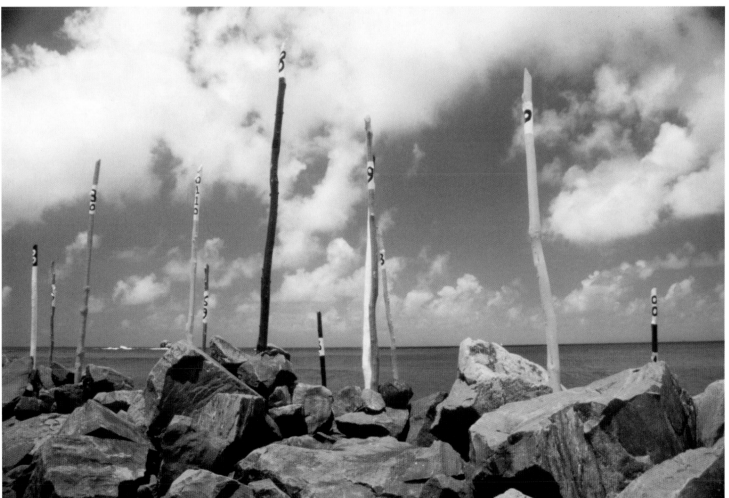

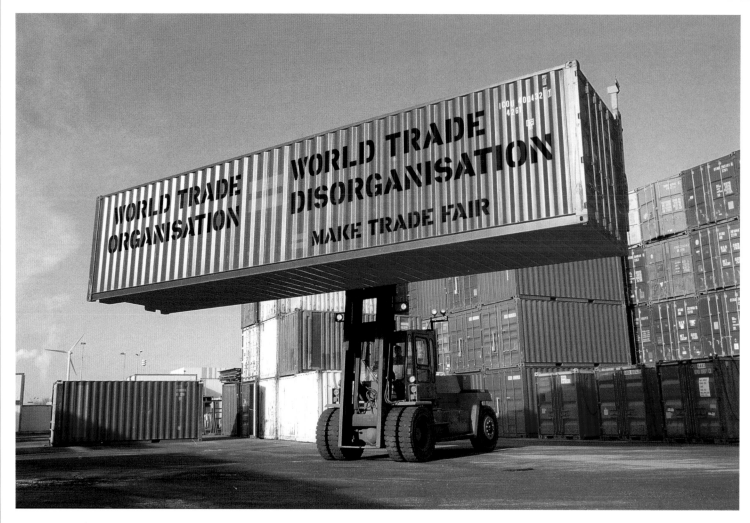

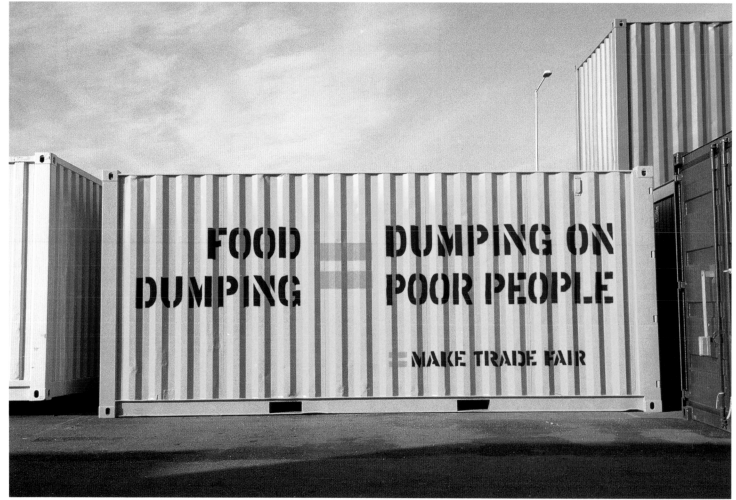

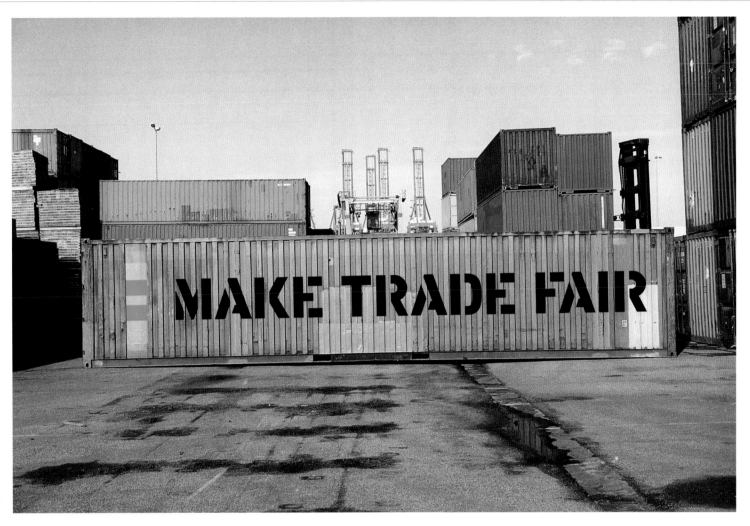

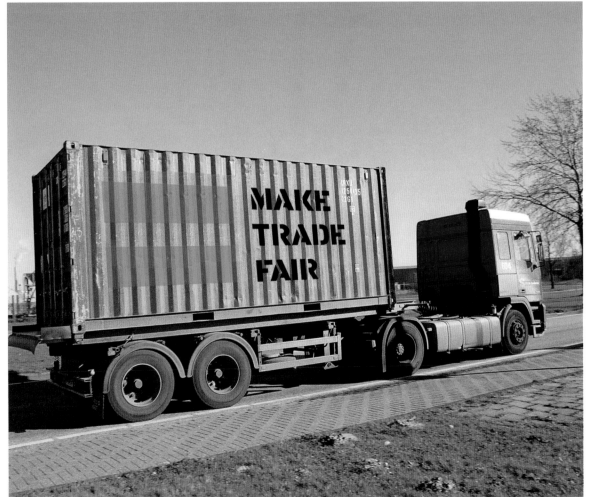

1, 2, 3, 4. OXFAM MAKE
TRADE FAIR CAMPAIGN;
THE NETHERLANDS
KESSELSKRAMER
THE USE OF SHIPPING
CONTAINERS AS A SITE FOR
THE CHARITY OXFAM'S CAMPAIGN
CALLING FOR FAIR TRADE GAVE THE
MESSAGE BOTH PROMINENCE – THE
CONTAINERS WERE PLACED IN CITY
CENTRES IN NINETEEN COUNTRIES
ON FIVE CONTINENTS – AND ADDED
IMPACT THIS WAS DUE TO THE
ASSOCIATION BETWEEN MEDIUM
AND MESSAGE THESE CONTAINERS
ARE THE MEANS BY WHICH TRADED
GOODS ARE SHIPPED AROUND
THE WORLD

DIMENSIONALITY

Graphic design, we tend to assume, is two-dimensional. A book may be a three-dimensional object, but taken page by page, layouts are two dimensional, images are two-dimensional, and type – the basic building block of graphic design – is designed to be applied two-dimensionally. But this has not always been the case. Masons carved letterforms into stone on Roman villas, for example; while the 'technology' existed to apply lettering with paint. And the reason was not just durability – frescoes at Pompeii have survived 2,000 years and a massive volcanic eruption – but rather that three-dimensionality gives words and images a particular quality. In some circumstances, this might set up a striking visual contrast between the flat and the dimensional; in others, it may serve to enhance or project an important element within a larger composition; in others, it may just make an image seem more alive, by making a part of it more tangible.

For the launches of a Comme des Garçons perfume in Paris and Tokyo, designer Marc Atlan created installations using clear plastic bags printed with the Comme des Garçons logo and filled with perfume. At the Japanese launch, the installation was created within the Comme des Garçons Aoyama flagship store, Isetan. Atlan placed bags of perfume around the store and wrapped columns in large scale graphics announcing the new perfume. For the launch held at the Ritz Hotel in Paris, Atlan created an even more tightly knit combination of two- and three-dimensional elements. A large scale image was sited at the top of a flight of stairs, on each of which were placed plastic bags filled with coloured liquid. The juxtaposition of the image, which showed a woman holding a bag of perfume, and the river of bags spilling down the stairs had the effect of tying the two together visually, bringing the image powerfully into the room.

Three-dimensional billboards

Even where the proposed site would seem to indicate the use of flat, two-dimensional graphics, there can be scope for introducing a three-dimensional element. Advertising agencies, striving to create difference in their outdoor work, increasingly find ways to turn the two-dimensional billboard poster into a three-dimensional installation. The Ohio-based advertising agency Boone Oakley, for example, regularly uses the assumption that billboards should be static and two-dimensional to play subversive tricks on viewers and enliven its ads. One campaign for Charlotte Plastic Surgery, a cosmetic surgery clinic, involved loosely draping a sheet marked 'before' over the billboard mount. Drooping in the middle and sagging at the corners, the pre-facelift sheet was later replaced with one stretched tightly over the billboard, bearing only the word 'after' and the clinic's name. Another billboard for the same client featured a giant clock, whose hands turned backwards – the implication being, of course, that at Charlotte Plastic Surgery, they can turn back time. In its outdoor advertising for another client, the Charlotte Hornets basketball team, the agency again played with the idea of the billboard poster as a flat, two-dimensional sheet. Running, jumping, skidding players appeared to cause the sheet to fold over on itself, bunch up, or stretch elastically to accommodate a particularly high jump. The mere fact of playing with conventions in this way is enough to turn people's heads – to such an extent that a series of WCRS' Mini advertisements featuring the car itself needed to do no more than point out that a Mini had driven up a wall to remain in the minds of anyone who saw it.

1. CHARLOTTE PLASTIC SURGERY
BILLBOARD; OHIO, USA
BOONE OAKLEY

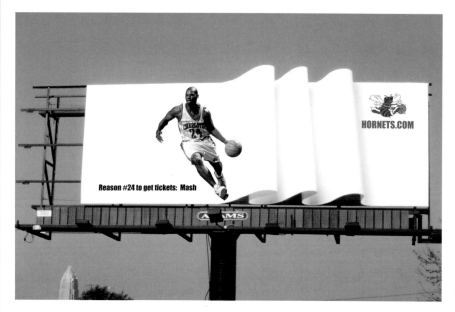

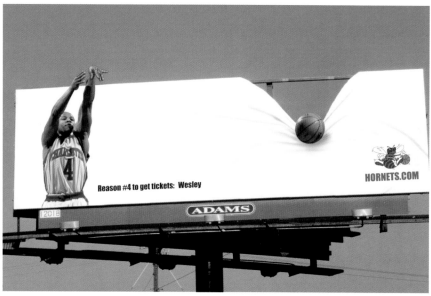

But while a combination of two- and three-dimensional imagery and objects can be memorable, it adds complexity to the job, sometimes requiring the input of engineers, specialist fabricators, installers and expensive equipment such as cranes and hoists. This is a lot of trouble to go to if the result is hardly more effective than flat graphics. Subtle dimensionality – for example, slight reliefs – are not visible at any great distance and can be suggested through the use of shadow in a two-dimensional image without the extra expense of fabricating three-dimensional objects.

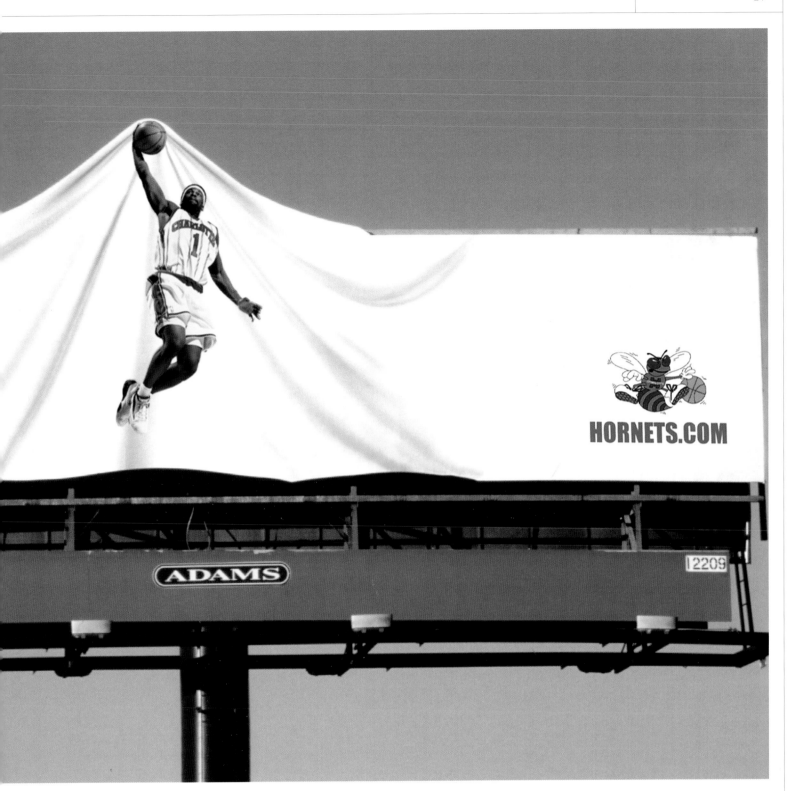

1, 2, 3. HORNETS BILLBOARDS;
OHIO, USA
BOONE OAKLEY

INTERACTION

Interaction in graphic design is not restricted to those pieces large enough to walk through, or those incorporating mechanical or digital technologies. Turning pages, refolding a map or filling in a form are all, in a sense, interactive. But it is true to say that with larger scale graphics, the opportunities for interaction increase, not least because there is greater scope for the inclusion of the bulkier encumbrances of technological hardware.

Public space is characterised by inhabitation – people move through it, conduct their business, and generally interact with each other on social, personal and commercial levels. It makes sense, therefore, that environmental graphic design should also be able to incorporate aspects of interactivity – to blend in with the general blur of human activity, to enable users and viewers to interact with one another, or to respond to the needs of users and viewers in providing bespoke information tailored to time and circumstance.

Human participation in environmental graphic design can effectively be divided into two types: those where audience requests are responded to by the installation, and those where live performance or choreographed movement is part of the display itself.

1, 2, 3. POMPIDOU CENTRE
TEMPORARY SIGNAGE;
PARIS, FRANCE
ATELIER DE CRÉATION
GRAPHIQUE

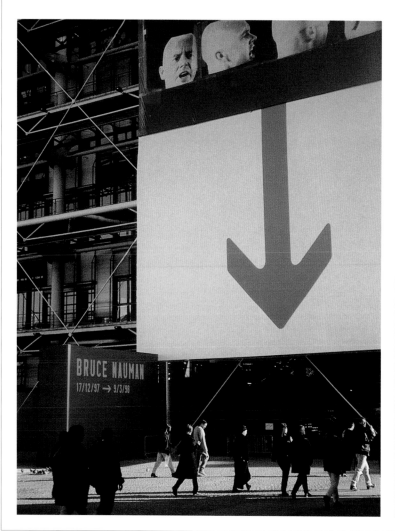

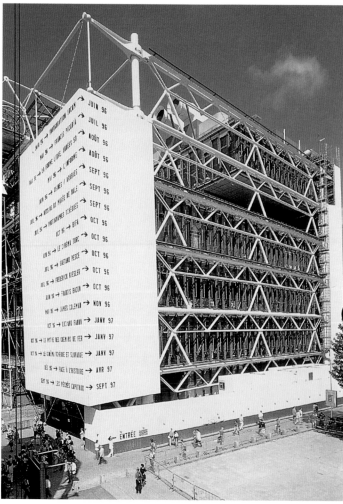

Theatrical hybrids

During renovations at the Centre Georges Pompidou arts complex in Paris, the building was wrapped in a large white construction barrier. Pierre Bernard of the Paris-based design consultancy Atelier de Création Graphique was commissioned to use the surface to communicate the attractions of the Centre. As there would be no opportunity to replace the barriers throughout the duration of the renovation, Bernard opted to list all of the events and exhibitions scheduled for the period in a typeface, based on French car number plates, designed for the purpose. As each event passed, a pair of abseilers would descend the building to cross it off the list. In this case, restrictions within which the designers worked not only created the opportunity for drama and performance as an integral part of the graphic communication for those who happened to witness each update, but even for those who did not, the mere fact that the list was being updated created a sense of urgency around visiting what exhibitions remained on the list before the complete closure of the museum for two years in 1998.

Similarly, in an exhibition stand designed by Imagination for Ericsson, Lycra-clad performers were employed to shift overlaid graphic panels within a two-storey frame, in a choreographed display that attracted and held the attention of passers-by in a busy exhibition hall.

1. ERICSSON EXHIBITION STAND; HANOVER, GERMANY
IMAGINATION

2, 3. INTERACTIVE LIGHT INSTALLATION; CALIFORNIA, USA
CAMERON MCNALL AND
DAMON SEELEY
DESIGNED BY ARCHITECT CAMERON MCNALL WITH DAMON SEELEY, THE INTERACTIVE LIGHT INSTALLATION AT THE SOUTHERN CALIFORNIA INSTITUTE OF ARCHITECTURE (SCI-ARC) ALLOWED MEMBERS OF THE PUBLIC TO INTERACT WITH THE DISPLAY USING THEIR MOBILE PHONES. FOR A PERIOD OF TWO WEEKS, VISITORS TO THE SITE WERE ABLE TO DIAL A NUMBER AND ONCE CONNECTED, CONTROL THE DISPLAY OF COLOURED SQUARES OF LIGHT FOR A PERIOD OF 30 SECONDS BY PUSHING THE NUMBER KEYS ON THEIR PHONES

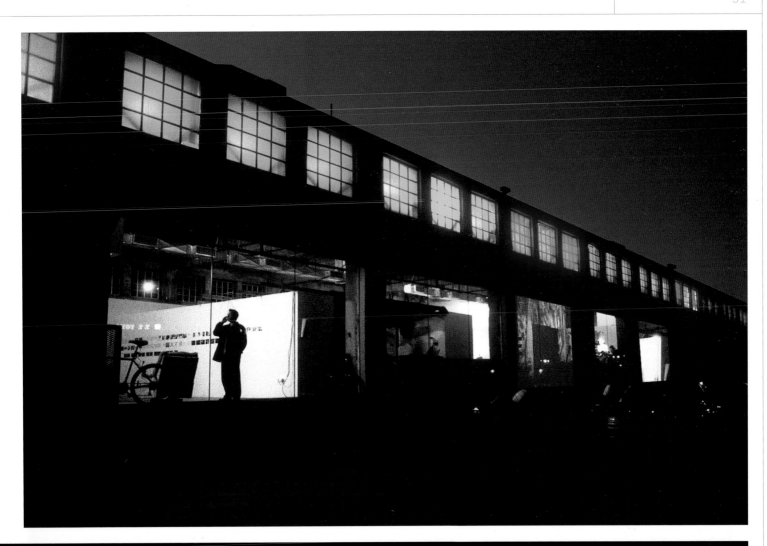

Audience participation

In recent years, one might argue that the developments of consumer electronics, from the personal stereo and the portable, personal computer to the mobile phone, have made the world a more private place, less reliant on shared sources of information – such as large scale graphics in public places. However, designers have adapted to these changes in order to incorporate the interactive capacities of these new technologies into large scale graphic installations designed for widespread public consumption.

Mobile phones, as well as the web, are the input tools of choice in a project by Dutch design studio Mattmo for the ethnically diverse city of Rotterdam. The designers wanted to create a platform through which young people, who may feel awkward about expressing their feelings on personal relationships in ordinary conversation, could communicate with people of all cultural backgrounds. Users will be encouraged to use mobile phone and web technologies to leave messages about such 'tiny taboos'. The results, like digital graffiti, will be then broadcast anonymously on sites throughout the city, from the windows of trams and subway trains, to tickertapes and building facades.

The Talk zone, one of 14 themed pavilions at the UK's Millennium Dome visitor attraction, was designed to promote and discuss the idea of human interaction. Not only did the two buildings – designed to resemble two heads in conversation – literally talk to one another, but visitors also were encouraged to communicate via the Talk zone by inputting short sentences into a computer which were then broadcast via text scrollers to the crowd outside in the main arena of the Dome.

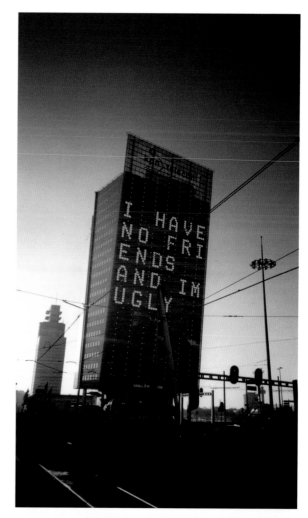

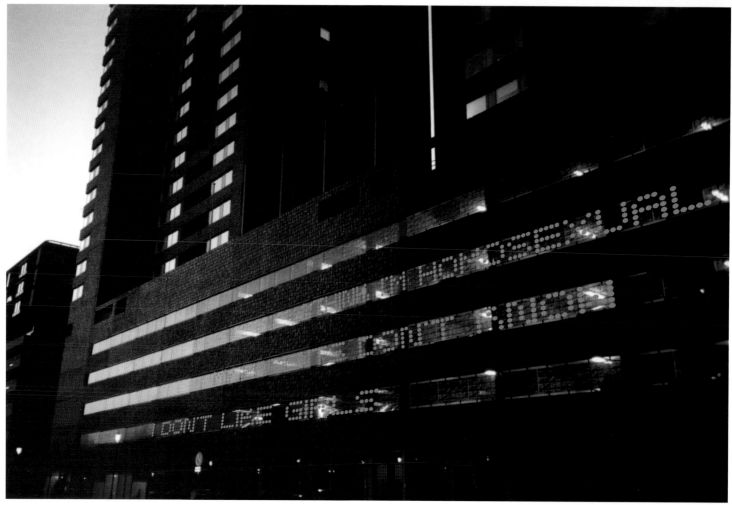

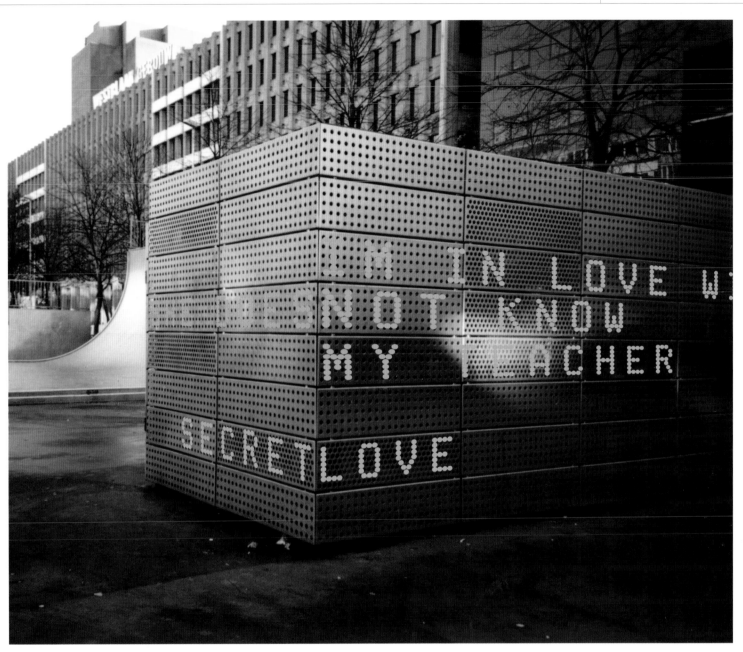

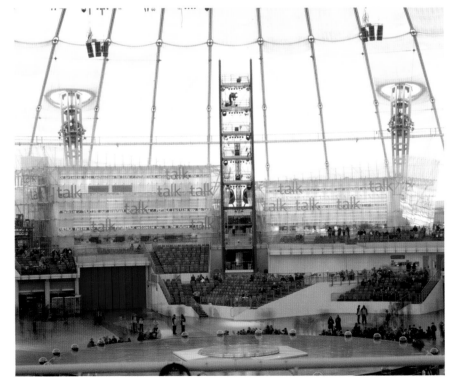

1, 2, 3. TINYTABOOS;
ROTTERDAM, THE NETHERLANDS
MATTMO
CONCEPT RENDERINGS OF A
CITYWIDE GRAPHIC INSTALLATION
THAT WOULD ENABLE THE
AUDIENCE TO COMMUNICATE
WITH EACH OTHER.

4. THE TALK ZONE, MILLENNIUM
DOME; LONDON, UK
IMAGINATION

The technologies employed by designer Peter Anderson in an installation at the Belfast restaurant Cayenne allow less for direct, personal interaction with the environment and more for the ability of the entire crowd to affect the graphics via sensors attuned to the atmosphere within the room. The installation, Magnetic Man, consists of a 40 feet light box, running the length of the restaurant ceiling. Across its surface plays an animated typographic sequence comprised of regular English words and the computer script. The script is taken from a program designed to make the screen interface on a monitor indefinitely revolve. The installation is intended to draw a parallel between a traditional Irish folkloric belief in the enchanting properties of food, and what the designer believes is a similar view of technology in our own times. Twelve preset animations cast a 'spell' over the diners below. But there is also the option to switch off the pre-settings, and allow the installation to respond to changes in noise levels throughout the room through a series of microphones: the sound of laughter, or a knife being dropped on a plate, causes the entire artwork to shiver. While the piece as a whole responds to the audience as a whole even without conscious intention on their part; according to the designer, the more observant diners notice how it works, and begin to play with it — becoming enchanted.

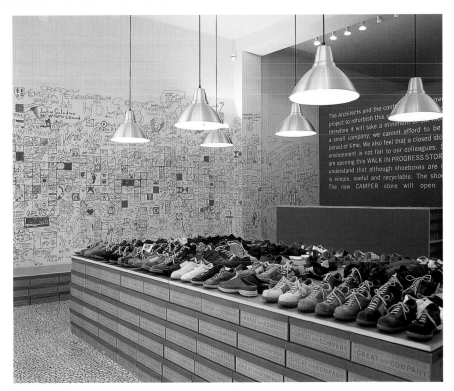

1, 2, 3, 4. MAGNETIC MAN; BELFAST, NORTHERN IRELAND
PETER BOYD JOINES ANDERSON
CAYENNE IS A BELFAST RESTAURANT WHICH FEATURES ARTWORKS CREATED BY PETER ANDERSON. AMONG THESE IS A TYPOGRAPHIC ILLUSTRATION DRAWN FROM THE BELFAST TELEPHONE DIRECTORY WHICH COVERS A WALL; MOUNTAIN PEOPLE – A LENTICULAR IMAGE REFERRING TO THE MOUNTAINOUS TOPOGRAPHY OF THE REGION; AND MAGNETIC MAN, AN INTERACTIVE LIGHT BOX.

5, 6. TEMPORARY CAMPER STORE INTERIOR; MILAN, ITALY
MARTÍ GUIXÉ
THE TEMPORARY INTERIOR DESIGN SOLUTION CREATED BY MARTÍ GUIXÉ FOR THE MILAN STORE OF SHOE BRAND CAMPER ALLOWED VISITORS TO INTERACT WITH THE ENVIRONMENT BY LEAVING THEIR OWN TAGS ON THE WALL.

RESPONSIBILITY

Many large scale graphics occur in the public realm, which might be
loosely defined as both a physical and a mental space. Physically, it is that
part of the environment that we all enjoy equal access to – the roadways,
city centres and public squares – but further, we associate with such
places civic virtues and our sense of community, and even democracy.
As James Howard Kunstler, the American writer on the environment
and urbanism has written, 'The public realm is the physical manifestation
of the common good.' In recent years, anti-corporate activists have
questioned the motivations and techniques of branding and advertising
in general, and the use of space in the public realm for commercial
purposes in particular. Offending material is sometimes subverted to turn
the power of the medium back on the advertiser – examples can be seen
online at sites such as Subvertise.org and Billboardliberation.com.

Billboard advertising is the most obvious manifestation of corporate
communication in public space, but as it has been around – in one
form or another – for centuries, we tend not to notice the extent to
which it intrudes on our consciousness as we go about our business
in the streets, in airports, in sports stadia and so on. Today, designers
and advertisers seek out more unusual sites in order to surprise us
into noticing these adverts. In the UK in recent years, advertisements
have appeared strapped to the backs of cows standing in a field next
to a railway line, projected onto the Houses of Parliament and St Paul's
Cathedral (without permission in both cases) and stuck to pavements in
the public street (again, without permission). The tricks work and the
advertisements do get noticed, but this does not always generate
the desired effect. For all that we live in a landscape of commercial
messages – even a brandscape, as some have termed it – the public
at large is increasingly joining the activists in criticising advertisers
when they step over the invisible line between acceptable efforts to
promote products and communicate with customers, and intruding on
the private mental space of people using public areas. And designers
and advertisers themselves are not unaware of the controversial nature
of broadcasting in the public realm. The famous ad-man David Ogilvy
remarked that 'As a private person, I have a passion for landscape, and
I have never seen one improved by a billboard. Where every prospect
pleases, man is at his vilest when he erects a billboard. When I retire
from Madison Avenue, I am going to start a secret society of masked
vigilantes who will travel around the world on silent motor bicycles,
chopping down posters at the dark of the moon. How many juries will
convict us when we are caught in these acts of beneficent citizenship?'[7]

To an extent, this is something that governments can and do legislate
on – advertising is banned in certain places either for reasons of safety
or to preserve the character of an area. But this is not really about
staying on the right side of the law. It profits no one if a piece of large
scale graphic design is legally situated, but enrages everyone who
sees it. It is about being sensitive to the fact that, in a sense, when
broadcasting into the public realm, the broadcaster is a guest of those
who inhabit it, and should behave accordingly. When Yahoo! erected an
enormous sign near the NoHo Historic District in Manhattan, it infuriated
residents: City Council representative Kathryn E. Freed told the New York
Times that she receives complaints about the sign every day.

Designers should also be sensitive to issues of safety and public order.
In 2002, a 60 feet billboard showing Calvin Klein model Travis Fimmel
in his underwear was removed from the busy intersection of London's
Oxford Street and Tottenham Court Road after road safety officials
noticed that some women drivers were slowing down to look at it, causing
congestion and possible hazards. Previously, 'Hello Boys', a campaign for
the Gossard Wonderbra, was reputed to have caused a few crashes as
male drivers found their attention distracted.

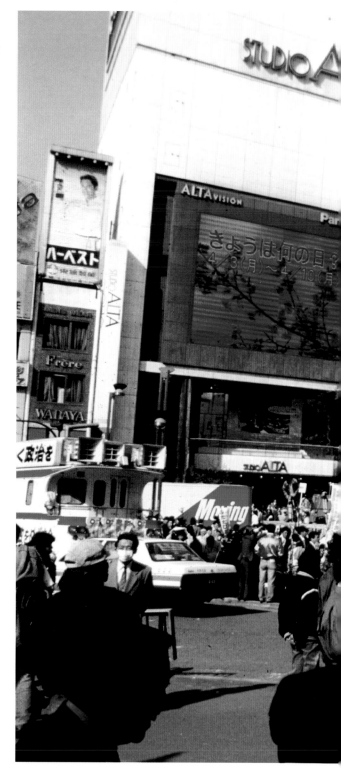

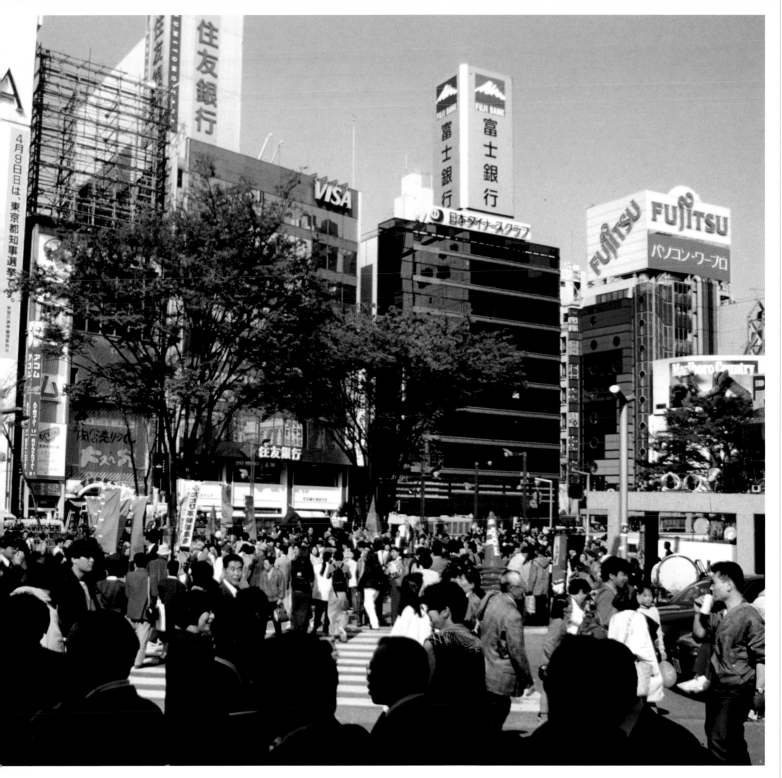

SIGNS IN THE CITY; JAPAN
THE COMPETITION BETWEEN
SIGNS IN ALL OF THE MAJOR
CITIES OF THE WORLD CAN RESULT
IN INFORMATION OVERLOAD AND
A FEELING OF RESENTMENT
TOWARDS THOSE WHO CLAMOUR
FOR OUR ATTENTION

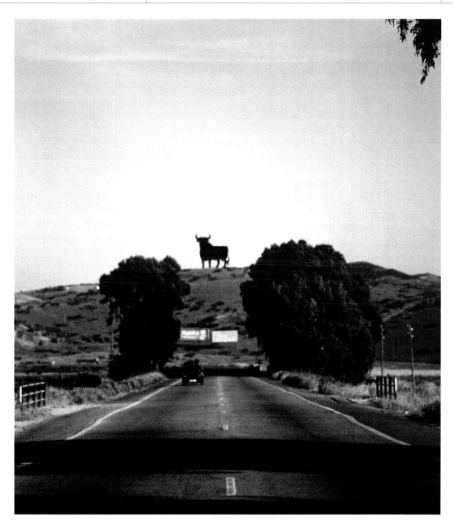

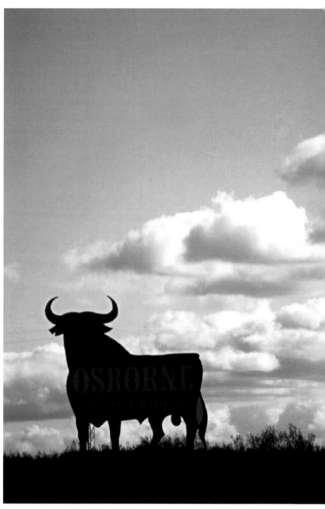

Even where safety is not an issue, content that might pass without comment in the pages of a book or magazine provokes a fiercer reaction when it appears in public places. In Berlin, a large scale poster aimed at raising money for a Holocaust Memorial was removed in August 2001. The strapline – 'The Holocaust Never Happened' – was supported by smaller text warning against the possibility that Holocaust denial will grow unless memorials are made to remind people, but it was argued by opponents of the poster that it was liable to be misunderstood.

Public realm, public property

But advertising within the public realm is not always resented by the public who inhabit it. A familiar sight along the major highways of Spain are the figures of a black bull, two-dimensional cut-outs supported by metal scaffold, enormous even in the context of the mountains on which they sit, silhouetted against the sun. A road journey from Barcelona to Madrid via Zaragoza, for example, takes the driver past eleven of these identical monuments. The bulls have come to be associated with Spain to such an extent that many visitors assume they are indeed some form of landscape-based logo for the country. In fact, the bulls are advertising the Osborne sherry and brandy company of El Puerto de Santa María, Andalucía. The first was erected in 1957 and, until 1988, they were more easily identifiable as advertisements as they bore the name Osborne. In that year, however, a new law forbade advertising by main roads and the lettering was removed. In the 1990s, when the government threatened to enforce the law more strictly, and demand the removal of the bulls altogether, a public outcry followed. The bulls, their champions argued, had become part of national heritage. Today, just short of 100 Toros de Osborne remain, dispersed across the country from Bilbao in the North to Cadiz in the South, their future seemingly assured by the extent to which the Spanish people have come to regard them as a form

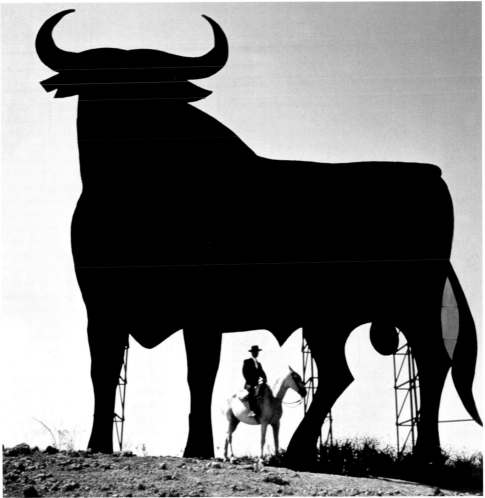

1, 2, 3. THE TOROS DE OSBORNE;
SPAIN
(2) SHOWS THE BULL SILHOUETTE
AS IT WAS ORIGINALLY INTENDED,
BEARING THE NAME OF THE SHERRY
BRAND 'OSBOURNE'. THE OTHER
IMAGES SHOW THE SILHOUETTES AS
THEY APPEAR TODAY, AFTER THE
LETTERING WAS REMOVED DUE TO
1988 SPANISH LEGISLATION.

of public property, even while recognising the fact that they are, or were, sherry advertisements. They have even inspired a book, Un Toro Negro y Enorme, written by José Bergamin and published by the cultural association España Abierta, which claims for them a place in the country's cultural history. The story of the Osborne bulls shows the extent to which commercial messages, even in the public realm, can be not only tolerated but loved, in the right circumstances.

It is also interesting to note that terms such as 'visual pollution' tend only to be used with reference to the communications efforts of major corporations. The right of private individuals to air their views – whether through public art or via the banners waved at football matches or on demonstrations – is rarely questioned.

INTRODUCTION

Graphic design on a large scale requires designers not just to think differently about materials, and legal constraints, but about the completely different way in which audiences read environmental graphic design. As Adrian Caddy, creative director of Imagination observes, 'A lot of graphic designers used to books and brochures have difficulty in adjusting to a human-sized or building-sized canvas, and the natural tendency is just to design a poster and blow it up really big. And of course that doesn't work because it doesn't take into account the form of the thing it has to go onto, and what happens as you move closer or further away from it.' Unlike design for print, environmental graphic design involves considerations of movement — either of the object or the audience — of distance, and of incomplete or partial views, for example.

1, 2, 3, 4. ALBERT HEIJN STORE;
THE NETHERLANDS
CONRAN DESIGN GROUP
AT THE ALBERT HYNE STORE,
THE DESIGNERS EXPLOITED THE
INSTINCT SHOPPERS HAVE TO LOOK
UPWARDS WHEN POSITIONING
PICTORIAL PRODUCT DESCRIPTIONS

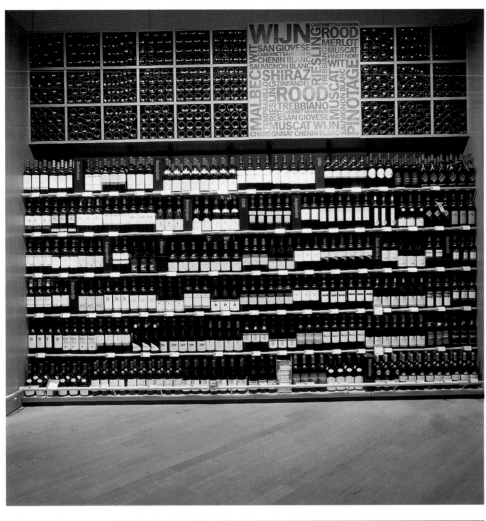

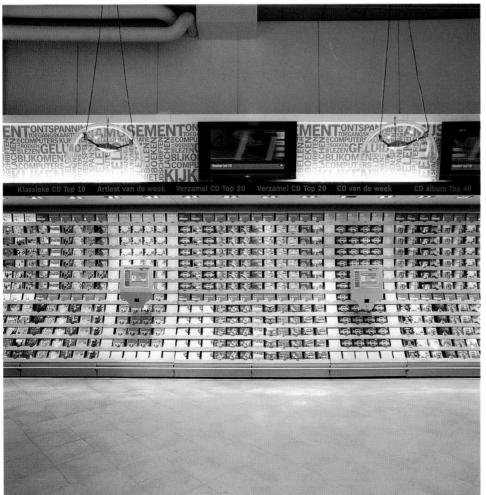

VIEW

Twenty million tourists a year troop through New York's Times Square, principally to marvel at the illuminated 'spectaculars', as the area's illuminated billboards have been known since the 1930s. Little wonder, then, that prominent spots in the Square are highly prized – and with many sites worth over a million dollars a year, the rental income from the space on the outside of the Square's office buildings can be worth more than that of the space inside. Visibility, for most large scale graphics, whether they are for promotion or wayfinding, is of paramount importance.

But the nature of the sites in which they are displayed means that with most large scale graphics, it is rarely as simple as placing an image in front of a captive audience. There are an infinite number of circumstances to contend with, and opportunities to be exploited.

The angle of view

The first is the angle of view: a flat poster against a wall may be visible in part almost through 180 degrees, but it will only be visible in its entirety and with almost no distortion to a viewer standing at a point on a line perpendicular to the centre of the poster. Many designers of large scale graphics find ways around this problem by developing three-dimensional graphics, or by exploiting the dimensionality of the physical world in which most such graphics exist to wrap graphics around buildings and the like.

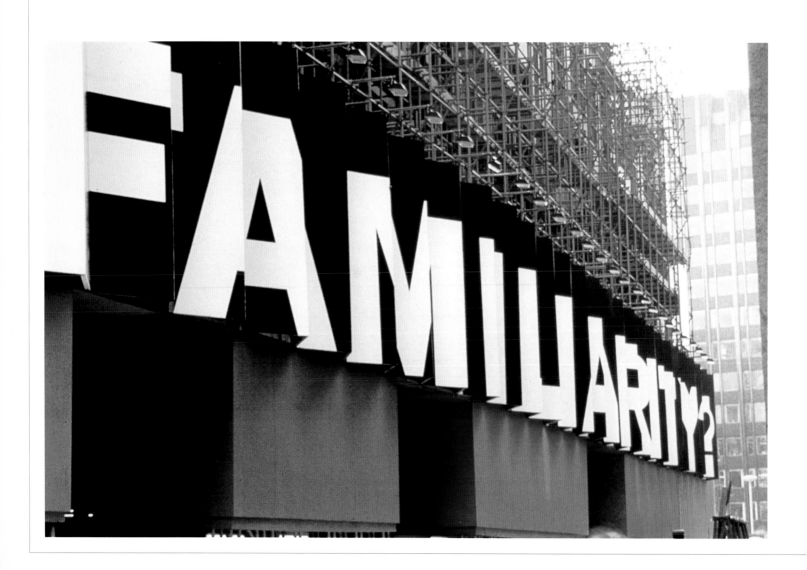

In the case of the familiarity construction barrier in London designed by Studio Myerscough with architects Alford Hall Monaghan Morris, the designers were able to be confident of the angle of view as the narrow, high-sided street on which it is situated forces the viewer to look straight ahead while moving along it. They were therefore able to construct a stepped screen on which the word 'Familiarity' appears (when seen from one end of the street) and a collection of images (when seen from another). The letters and images are split over several panels, but because of the restricted potential for deviating from the path, the designers could be sure that the viewer would see the word and images in alignment.

Similarly, due to the scale and positioning of a proposed graphic, the Amsterdam office of Wieden & Kennedy was able to assume that two parts of a composite image, placed on two adjacent buildings, would be viewed together. As sponsors of the Dutch national football team, Nike regularly references its association with the team in its own promotions. Its activities have ranged from getting advertising agency KesselsKramer to stick Nike swooshes over the amber bulbs on Amsterdam's traffic lights – the Dutch team plays in orange – to what is reputed to be the world's largest building graphic. Designed by advertising agency Wieden & Kennedy, and produced and applied by VgL, the graphic showed Dutch player Edgar Davids appearing to burst through the glass curtain wall of the 150 metre high Rotterdam office of Nationale-Nederlanden, another team sponsor.

1, 2. FAMILIARITY CONSTRUCTION BARRIER; LONDON, UK
STUDIO MYERSCOUGH
DESIGNED TO PROMPT VIEWERS TO RECONSIDER THE COMPARATIVELY UNDER-DEVELOPED NEIGHBOURHOOD THAT MOST WERE PASSING THROUGH ON THEIR WAY TO WORK, THE FAMILIARITY CONSTRUCTION BARRIER USED IMAGES OF OBJECTS TO SUGGEST LOCAL SIGHTS, SOUNDS AND SMELLS, SUCH AS A FAMOUS FISH MARKET.

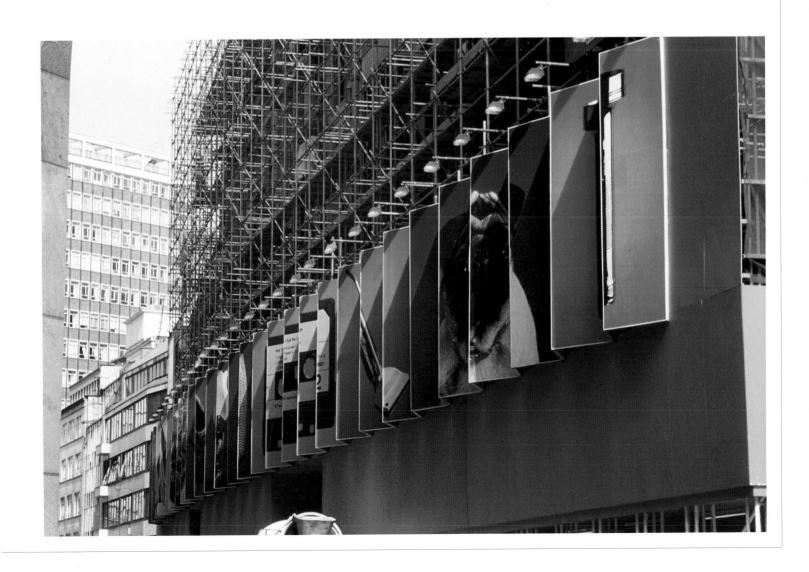

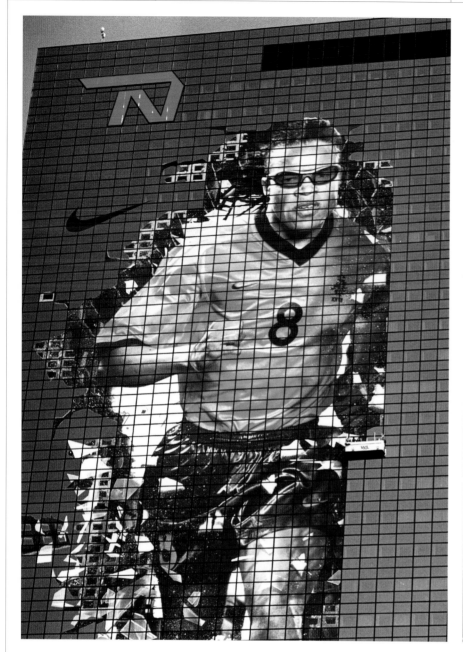

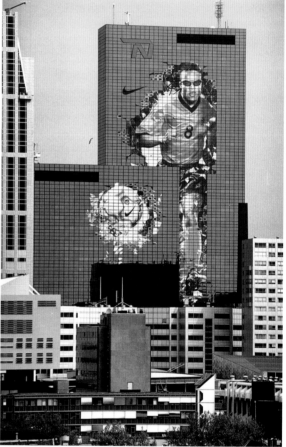

Nearly 10,000 square metres of graphics were required to produce an image bigger than the Statue of Liberty. In a neat twist, the proximity of an adjacent building was exploited in the design: the ball Davids kicked appeared to come crashing through the wall of the second building. Due to its size, few visitors to the vicinity could fail to see the dramatic image. In fact, the only people to whom the design was invisible were inside the building: the graphics were printed onto 3M PWMF, a translucent film, allowing light to enter the building and its occupants to see out.

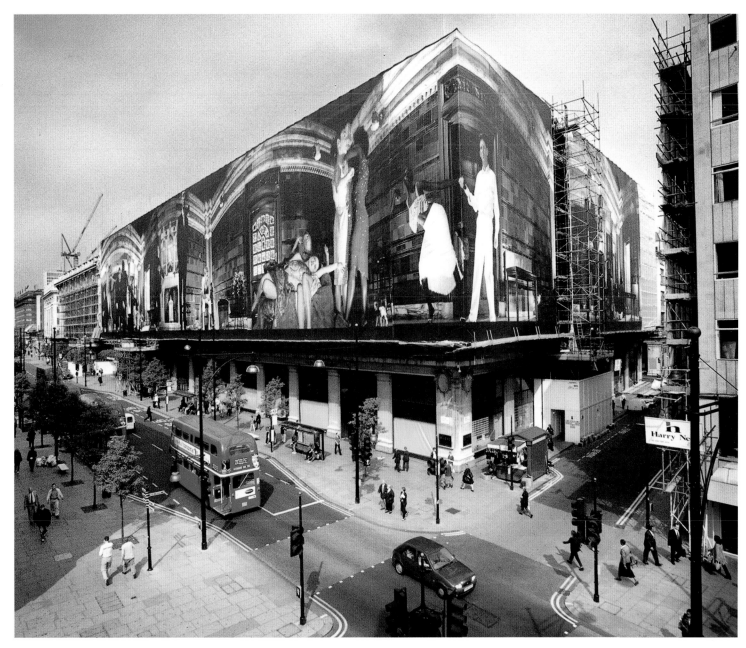

Exploiting forms

A narrative in a book or magazine is sometimes propelled by the turning of a page – new chapters begin on new pages, for example, or full bleed images are contrasted with dense text on consecutive spreads. In the same way in environmental graphic design, the narrative is often propelled by the turn of a corner – from one street to the next, or from one room to another within a museum or exhibition stand. Such moments provide opportunities for excitement and revelation, or discontinuity and confusion. When the London department store Selfridges was undergoing construction work, the artist Sam Taylor-Wood was briefed to create an image for the construction netting that would wrap around the top of the building. Taylor-Wood is best known for her work with a panoramic camera, taking 360 degree images of rooms that start and end in the same place at opposite ends of the photograph, usually with a series of intriguing 'events' happening in the middle. For Selfridges, she constructed just such a scene, using celebrities such as Elton John, and made a feature of the wrap that extended around the building by laying the 360 degree image along it. As there is no start or end to the image, the viewer could approach it from any of the roads that surround the store and continue to follow it without feeling like they had arrived in the 'wrong place'.

1, 2. NIKE BUILDING GRAPHIC;
ROTTERDAM, THE NETHERLANDS
WIEDEN & KENNEDY

3. SELFRIDGES CONSTRUCTION
BARRIER; LONDON, UK
SAM TAYLOR-WOOD

Up and down

Environmental graphics, of course, do not have to be on walls. In a
complex environment, other views are often possible – for example,
the one of the ground, either while standing on it, or from a vantage
point above. Studio Myerscough used an aerial perspective in its design
for an exhibition of music fashion, 'Rock Style'. Visitors to the exhibition
were able to look down onto the tops of display cabinets, into which
music-related names and phrases had been drilled – the lighting in the
cabinets required ventilation, and the type also performed this function.
It is not an obvious place to put such graphics – if the room in which
the cabinets sat had been considered in isolation, the designer would
have assumed that the tops of the cabinets were out of view, but from
the wider environment, they were not. Many designers find that only by
making models of the environment can they fully appreciate the range
of views that may be available.

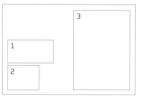

1. ON PITCH PROMOTION FOR
TETLEY BEER; UK
GRAPHICS ON THE GROUND CAN BE
AFFECTED BY FORESHORTENING –
DUE TO THE ANGLE OF VIEW, THEY
ARE VERTICALLY 'COMPRESSED'. TO
COUNTER THIS, ROAD MARKINGS,
FOR EXAMPLE, ARE PAINTED
'TALLER' THAN THEY ARE INTENDED
TO BE SEEN: AT SPEED, FROM THE
VIEWPOINT BEHIND THE STEERING
WHEEL, THEY WILL APPEAR
NORMALLY PROPORTIONED. SPORTS
PITCHES ARE REGULARLY PAINTED
WITH PROMOTIONAL GRAPHICS,
WHEN ADVERTISING THE SPONSOR
OF THE TEAM OR TOURNAMENT. FOR
THESE, THE PRINCIPAL AUDIENCE IS
OFTEN NOT THE FANS AROUND THE
EDGE OF THE PITCH, BUT THE MUCH
LARGER TV AUDIENCE. IN ORDER
THAT THE IMAGE APPEARS TRUE ON
TELEVISION, A PROJECTION OF THE
IMAGE IS MADE ONTO THE PITCH,
WHICH IS THEN ADJUSTED –
SHORTENED OR LENGTHENED –
UNTIL IT LOOKS RIGHT THROUGH
THE TV CAMERAS. THE IMAGE IS
THEN PAINTED ONTO THE PITCH IN
THOSE PROPORTIONS. PROJECTIONS
CAN ALSO BE USED TO JUDGE THE
EFFECT OF DISTORTION THAT THE
HEIGHT OF A TALL BUILDING WILL
HAVE ON AN IMAGE, FOR EXAMPLE.

2, 3. ROCK STYLE; LONDON, UK
STUDIO MYERSCOUGH

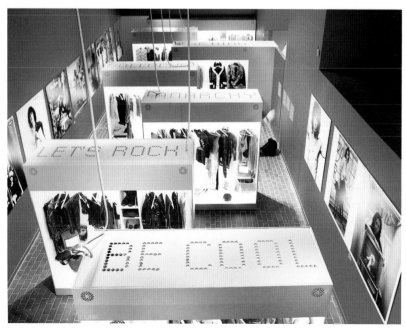

DISTANCE

Visibility over long distances is often the reason why environmental graphics have to be large, but scale in itself is not enough to ensure readability. Factors such as lighting are important both inside and outside, as is the selection of appropriate typefaces – script faces, for example, tend to be illegible at any reasonable distance. One way to increase legibility is to use contrasting colours. According to authors Karen E. and R. James Claus[8], the 16 colour combinations giving the best legibility of letters outdoors and viewed from a distance are, in descending order: black on yellow, black on white, yellow on black, white on blue, yellow on blue, green on white, blue on yellow, white on green, white on brown, brown on yellow, brown on white, yellow on brown, red on white, yellow on red, red on yellow and white on red. Blue, yellow and red, of course, are primary colours. Shades derived from mixing other colours, such as pink or purple, create less contrast with other colours, and are therefore less legible.

Exhibition stands

Visibility from a distance is a particular problem for exhibition stands: the competition from rival stands and, often, poor signage in the exhibition hall itself means that stands have to work hard to identify themselves and draw in visitors from far off. The Hub, designed by BDG McColl, uses height to put itself in the sightline of exhibition visitors. Graphics identifying the stand run up a tall vertical element, and projections are made onto a screen suspended high above the stand. In its design for a Sony Ericsson exhibition stand, Lorenc + Yoo Design resolved the problem of identification typographically – from a distance, it is clear that in cross-section, the stand forms the company's initials, SE.

1, 2. THE HUB, WORKPLACE 2001;
LONDON, UK
BDG MCCOLL

3, 4. SONY ERICSSON EXHIBITION
STAND; USA
LORENC + YOO DESIGN

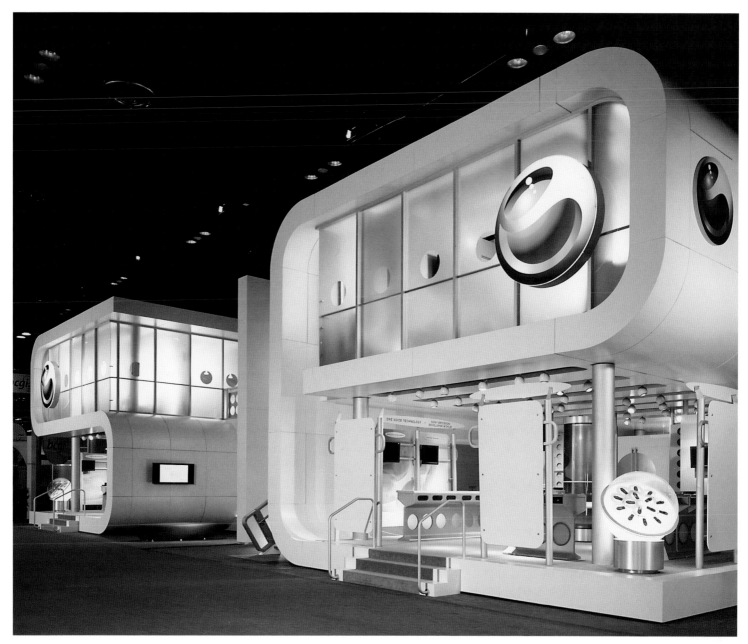

Exhibition stands, however, like museums or retail environments, are primarily about display, and it is easy to overwhelm the objects on display with the design of the stand and the large scale graphics required to attract visitors to it – especially as the objects themselves are physically small. The products or exhibits can be enhanced and explained, and made into a coherent whole around which the viewer can navigate, by a graphic treatment which envelops the environment, but in such circumstances, the large scale graphics almost always work at two levels. The first is the macro level, with the design framing the collection, explaining routes and themes, marking out separate areas and atmospheres. On the micro level, the scheme must present and describe individual exhibits. And at both levels, the graphic communication must work to support rather than overshadow or detract from the products on display.

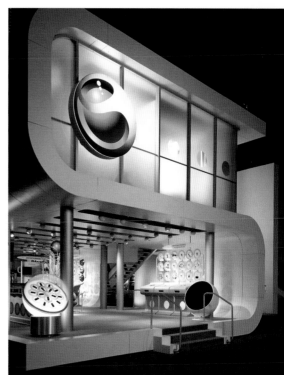

Exploiting distance

'Tiles of the Ocean', a mosaic mural, also offers viewers a different experience depending on whether they view it up close or at a distance. The mural is situated at the Lisbon Aquarium (Aquaria de Lisboa), which was created as a principal attraction for Expo 98, staged in that Portuguese city. It celebrates the richness and diversity of the world's oceans and marine habitats. The mural, designed by Chermayeff & Geismar, runs through both the interior and exterior of the aquarium building, entertaining visitors as they queue for entry. At up to six storeys high, and 240 feet long, the mosaic was created in a process that combined computer technology with traditional craftsmanship. Photographs of fish were pixelated and assigned a greyscale value; a selection of ten geometric tile patterns were matched to the ten greyscale values, and over a million tiles were made by local craftsmen and installed to form the mural. The variety of tile designs means that the mural can be enjoyed close up as well as at a distance, and the overall effect caused by the pixelation process is also reminiscent of seeing through water.

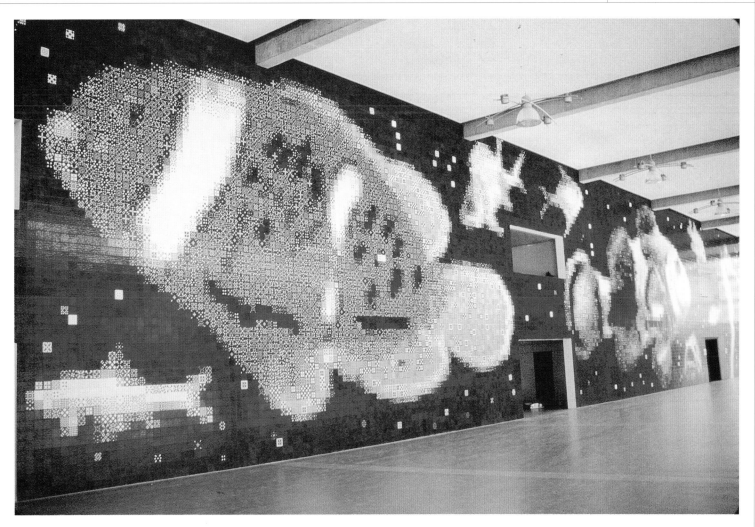

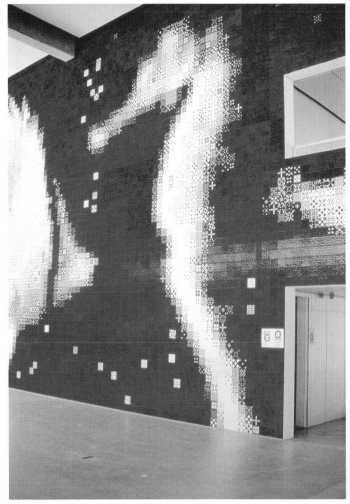

1, 2, 3, 4. TILES OF THE OCEAN;
LISBON, PORTUGAL
CHERMAYEFF & GEISMAR
WHEN THE MURAL IS VIEWED FROM
NEARBY (2), THE INTRICACIES OF
THE DECORATED TILES SHOW OFF
THEIR CRAFTMANSHIP WHEN THE
VIEWER INCREASES THEIR DISTANCE
FROM THE WORK (1, 3, 4), THE
OVERALL MARINE THEME
BECOMES APPARENT

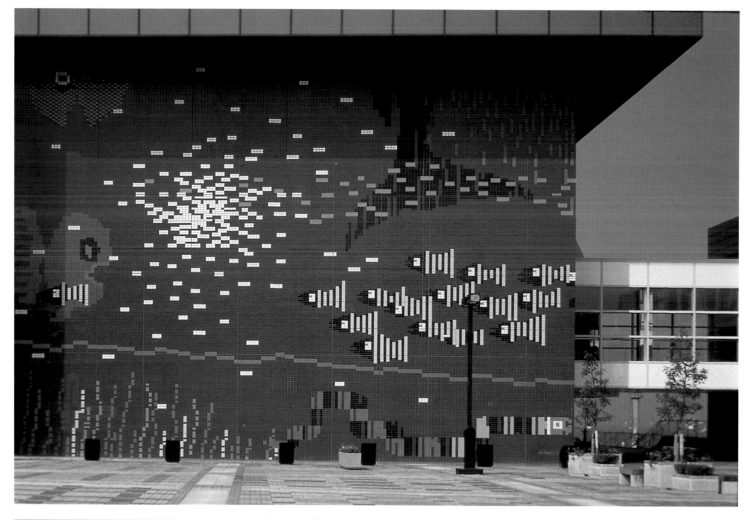

1, 2. TILES OF THE OCEAN;
LISBON, PORTUGAL
CHERMAYEFF & GEISMAR

3, 4. AMERICAN IMMIGRANT
WALL OF HONOR; ELLIS ISLAND,
NEW YORK, USA
RALPH APPELBAUM ASSOCIATES
DESIGNED BY RALPH APPELBAUM
ASSOCIATES, THE AMERICAN
IMMIGRANT WALL OF HONOR AT
ELLIS ISLAND IMMIGRATION MUSEUM
IS THE LARGEST WALL OF NAMES IN
THE WORLD (OTHERS INCLUDE MAYA
LIN'S FAMOUS BLACK GRANITE
MEMORIAL WALL IN WASHINGTON
DC, COMMEMORATING OVER 58,000
AMERICAN DEAD OF THE VIETNAM
WAR). SITUATED ALONG THE
DOCKSIDE WHERE MANY IMMIGRANTS
FIRST ARRIVED IN AMERICA, THE
WALL FEATURES A GROWING LIST OF
THEIR NAMES. THE INSCRIPTIONS,
PAID FOR BY THE DESCENDANTS OF
THOSE LISTED, CURRENTLY NUMBER
OVER HALF A MILLION AND CAN ONLY
BE READ AT CLOSE RANGE. FROM A
DISTANCE THE NAMES ARE NOT
LEGIBLE, BUT THE 652 FEET
CURVING STAINLESS STEEL WALL
ACTS AS A SCULPTURAL MONUMENT
THAT DRAWS VISITORS IN FOR A
CLOSER LOOK

MOVEMENT

Most environmental graphics are necessarily static, and any animation of the image is caused by the viewer physically moving themselves around the object or environment. But there are a variety of areas in which large scale graphics have built-in movement — for example, in some projections or cinema title sequences, or when attached to moving objects — such as trains, planes and automobiles.

Vehicle liveries

These are an integral part of many identity programmes, ranging from the simple application of a logo to the door of a florist's van to the coating of a fleet of aircraft. For a period in the late 80s and early 90s, London-based design consultancy Roundel did the majority of its work for the various companies operating on Britain's rail network, and learned a number of lessons about the specific challenges of applying large graphics to moving machines, later applied in other projects to bus, truck, tanker and even vehicle transporter liveries. The first is the issue of perspective — the identity must be visible 'at a distance and on the move'. On the page, the design is still, and although for passenger trains, if not for freight, the viewer spends some time close by to a stationary train while in the station, in practice most viewers see the train passing by a couple of miles away, and at over 100mph. Detail can be missed, patterns are transformed into a blur of lines, and fine gradations of colour flatten into one.

Furthermore, machines produce their own environmental conditions, and the designer must understand these. On trains, for example, the sides of the engine are interrupted by grilles which emit heat and dirt. The designer must discover where the sources of dirt are on the vehicle, and establish how often the different parts of the vehicle are cleaned – it is no use placing an important graphic element in a place that is covered in dirt and stains most of the time, or where engine heat will cause vinyls to peel.

Mobile audiences

The issue of movement can be significant even when one is not designing graphics for a moving vehicle: frequently, due to the nature of large scale graphics, they are designed to be seen by a viewer on the move, either as a pedestrian within a city or interior environment, or from a moving vehicle, as in the case of roadside signs and advertising. A Metropolis magazine article on the redevelopment of Times Square quotes Mary Beth Betts, the curator of 'Signs & Wonders', an exhibition on the Square's advertising. Noting the number of video screens now in use, she referred to the fact that when people are on the move, they can take in only the simplest and most immediate images and messages: 'Historically, the neon ads that have worked have been short and memorable images, like a kitten chasing a spool of thread over and over... Those signs have always been about pedestrian traffic, capturing the attention of someone walking through the square with a direct message. Video demands a longer attention span, and Times Square is not supposed to be for folks standing in a museum. I'm not sure how all the video works.'[9]

1. KCR LIVERY; HONG KONG ROUNDEL
THE COMPREHENSIVE IDENTITY PROGRAMME DESIGNED BY ROUNDEL FOR THE KOWLOON-CANTON RAILWAY (KCR), AN EXTENSIVE RAIL, TRAM AND BUS NETWORK IN HONG KONG, INCLUDED SIGNAGE AND LIVERY AND STATION INTERIORS.

2. RAILFREIGHT LIVERY; UK ROUNDEL

3. HEATHROW EXPRESS LIVERY; LONDON, UK
MINALE TATTERSFIELD DESIGN STRATEGY
IN THE NOT-SO-DISTANT PAST, LONDON RESIDENTS AND VISITORS TO THE CITY WOULD DREAD THE JOURNEY TO HEATHROW, TRANSPORT PROVISION FOR ONE OF THE WORLD'S BUSIEST AIRPORTS WAS TERRIBLE. THE INTRODUCTION OF THE HEATHROW EXPRESS TRAIN SERVICE MADE THE JOURNEY QUICKER, IF NOT CHEAPER, AND IT IS THIS QUALITY THAT IS SUGGESTED BY THE TRAIN LIVERY. CREATED BY MINALE TATTERSFIELD DESIGN STRATEGY THE WHITE TRIANGLE ON THE FRONT CARRIAGE IS REMINISCENT OF THE ONLY SUPERSONIC PASSENGER PLANE, CONCORDE, A REFERENCE NOT JUST TO SPEED, BUT TO AIRPLANE TRAVEL TOO.

As people move through an environment on foot, they have to keep
reorienting themselves, and checking that there are no obstacles in
their path. It is unlikely that anyone will read anything but the briefest
of messages while moving along. Less, as Mies van der Rohe used to say,
is more. Architect Robert Venturi famously responded to Mies' assertion
with one of his own: 'Less is a bore,' but in 'Learning from Las Vegas'[10],
Venturi and Denise Scott Brown devote considerable space to the
problem of identifying the offers of each building on the American
highway, where 'The big sign and the little building is the rule of Route
66.' In a condition of urban sprawl, the signs have to work hard to
identify buildings to drivers passing by at high speeds. Referring to
research published in 'The View from the Road'[11], the authors note
that 'more than half the objects sighted along a road by both drivers
and passengers are seen straight ahead and narrowly to the sides, as
if with blinders (that is why the sign must be big and must be on the
road). About one third of the attention is off to the immediate sides.
Attention is also more focused on 'moving' objects than on 'stable'
ones, except where the observer passes a visual barrier and, in order
to reorientate, surveys a new landscape. Speed is the determinant of
focal angle, both for driver and passengers. Increases of speed narrow
the focal angle with a resulting shift from detail to generality; attention
shifts to points of decision.

1. ELLIS ISLAND IMMIGRATION
MUSEUM; NEW YORK, USA
CHERMAYEFF & GEISMAR
DESIGNED BY CHERMAYEFF &
GEISMAR IN COLLABORATION WITH
METAFORM, INC.; THE 80,000
SQUARE FEET EXHIBITION AT THE
ELLIS ISLAND IMMIGRATION
MUSEUM TELLS THE STORY OF
MULTI-CULTURAL IMMIGRATION TO
AMERICA. MOVING PAST THE PRISM
FLAG REVEALS PORTRAITS OF
AMERICANS WHOSE ETHNIC
DIVERSITY IS CELEBRATED IN THE
EXHIBITION

2, 3, 4. 'COMETH THE HOUR';
BIRMINGHAM, UK
TBWA

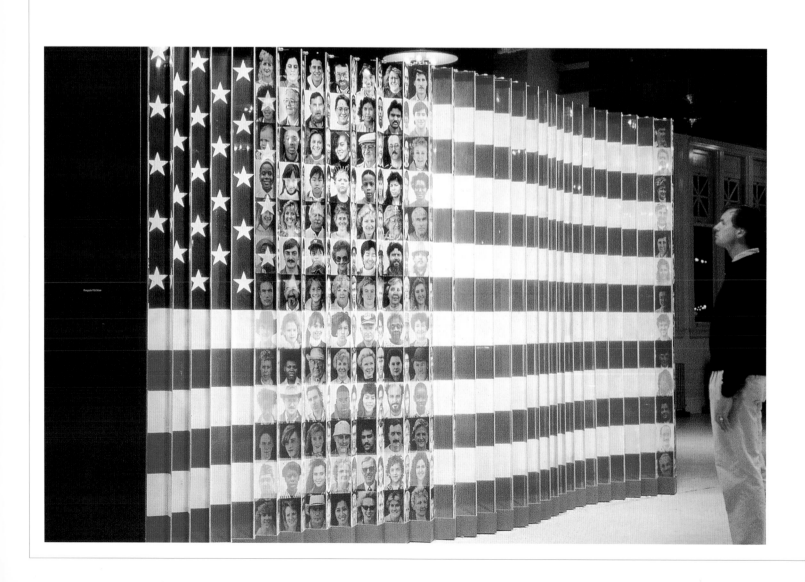

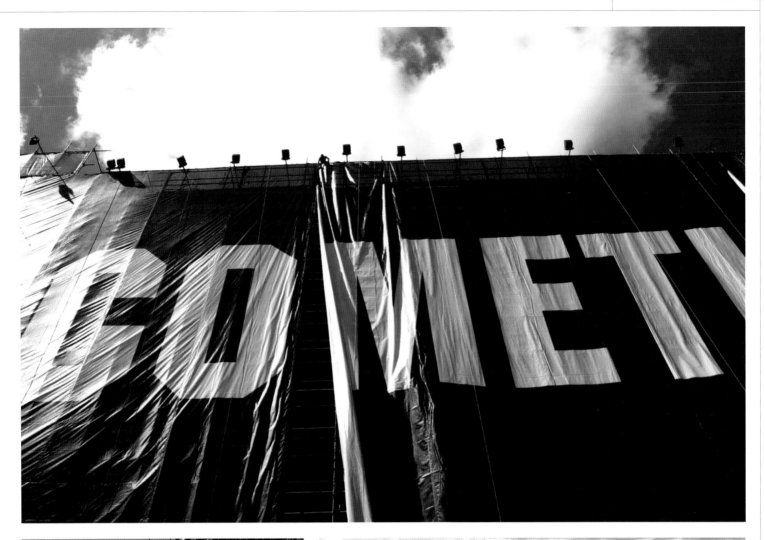

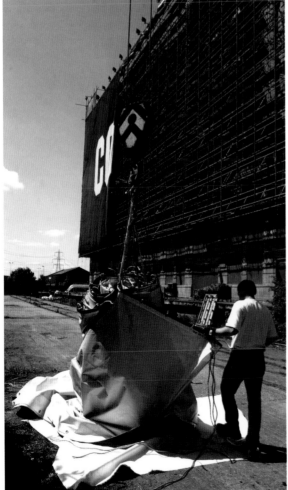

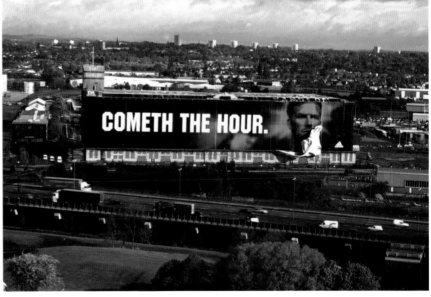

Timed to coincide with the build-up to the 2002 World Cup, a vast advertisement for sportswear company Adidas was positioned alongside the M6 motorway in the UK city of Birmingham. Featuring the head of England captain David Beckham, and the simple slogan 'Cometh the Hour', the billboard measured 132 metres by 23.75 metres. Beckham's head alone measured 20 metres from ear to ear and another 20 metres from forehead to chin. Although the strapline was not chosen to reflect the specific requirements of the site – the billboard was part of a larger campaign – a poster covering almost an acre may seem excessive when the message to be delivered is just three words. Although it could be seen from a mile away, allowing for the speed of traffic along the motorway, it would have been in view for not much more than 45 seconds. And given that the driver's attention is occasionally required elsewhere, a three-word message seems about right.

1. FALCON 900 B PRIVATE JET
MARC NEWSON AND
RICHARD ALLEN
CUSTOMISED FOR A PRIVATE
CLIENT, THIS JET WAS GIVEN A
BESPOKE LIVERY TO COMPLEMENT
A COMPLETE INTERIOR REFIT.
THE SILVER SPOTS, WHICH GET
PROGRESSIVELY SMALLER ON
THE WAY FROM THE COCKPIT DOWN
THE WHITE FUSELAGE, AND AWAY
FROM THE AIR-INTAKE ON THE
ENGINES, ARE SUGGESTIVE OF
HIGH SPEED MOVEMENT.

2, 3, 4. BIRMINGHAM FLIGHT
SEQUENCE; BIRMINGHAM,
ALABAMA, USA
LORENC + YOO DESIGN
COMMISSIONED BY THE CITY OF
BIRMINGHAM, ALABAMA, THE
BIRMINGHAM FLIGHT SEQUENCE
WAS DESIGNED TO IMPROVE THE
APPROACH ROAD TO BIRMINGHAM
AIRPORT. THE HALF-MILE SEQUENCE
OF SCULPTURAL FORMS IS AN
INSTALLATION DESIGNED TO
REFLECT BOTH THE MOVEMENT OF
AIRPLANES AND THE FACT THAT IT
IS SEEN AT SPEED FROM A PASSING
CAR. THE FORMS ARE SIMPLE 'V'S,
LIKE PAPER AIRPLANES, WITH
NO DETAIL DEMANDING CLOSER
SCRUTINY, SAVE SHADOWS CAST
BY THE PASSING SUN IN THE DAY,
AND BLUE LIGHTING ON THE
UNDERSIDES BY NIGHT. THE FACT
THAT THEY ARE SPACED ALONG
THE ROAD MEANS THAT PASSING
MOTORISTS CAN BEGIN TO 'READ'
THEM IN THE CONTEXT OF THE
LANDSCAPE IN THE SAME WAY AS
OTHER REGULAR FEATURES SUCH AS
ROAD MARKINGS AND LAMP-POSTS.

APPLICATION
PRINT
FABRICATION
LIGHT
TECHNOLOGY

INTRODUCTION

Many variables determine the choice of application techniques for environmental graphics: most obviously, they will be two- or three-dimensional. Considerations such as the need for durability, weather resistance and adaptability also apply. Cost and convenience, too, are significant factors. On the following pages are examples of environmental graphics that have been applied through an enormous variety of techniques and technologies, from robotics and electronic display through constructions in metal and stone to printing on substrates ranging from vinyls to fabrics. In the normal course of graphic design practice, there are always choices to be made about how a piece of work will be taken off the screen and given tangible physical form: printers with specific capabilities must be sourced and briefed, papers – and occasionally other substrates – selected. But with environmental graphics, the scope is often much wider, and an awareness of all possibilities is critically

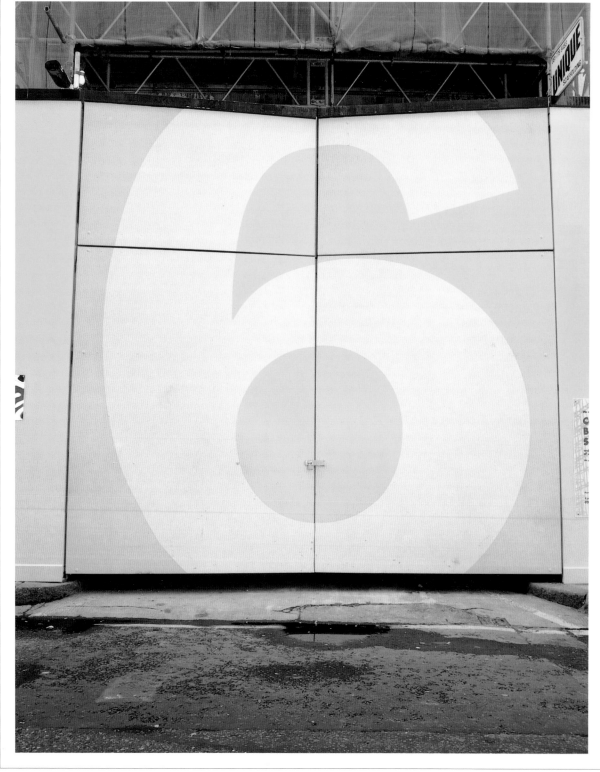

1, 2. 6 GREENCOAT PLACE CONSTRUCTION BARRIERS; LONDON, UK
STUDIO MYERSCOUGH
THE 4 5 METRE HIGH FIGURES IN GREEN COATS ON THESE CONSTRUCTION BARRIERS DESIGNED BY STUDIO MYERSCOUGH WERE A PLAY ON THE NAME OF THE STREET IN WHICH THEY WERE PLACED – GREENCOAT PLACE THEY WERE APPLIED AS SELF-ADHESIVE PRINTED VINYLS ON TIMBER PANELS

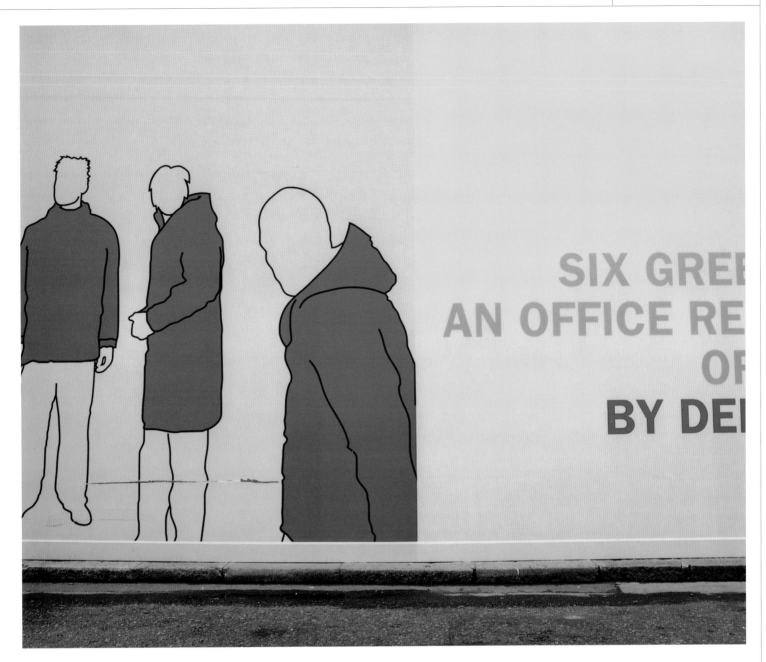

important for success. It is worth remembering, however, that regardless of technology, outcomes are only ever as good as the idea, and the simplest technologies, harnessed to a good idea, can be powerfully effective. When the city of Sortland in Norway's Vesterålen region was accused by travel guides Lonely Planet and the Rough Guide of having little to appeal to the visitor, local artist Bjørn Elvenes came up with a solution. Since 1998, the entire inner city – from fishermen's cottages to warehouses and public buildings – has turned various carefully selected shades of blue, symbolising the city's maritime heritage. Now known as The Blue City, Sortland has been placed firmly on the tourist trail with the aid of 50,000 litres of paint.

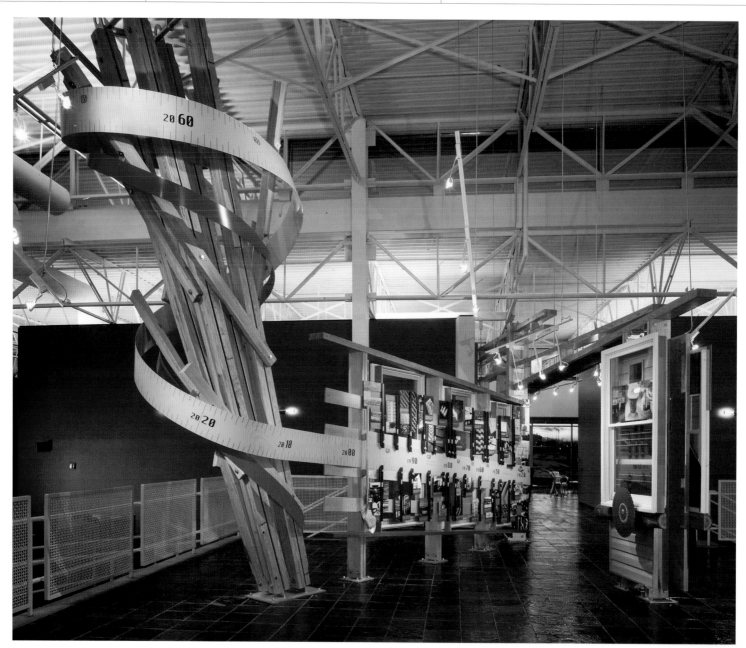

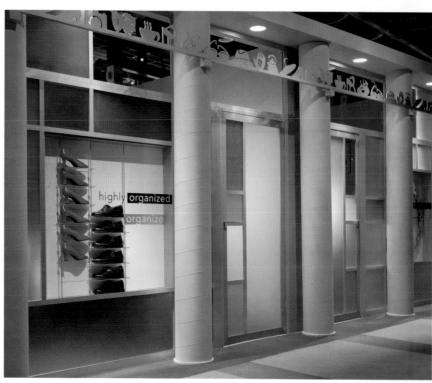

PRINT

Most two-dimensional environmental graphics, from vehicle liveries to banners the size of office buildings, are printed and often installed by specialist large-format printers such as Scanachrome, which has offices across Europe, or Supergraphics in the United States. These firms and others like them can print large format images onto almost any flexible material. Very large graphics require a number of individually printed sheets to be stitched together, but most specialist printers can produce sheets sufficiently large for most applications. Scanachrome, for example, can print seamless posters up to 5 metres by 25 metres.

Most large graphics are printed onto vinyls, which can adhere to other substrates such as concrete, glass and steel, and also come in a mesh for applications where the ability to see through the graphic is important. Printing technology manufacturers such as 3M produce a vast range of vinyls for every circumstance – indoor and outdoor use, for example – and inks that are specially formulated to be water- and UV-resistant, providing protection from fading by the sun in outdoor applications.

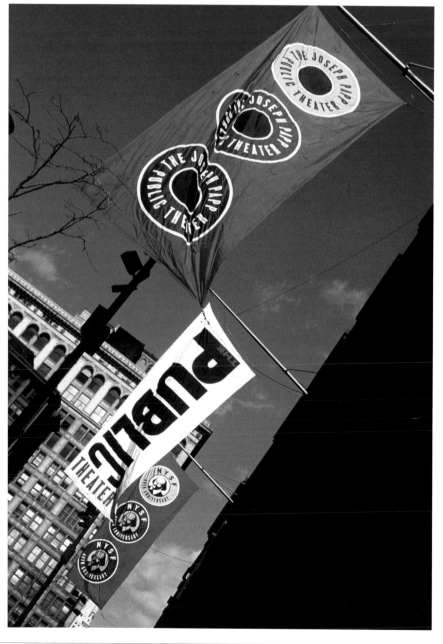

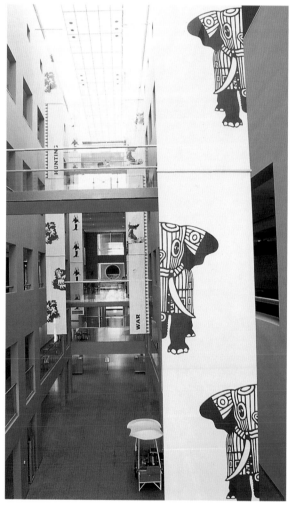

1. NEW YORK PUBLIC THEATER BANNERS; NEW YORK, USA
PENTAGRAM
THE NEW YORK PUBLIC THEATER BANNERS WERE PART OF A GENERAL CAMPAIGN TO CAPTURE THE ATTENTION OF THE NEW YORK PUBLIC AND CONVINCE THEM THAT THE PUBLIC THEATER WAS FOR THEM, NOT JUST A CULTURAL ELITE. TYPOGRAPHY WAS BASED

Since the development of computer-generated vinyl technologies in the early 90s, the opportunity has arisen to create graphic wraps for all types of vehicles far more cheaply and easily than the painting techniques previously required. Using colour-printed vinyls, the entire shell of a vehicle, including windows, can be covered in graphics. Like large-format banners, vehicle wraps can be printed directly from CMYK Illustrator or Photoshop files, and can be ready for installation days after designs are completed. Because of this, there has been explosive growth in the number of vehicles being wrapped, especially in the United States. Here, in addition to corporate liveries being applied to fleets of company vehicles, all-encompassing ads are regularly wrapped around public buses and trains, as well as private vehicles, on a temporary or semi-permanent basis.

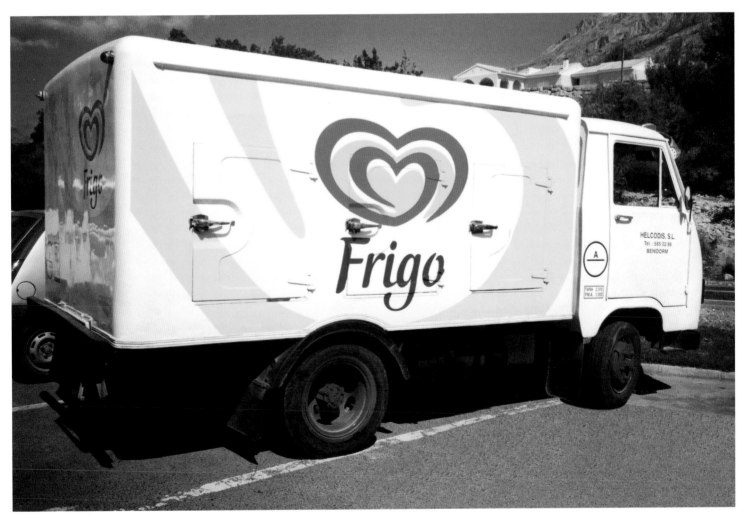

ON TRADITIONAL NINETEENTH CENTURY POSTERS AND UPDATED TO AVOID NOSTALGIC OVERTONES (THE PUBLIC THEATER PRESENTS CONTEMPORARY WORKS). SOME WORDS WERE BLOWN UP TO CONVEY KEY MESSAGES – THE TIME, PLACE AND TICKET PRICE. THE BANNERS AND POSTERS WERE USED TO CAPITALISE ON THE FACT THAT UNLIKE OTHER LARGE AMERICAN

CITIES, NEW YORK IS STILL A 'WALKING TOWN', WHERE PEDESTRIANS ARE ABLE TO READ INFORMATION PRESENTED TO THEM AT STREET LEVEL.

2. ROYAL ARMOURIES BANNERS; LEEDS, UK
MINALE TATTERSFIELD
THE IDENTITY FOR THE ROYAL ARMOURIES MUSEUM, DESIGNED

BY MINALE TATTERSFIELD DESIGN STRATEGY, WAS BASED ON THE REMAINS OF A SUIT OF ARMOUR BELONGING TO HENRY VIII. THE HORNED HELMET APPEARS IN THREE DIMENSIONS, ON A PLINTH AT THE ENTRANCE OF THE MUSEUM, AND IN TWO, ON BANNERS. IN THE ABSENCE OF FORMAL DIRECTIONAL SIGNAGE, THE BANNERS ARE USED FOR WAYFINDING. THE BUILDING

HAS AN INTERNAL 'STREET', SPANNED BY WALKWAYS, WITH GALLERIES ON SEVERAL LEVELS ON EITHER SIDE. THE BANNERS HANG THE FULL HEIGHT OF THE STREET, INDICATING THE LOCATION OF DIFFERENT GALLERIES

3. UNILEVER ICE CREAM IDENTITY; WORLDWIDE
CARTER WONG TOMLIN

Anticipating applications

Textiles are also used as a substrate for printed graphics, as in the case of the Royal Armouries and New York Public Theater banners. Other substrates can be printed onto directly too, including wood, metals, glass and ceramics. Sometimes, of course, the designer cannot foretell what substrates a design may be printed on at some point in the future. This is particularly true in the case of identity programmes, where much of the application work is done according to guidelines laid down by the designer, but after the job has left the studio for the last time. One such identity programme was carried out by design consultancy Carter Wong Tomlin for Unilever. The multi-national corporation had an ice-cream product known by a myriad of different identities in counties around the world, and having to manage each one separately was becoming problematic. So Unilever briefed the designers to create a single mark and identity guidelines for the product known variously as Wall's in the UK, Algida in Italy, Frigo in Spain and by over 20 other names and logos throughout the rest of the world. As in most large scale identity projects, the designers produced an identity manual, showing how what they termed the 'happiness mark' should be applied to ensure consistency across all applications. But unusually, they also created a printing swatch book, to describe how the mark could be applied to as many likely substrates as possible, from brown cardboard and matt plastic to metals and even fabric, through embroidery. The book also provides information

1, 2, 3. UNILEVER ICE CREAM
IDENTITY; WORLDWIDE
CARTER WONG TOMLIN

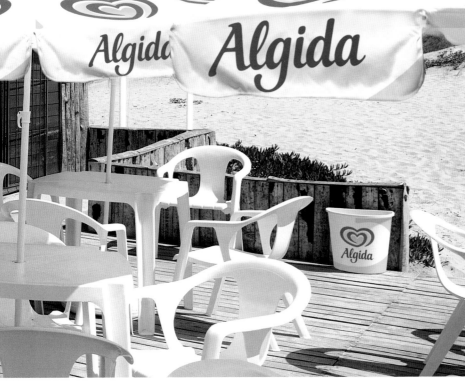

on the best material weights, ink and dye mixes, screening processes, Pantone and other colour references, and technical specifications, among much else. The brand managers can therefore take the samples to printers in their local markets and show what is required, without any further input from the designers. The mark has since been successfully used in environmental applications, as well as packaging, around the world, on substrates ranging from the steel of a Greek ferry hull to the cotton of an Italian parasol.

Low-tech application

The advantages of printing technologies that can create vinyls for the sides of sea-going vessels as well as a backlit sign for an exhibition stand are obvious. Furthermore, many large format printers offer a service whereby a graphic the size of a building can be reproduced from a single digital file, printed and stitched off-site, meaning that the only on-site work required is installation. However, covering large areas in printed graphics can be expensive, and paint can sometimes be a cheaper alternative, with its own unique qualities. Sign-painting used to be the most common way of making any large scale graphic, from a shop-front to a billboard. In Western countries its use in the kind of applications described in this book has fallen into decline to some extent, though it is still used widely in the theatre and at theme parks, for example, and hand-painted signs and advertisements are commonplace in countries such as Sri Lanka and India. Traditional sign-painting skills were used, however, by design company Imagination when it created the Guinness Storehouse brand experience centre in Dublin. Here, hand-painted lettering was applied directly to the interior walls of the former brewery, contributing to the atmosphere in a way that vinyls would not.

The choice of how to apply graphics to the environment, even through such 'straightforward' and established means as printing or painting, can be complicated by a number of factors, including the capabilities

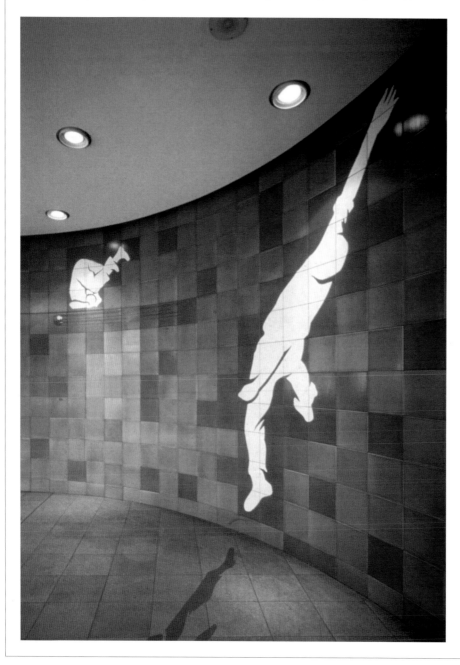

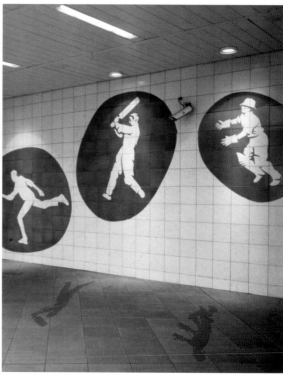

of printers or sign-painters in the local area, regardless of what might theoretically be possible with the most up-to-date technologies, or what has historically been achieved by specialist craftsmen. The exhibition 'Towards 2000', organised by the Indo-British Partnership, was staged to celebrate a history of connection and collaboration between Britain and India. The circumstances of its design and construction reflect this: designed by London-based Fitch, the 125,000 square feet exhibition was held in New Delhi and constructed by over 1,000 Indian contractors in just two weeks. Simple paint was deemed the most appropriate way to extend the exhibition's blue and orange colour scheme over such a large area, and white vinyls formed the bulk of the typography applied to walls throughout the show. But in the creation of some of the other large graphic elements, the designers experienced some problems stemming from differences in working practices and the use of technology between the two countries. Certain portable storage systems used by the designers for digital files were not compatible with the equipment used by the printers in India, so a common currency had to be found in the form of films and bromides. Likewise, a plan for a large wall of coloured panels outside the exhibition had to be tweaked to cope with circumstance. The designers had originally intended the wall to be made of cloth, but found that there was no printer capable of printing cloth on that scale available locally, so metal panels were substituted.

1, 2. OVAL TUBE ENVIRONMENTAL DESIGN; LONDON, UK
MINALE TATTERSFIELD
PRINTED ONTO TILE, ILLUSTRATED FIGURES OF CRICKETERS IN ACTION, AS WHITE SILHOUETTES ON BRIGHT GREEN OVALS, ARE LOCATED AROUND THE TICKET HALL OF OVAL TUBE STATION IN LONDON. THE AREA IS HOME TO THE FAMOUS OVAL CRICKET GROUND.

3. AMBUJA CEMENT ADVERTISING; GALLE, SRI LANKA
THE WORK OF TRADITIONAL SIGN PAINTERS IS STILL WIDESPREAD THROUGHOUT MANY PARTS OF THE WORLD.

4, 5. TOWARDS 2000; NEW DELHI, INDIA
FITCH
ORGANISED BY THE INDO-BRITISH PARTNERSHIP, THE EXHIBITION CELEBRATED THE HISTORY OF CONNECTION AND COLLABORATION BETWEEN BRITAIN AND INDIA. THE ORIGINAL DESIGNS EVOLVED TO ACCOMMODATE THE AVAILABILITY OF MATERIALS IN INDIA.

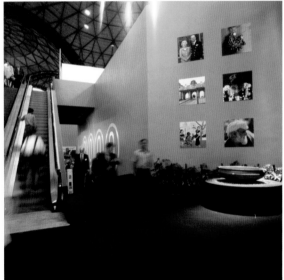

GUINNESS STOREHOUSE;
DUBLIN, IRELAND
IMAGINATION

**1, 2, 3. NEW JERSEY
PERFORMING ARTS CENTER;
NEW JERSEY, USA
PENTAGRAM**
IN KEEPING WITH ITS COMMITMENT
TO HIGH-QUALITY ARCHITECTURE
AND DESIGN, THE NEW JERSEY
PERFORMING ARTS CENTER
(NJPAC) WANTED TO GIVE ITS
LUCENT TECHNOLOGIES CENTER
FOR ARTS EDUCATION – HOUSED
IN A MOCK-GOTHIC BUILDING
– A CONTEMPORARY FACE-LIFT.
PENTAGRAM'S SOLUTION, WHICH
USES TRADITIONAL SIGN-PAINTING
TECHNIQUES, IS BOTH STRIKING
AND COMPARATIVELY ECONOMICAL.

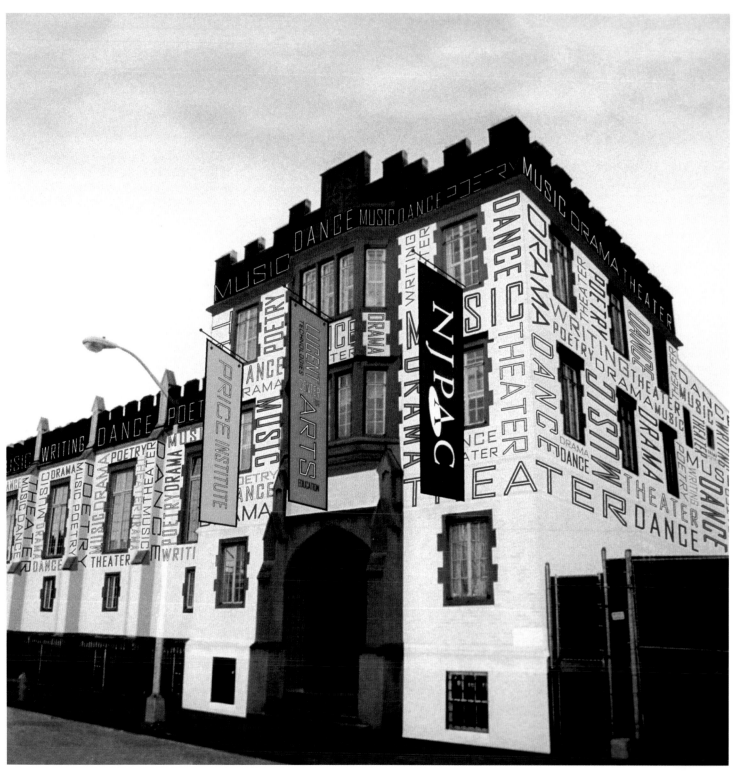

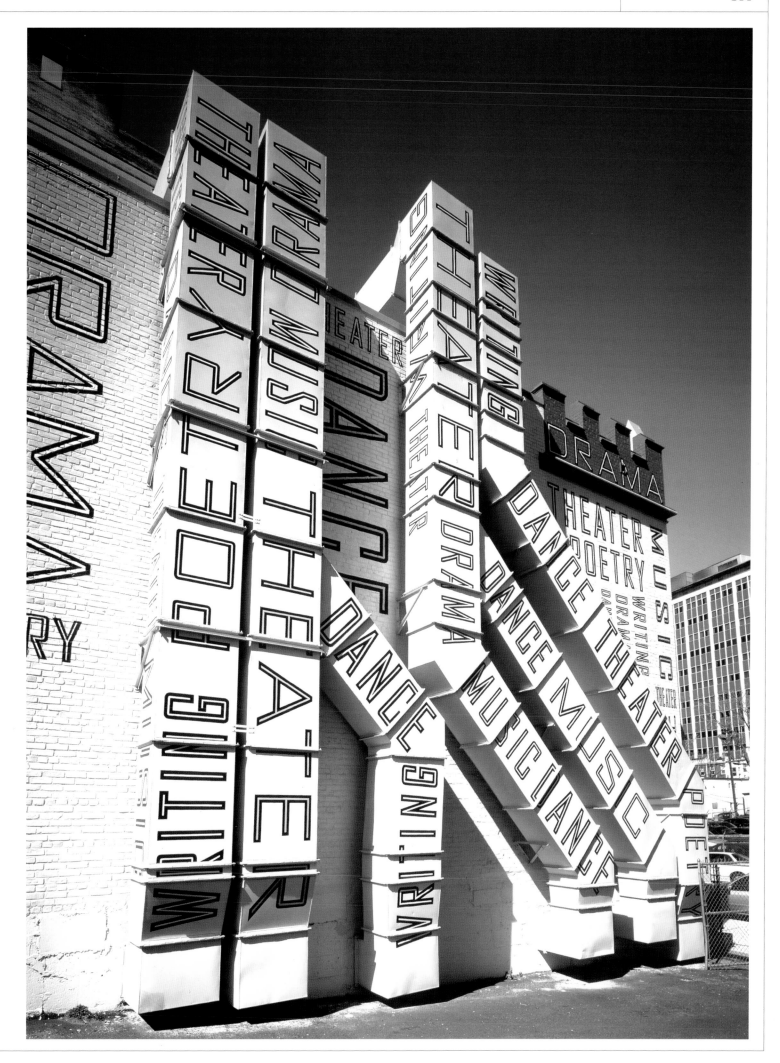

FABRICATION

As described earlier (in Design/Context: Dimensionality), the move from printed flat graphics into three-dimensional signs, exhibits, installations and so on will usually require collaboration with a set of specialists with whom many graphic designers do not normally come into contact: structural, mechanical and electrical engineers, for example. It will also require collaboration with a fabricator or maker, who will actually create the physical object to be displayed. Some sign-makers offer a full service ranging from vinyls for vehicle liveries to sandblasting designs into stone. Others specialise in specific areas of fabrication, from steelwork to lighting. The New York-based design and fabrication company, the Artkraft Strauss Sign Corporation, for example, offers a range of services but is best known for its mechanical, illuminated and now electronic Times Square spectaculars, which the company has been producing since 1897. When one considers some recent examples – a Coca-Cola sign requiring a mile of neon tubes, 60 miles of optical fibres, and 13,000 incandescent bulbs, or the half-size replica of Concorde suspended over 42nd Street – it is easy to see why a high degree of specialised knowledge is required.

There are common materials, aluminium and high-density polyurethane foam, for example, and common methods for shaping them – such as sandblasting, carving and routing – offered by many signmakers. But beyond these, there is, of course, an almost infinite number of ways to make environmental graphics three-dimensional, and searching out the right materials and makers is one of the key elements of the design process. The Rose Center for Earth and Space, the American Museum of Natural History's spectacular planetarium and space exhibit, is just such an example. Designed by Ralph Appelbaum Associates, the immersive exhibition environment covers around 23,000 square feet and explores the wonders of space through a variety of 'old' and 'new' media.

The project required a wide range of collaborative partnerships with other companies, including structural and mechanical engineers, consultants in acoustics, lighting and glass and a raft of specialist fabricators. The mosaic, shown above left, depicting elements of the cosmos, covers the floor on which many of the exhibits stand and is composed of hand-crafted glass tiles.

In historical terms, of course, the use of heavy materials such as stone is not new to graphic designers; the profession grew out of such forerunners as stone carving, from which many typographic conventions survive to this day. Indeed, the typographer Eric Gill (designer of the Gill typeface) also worked in stone, creating sculptures of Arial and Prospero for the facades of the BBC's central London Broadcasting House. The environmental design company Lorenc + Yoo Design combines design work in two and three dimensions with an interest in sculpture, as evidenced by its Prairie Stone landmark.

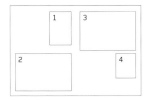

1. ROSE CENTER FOR EARTH AND SPACE; NEW YORK, USA
RALPH APPELBAUM ASSOCIATES

2, 3, 4. DETAILS OF IRON GATES AND STONE STATUE; SZOBOR PARK, BUDAPEST, HUNGARY
THESE HISTORICAL EXAMPLES OF TYPE FABRICATED IN MATERIALS SUCH AS METAL AND STONE SHOW THE LONG-LASTING TACTILE APPEAL OF SUCH WORK

Practical considerations

While designers will inevitably have to rely on the specialist knowledge of fabricators in order to finalise drawings and actually construct and install large scale graphics, it is also useful for designers themselves to know something about how things are made at the start of the process. Casting identical multiples of a sign or object, for example, can be much cheaper than individually hand-making each one. If removing minor variations between objects can be done without compromising the whole scheme, an otherwise prohibitively costly design can become affordable. Alternatively, using a 'component kit' to create a number of different objects from the same components can not only be economic, but might also facilitate variety. At the Washington State Exhibition Center, WPa Inc. was commissioned to design environmental graphics that would 'reflect and augment the excitement of events at the stadium, Exhibition Center and neighbouring new ballpark by providing sculptural graphic elements that address the huge flow of event attendees on Occidental Avenue.' The designers created three media kiosks, two of which are free-standing in the street while a third, the 'media tower', is attached to the building. These use LED readerboards to broadcast events to the street. By using the component-kit approach to the construction of the kiosks, the designers were able to 'tune' each kiosk to its exact location.

1. PRAIRIE STONE
LANDMARK; USA
LORENC + YOO DESIGN

2, 3, 4;. WASHINGTON STATE
EXHIBITION CENTER BANNERS
AND MEDIA KIOSKS; SEATTLE,
WASHINGTON, USA
WPA INC.

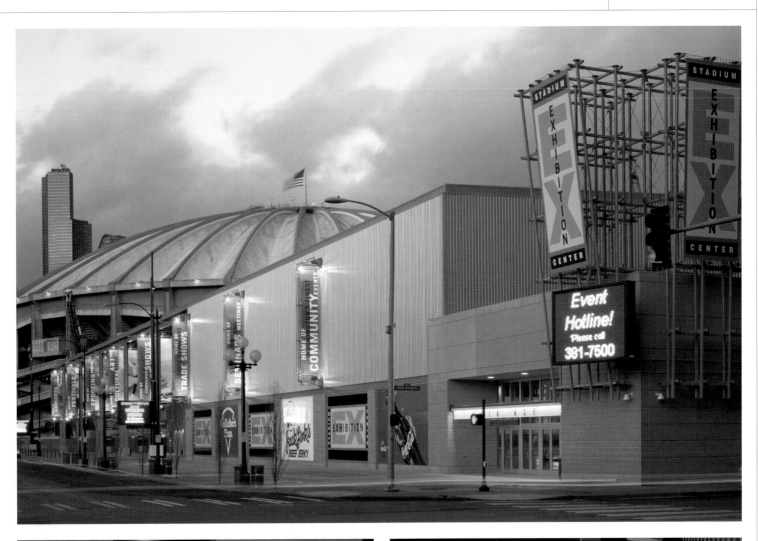

1. ADOBE HEADQUARTERS LOBBY;
SAN JOSE, CALIFORNIA, USA
MAUK DESIGN
REGULAR USERS OF ADOBE'S
SOFTWARE PRODUCTS SUCH AS
ILLUSTRATOR AND PHOTOSHOP ARE
INTIMATELY FAMILIAR WITH THEIR
ON-SCREEN INTERFACES. WHEN
MAUK DESIGN WAS COMMISSIONED
TO BRING THE ADOBE BRAND
TO LIFE IN THE LOBBY OF THE
COMPANY'S HEADQUARTERS IN
SAN JOSE, CALIFORNIA, IT WAS
TO THIS HIGHLY RECOGNISABLE
VISUAL PROPERTY, RATHER THAN
THE CORPORATE LOGO, THAT
THE DESIGNERS TURNED FOR A
CENTREPIECE DISPLAY. THE 20
FEET BY 25 FEET GLASS PANEL,
SUSPENDED ABOVE THE BUILDING'S
ENTRANCE, IS DRAWN DIRECTLY
FROM THE ILLUSTRATOR COLOUR
PALETTE, COMPLETE WITH GREY BOX
SURROUND. DURING THE DAY, THE
SUNLIGHT FILTERING THROUGH THE
PANEL CREATES COLOUR WASHES
ACROSS THE LOBBY, WHILE AT NIGHT,
THE BUILDING IS LIT FROM THE
INSIDE, AND THE PANEL ACTS AS A
COLOUR FILTER FOR THE BENEFIT OF
THOSE APPROACHING THE BUILDING
FROM OUTSIDE. THE LOBBY ALSO
CONTAINS A NUMBER OF STILL AND
MOVING IMAGE DISPLAYS ON LIGHT
BOXES AND PLASMA SCREENS.

2, 3. SAN FRANCISCO FOOD
BANK DONOR WALL;
SAN FRANCISCO, USA
SKIDMORE, OWINGS & MERRILL

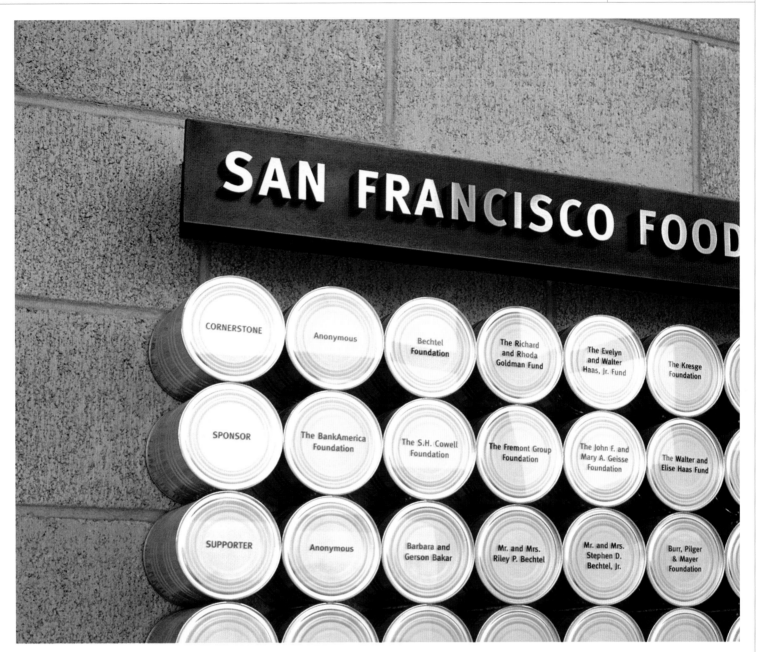

The use of substrates other than paper and plastic does not necessarily require heavy engineering, however. The Donor Wall at the San Francisco Food Bank was created by the graphic design department of the San Francisco office of Skidmore, Owings & Merrill, one of the world's largest architecture firms. With a number of Chicago skyscrapers to its name, SOM is well known for its design work on a staggering scale. The Donor Wall, however, relies on a simple but ingenious graphic idea, requiring comparatively straightforward fabrication. The names of donors are printed onto the tops of tin cans which are laid in a grid, while the amount donated is expressed with clear acrylic circles.

LIGHT

As one might expect, most large scale graphics require the use of materials and construction techniques more common to architecture than graphic design – steel scaffolds, timber panels, concrete plinths – which must be held in place with tension cables and steel bolts, resistant to the loads imposed by human activity, wind and their own dead weight. And yet it is possible to create large scale graphics from a material even less physically substantial than paper and ink: light.

As discussed earlier, we live in what might be called a graphic landscape; any photograph of the world's major cities taken at night, even from space, will show that we also live in a landscape characterised in large measure by light. Where once nightfall marked the end of almost any activity requiring good visibility, today, many parts of our cities are scarcely darker during the night than the day. In recent years, the lightening of our cities has increased ever faster, as changing lifestyles call for 24-hour shop opening, meaning that a billboard that is not illuminated at night misses half of its potential audience over a 24-hour period. Further, companies are giving increasing thought to aspects of corporate identity beyond the logo, which has led many to start thinking about their offices in the same terms as their printed materials. Just as they want consistency and high visibility across all of their brochures, they want the same for their buildings and facilities, hence the dramatic rise in the number of so-called 'night-time identity' lighting schemes for office buildings unoccupied after the end of the working day.

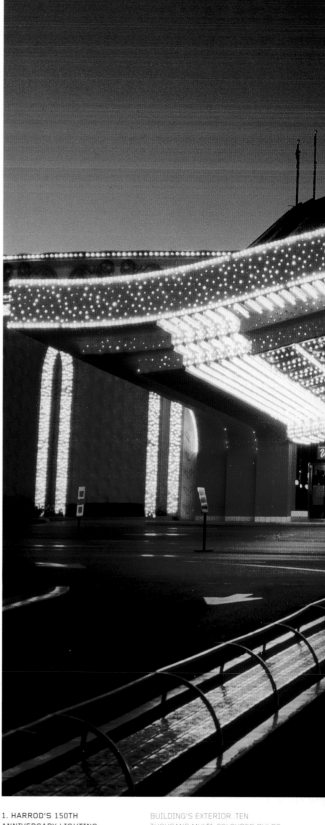

1. HARROD'S 150TH
ANNIVERSARY LIGHTING;
LONDON, UK
THE PARTNERS
IN ORDER TO MARK THE 150TH
ANNIVERSARY OF LONDON'S MOST
FAMOUS DEPARTMENT STORE,
HARROD'S, GRAPHIC DESIGN
CONSULTANCY THE PARTNERS
CONCEIVED A SPECTACULAR
LIGHTING SCHEME FOR THE

BUILDING'S EXTERIOR. TEN
THOUSAND MULTI-COLOURED BULBS
WERE USED TO ANNOUNCE
'COLOURFUL HARROD'S'

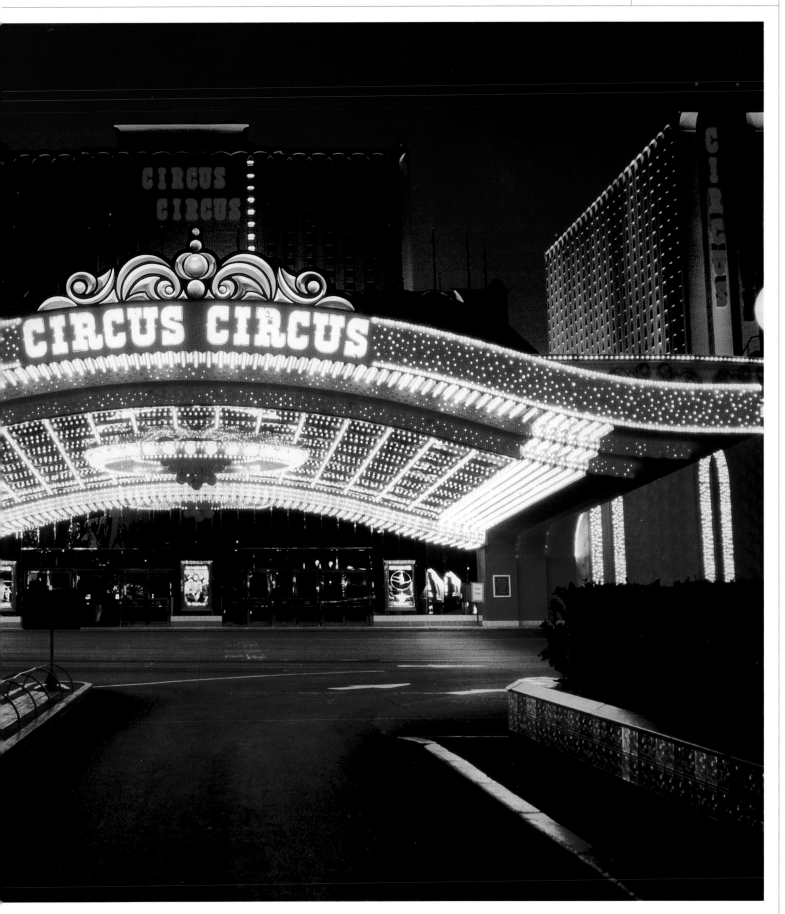

2. CIRCUS CIRCUS; LAS VEGAS, NEVADA, USA

EVERYTHING ABOUT LAS VEGAS IS ON AN EPIC SCALE, FROM THE BUFFET LUNCHES IN THE CASINO RESTAURANTS TO THE SUMS WON AND LOST ON THEIR GAMING TABLES. THE CIRCUS CIRCUS HOTEL, CASINO AND ADVENTUREDOME IS NO EXCEPTION: COMPRISED OF A NUMBER OF INTERLINKED BUILDINGS, INCLUDING THE 29-STOREY SKYRISE TOWER AND THE 35-STOREY, 1,000-ROOM WEST TOWER, THE COMPLEX ALSO BOASTS TWO CASINOS, THE OBLIGATORY WEDDING CHAPEL AND THE CIRCUS MIDWAY, COVERING AN AREA OF 120,000 SQUARE FEET AND FEATURED IN THE GUINNESS BOOK OF WORLD RECORDS AS THE WORLD'S LARGEST PERMANENT CIRCUS. THIS BEING LIGHT-LOVING LAS VEGAS, ONLY AN APPROPRIATELY-SCALED, ILLUMINATED SPECTACULAR WOULD DO AS FRONTAGE FOR SUCH EXCESS.

In most cities there are restrictions on what you can light at what times, just as there are limits to how tall you can build, or where you can place a banner. This is just one of many considerations that means graphic designers often choose to collaborate with specialist lighting designers, or sign-makers with electrical and lighting design experience, for work on light-based projects.

While most lighting displays are designed to work by night, those made of neon work by night and day. The gas itself glows with a red light, and the addition of other gases to the tubes now allows for more than 150 other possible colours, from green and blue to pastels, white and gold. In 1923, a Packard dealership in Los Angeles paid $24,000 dollars to the French company Claude Neon for the first two neon signs in the United States. Since then, the gas lamps have come to define the popular image of the American city, from the modernity of Los Angeles to the seedy glamour of Times Square, New York, and the luminous splendours of Las Vegas, the spiritual home of the neon sign. Conservation movements and museums have sprung up in both Los Angeles and Las Vegas, dedicated to celebrating the most distinctive visual elements of those cities. Other cities, too, have come to be characterised by a superabundance of 'liquid fire' – think of Tokyo, Shanghai and Hong Kong.

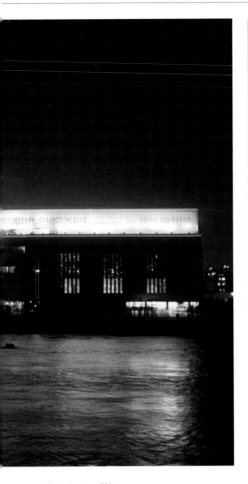

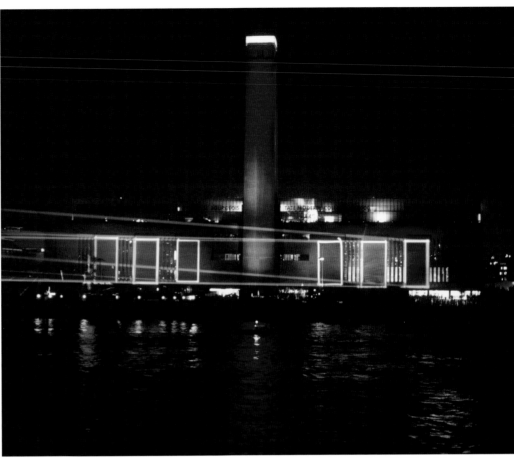

Light quality

Most lighting for architectural illuminations, signs, or retail interiors, however, is made not from neon but from a range of lamp types, each with their own qualities. The choice of lamp (Fluorescent, Incandescent lamp, Tungsten Halogen, High Intensity Discharge, Metal-Halide, High-Pressure Sodium, and so on) is determined by a number of factors. The first is practical; the different types vary in cost to buy and run, and have different average life-spans. If they are to be located somewhere inaccessible, a longer life span will be desirable. The second consideration is aesthetic. The quality of light is often referred to as 'warm' or 'cool'; this is a reference to the atmosphere created by the light, rather than the actual temperature of the lamp. Warm light is yellow, while cool light is whiter; environments such as shops and bars are usually lit with warm light as it is more flattering to people's appearances. Architectural details, on the other hand, can look more striking when lit with cool, white light. Lamps are given a colour temperature rating, measured in Kelvin (K). Paradoxically, the higher the temperature, the cooler the light: so a fluorescent map with a colour temperature of 4,100K would have a whiter, 'cooler' light than one with a colour temperature of 3,000K.

1, 2. TATE MODERN LAUNCH;
LONDON, UK
IMAGINATION

Son et Lumière

In addition to permanent installations such as architectural lighting or signage schemes, light is often used for temporary displays because of its ability to cover large areas without the need for extensive, expensive fabrication, and to leave no lasting marks left on the site. Tate Modern, a British gallery housing the Tate's collection of modern art, opened in 2000 after a five-year refit of the former Bankside Power Station by Swiss architects Herzog & de Meuron. It was to the architecture of the building that design company Imagination turned when it was commissioned to design a 'simple but surprising' light show to officially launch the new gallery. There would be two audiences for the display: invited guests in front of the Thames-side gallery itself, and spectators and TV cameras on the opposite bank of the river.

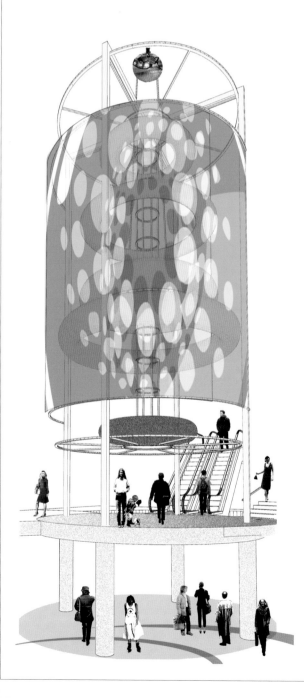

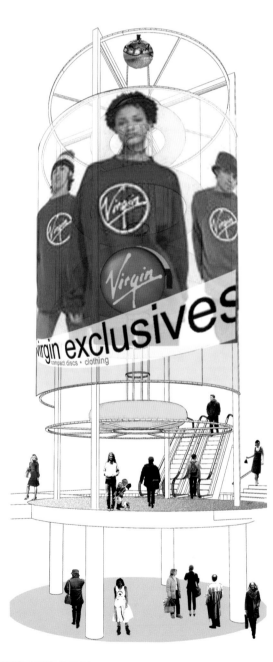

1, 2. BELFAST ODYSSEY; BELFAST, NORTHERN IRELAND
RODNEY FITCH
THE BELFAST ODYSSEY IS THE LARGEST URBAN DEVELOPMENT IN IRELAND AND INCLUDES A CINEMA COMPLEX, IMAX CINEMA, SCIENCE MUSEUM, RESTAURANTS, BARS, RETAIL AND A 10,000 SEATER INDOOR STADIUM FOR CONCERTS AND SPORTING EVENTS. EMPLOYED AS 'ENTERTAINMENT IMAGINEERS' FOR THE COMPLEX, DESIGN CONSULTANCY RODNEY FITCH FOCUSED ON THE PUBLIC SPACES WITHIN THE COMPLEX, AIMING TO MAKE THEM DYNAMIC THROUGH LIGHTING, SPECIAL EFFECTS AND MULTIMEDIA SO THAT WHOLE ENVIRONMENTS BECOME ANIMATED, RATHER THAN STATIC.

3. PUMA SHOP LAUNCH; LONDON, UK
INTERFIELD DESIGN
PROJECTIONS WERE CHOSEN AS A MEDIUM FOR ENVIRONMENTAL GRAPHICS AT THE LAUNCH OF PUMA'S FLAGSHIP LONDON STORE IN CARNABY STREET. ONE FACTOR IN THE DECISION WAS THAT THE STORE ITSELF IS SO HEAVILY BRANDED THAT THERE WAS LITTLE WALL SPACE FOR THE APPLICATION OF TEMPORARY GRAPHICS.

4, 5. STARBUCKS CENTER; SEATTLE, WASHINGTON, USA
WPA INC.

Throughout the launch party, lasers, fired from the opposite bank of the river, picked out details of the building's architecture. The end of the launch party was covered live by the BBC. To coincide with this, a lighting sequence began, involving lasers and coloured light washes from 50 arc wash luminaires, moving along the whole of the building's 200 metre (650 feet) length and to the top of the 99 metre (325 feet) chimney. The official 'launch' of the building was then signalled by the illumination of a light box on top of the chimney. The pre-programmed sequence, which had an audio accompaniment, lasted four minutes, and was repeated on a loop.

The designers had to allow for two angles of view in their scheme. The people at the foot of the building were better able to see the subtleties of the ripple effects in the colour washes, for example, while the whole picture was clearer to the TV cameras and spectators gathered on the opposite bank of the Thames.

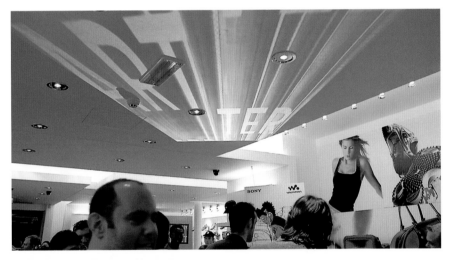

1, 2–9, & OVERLEAF.
HOLLYWOOD SHADOW PROJECT;
HOLLYWOOD, CALIFORNIA, USA
BY ARTIST CAMERON MCNALL.

Light and shade

During the daytime there is no need for artificial lighting outside. But that does not mean that light cannot be used as a medium for large scale graphics. WPa, Inc. designed the environmental graphics for the Starbucks Coffee Company's corporate headquarters. One of five main elements of the project, named 'movement' by the designers, was the task of leading staff to the employee entrance. The designers created a 148 feet pergola, into the top of which lines of text were cut. The effect of the sun shining through these cuts is to create an animated display of shadows on the underside of the timbers that bridge the walkway.

Further down the coast, in sunny California, the low white blocks of Hollywood's remaining production facilities formed the perfect backdrop for an innovative 'installation' by architect Cameron McNall. Seven steel-framed aluminium structures, designed to act as silhouettes, were erected on buildings around Hollywood. Each featured a distinctive image from a famous Hollywood movie such as 'Easy Rider' and 'The Birds'. At the end of each day, the sun moved behind each of the structures, creating shadow impressions of their images on the walls of buildings opposite, all of which are in some way connected to the film industry. And as the sun moved, the images shifted slightly, giving them an animated quality reminiscent of the films from which they were drawn. The project was an attempt to explore the subject of memory, and its connection with cultural products such as movies. In using light and shadow, the same materials from which movies are made, the designer found a medium that is visible, and yet at the same time as insubstantial as memory.

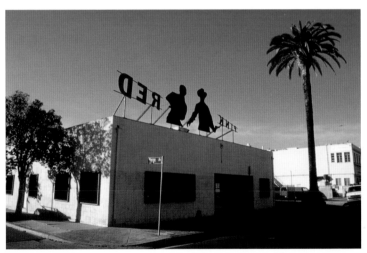

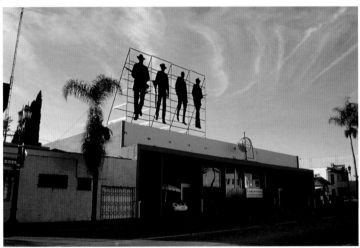

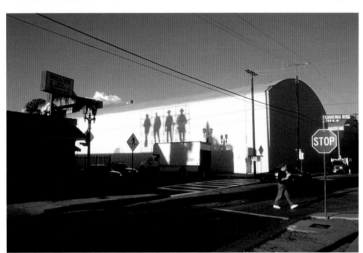

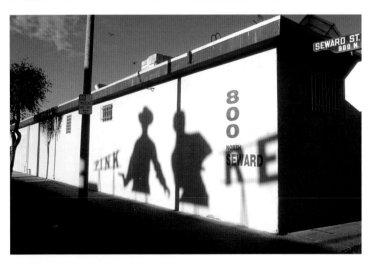

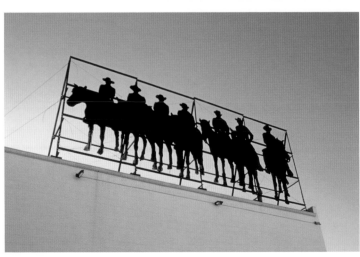

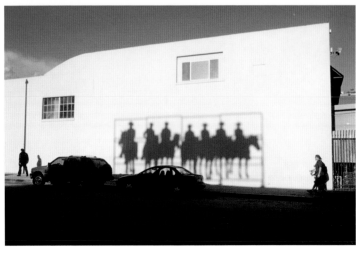

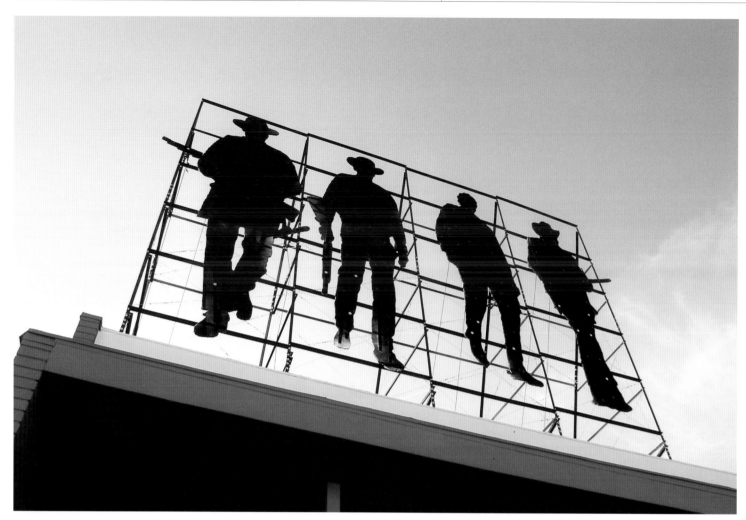

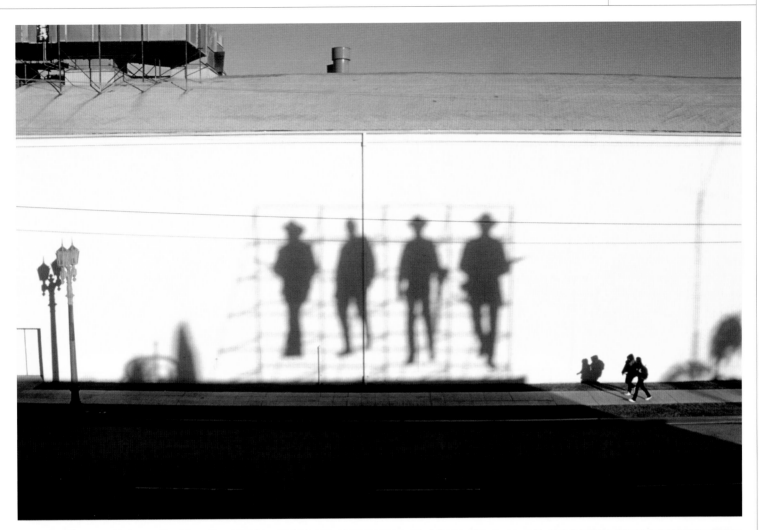

TECHNOLOGY

One of the advantages of graphic design over conventional architecture (in the context of communications) is its ability to respond quickly to required changes. If a specific event must be promoted, for example, a digital file can be delivered to a large format printer, a mesh banner the size of a building stitched together within a couple of days, and installation will be complete within a couple more. With new technologies, this response time can be narrowed further – to a matter of hours, minutes or even seconds – as long as it takes for the required message to be typed in.

To promote its three-a-side football tournament in London, Nike commissioned Hive Associates to create the world's first LED (light-emitting diode) advertising panel to be fitted to the side of a public transport vehicle, a London double-decker bus. Twenty-five buses on two key routes were fitted with the screens, which used LEDs bright enough to be seen both at night and in the daytime. The panels and reinforced display cases were specially designed to cope with the physical stresses that inevitably accompany their external positioning on a moving vehicle. Despite the requirement for toughness, the designers were still able to achieve panels with a profile of just 19mm – shallowness being a crucial requirement when positioning signs on buses negotiating London's narrow but busy streets.

1. NIKE LED SCREENS;
LONDON, UK
HIVE ASSOCIATES AND
JAMES SIRMAN

2, 3. 'BIG TIME' RENDERINGS;
LOS ANGELES, USA
CAMERON MCNALL WITH
DAMON SEELEY
A STREET-LEVEL INTERACTIVE GALLERY WILL OFFER SHOWS AND EXHIBITS FEATURING CUTTING-EDGE AND EMERGENT ART AND DESIGN. IT WILL BE POSSIBLE FOR THE PUBLIC TO VIEW SHOWS AND INTERACT WITH EXHIBITS VIA MOBILE PHONES, PERSONAL DIGITAL ASSISTANTS, TOUCH-SCREENS, AND EVEN REMOTELY FROM THE INTERNET.
ON THE LEFT BUILDING FACE, 12 FEET TENDRILS WILL EMERGE WORM-LIKE FROM THE BUILDING, EXHIBITING COMPUTER-DRIVEN 'BEHAVIOURS' DRAWN FROM A-LIFE (ARTIFICIAL LIFE) INTELLIGENCE. THEY WILL HAVE THE CAPACITY TO INTERACT WITH OR REGISTER THE PRESENCE OF VISITORS, AS WELL AS EXHIBIT 'FLOCKING' BEHAVIOUR, INTERACTING WITH EACH OTHER. THEY WILL ALSO EMERGE AT PRE-PROGRAMMED OCCASIONS, FOR EXAMPLE TO COINCIDE WITH EVENTS ON THE ADJACENT IMAGE WALL. THIS WALL, ON THE RIGHT BUILDING FACE, IS MADE UP OF 300 PANELS WHICH WILL DISPLAY RUDIMENTARY PIXELATED IMAGES THROUGH A COMBINATION OF MOTION, REFLECTIVE TECHNOLOGIES, AND BACKLIGHTING. IN COORDINATION WITH THE NEARBY TENDRILS, THE ENTIRE FACE WILL SERVE AS A MODERN-DAY GLOCKENSPIEL, MARKING IMPORTANT TIMES OF THE DAY.

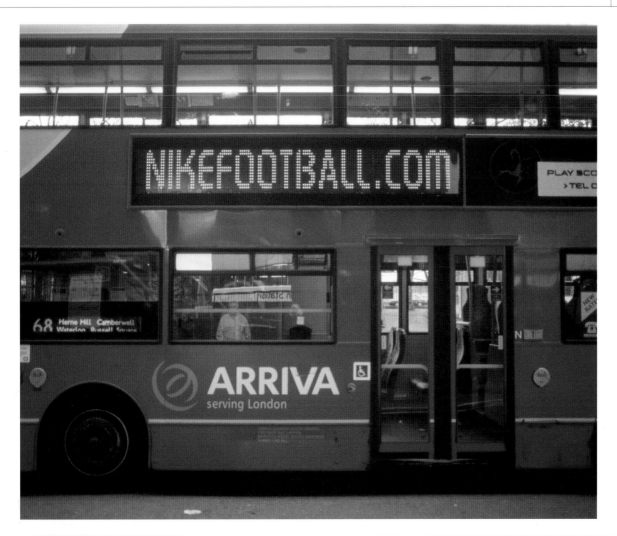

Hive Associates designed the panel's working to include a method of input that allows easy and secure up-loads of new messages – one of the principal advantages of an electronic system. But in the near future, they believe, technologies currently emerging will increase the possibilities offered by this form of communication still further. Wireless modems connected to the display could allow remote changes of messaging to be made, while the integration of mobile phone and internet technology would to allow passers-by to use mobile devices to interact with the messaging.

The moving image

Improvements in existing technologies, such as LED displays, also open up new possibilities. The basic alphanumeric LED display is a familiar sight, found everywhere from hotel lobbies and currency exchange booths to sports stadia. But it is now possible to create LED readers on a vast scale, with clusters of LEDs so closely packed that from a distance the image quality is similar to that of high-definition television. This makes it possible, for example, to have a building facade that is entirely composed of moving image.

Moving image plays a key role in the 'Big Time' project by architect and designer Cameron McNall, which proposes several sophisticated technological components, including a large wall of robotic arms, an adjacent innovative image wall that makes its images via moving panels that reflect and modulate light; and an interactive street-side gallery below.

And at VEAG's administration offices, design group PLEX has created a 'media facade' which occupies 18 windows at the front of the building. The windows are filled with Priva-Lite glass panes, which are completely transparent until a current is passed through them, at which time they become opaque. In the media facade, these opaque panes are used as back projection screens, on which specially commissioned films are shown by digital video projectors suspended from the ceiling behind the windows. The five-storey facade gives the otherwise inert building an identity and personality even at night, while it is unoccupied.

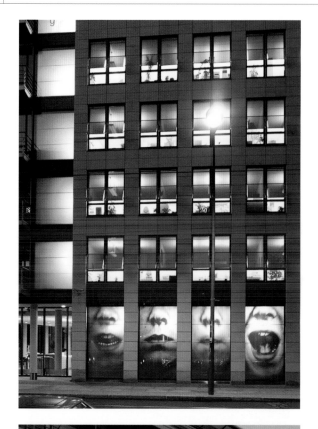

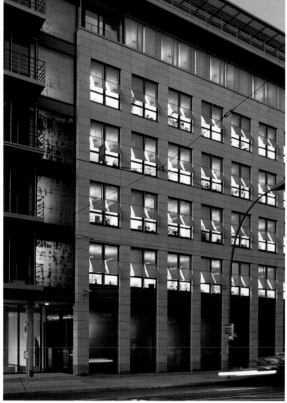

1, 2, 3. VEAG AG MEDIA FACADE;
BERLIN, GERMANY
PLEX GMBH

4, 5. EMPIRE OF SILENCE WALL,
EXPO.02; BIEL, SWITZERLAND
HIVE ASSOCIATES AND LIVE
COMMUNICATIONS
THIS IS THE MOST EXTENSIVE
USE OF LENTICULAR IMAGE
LENSES TO DATE.

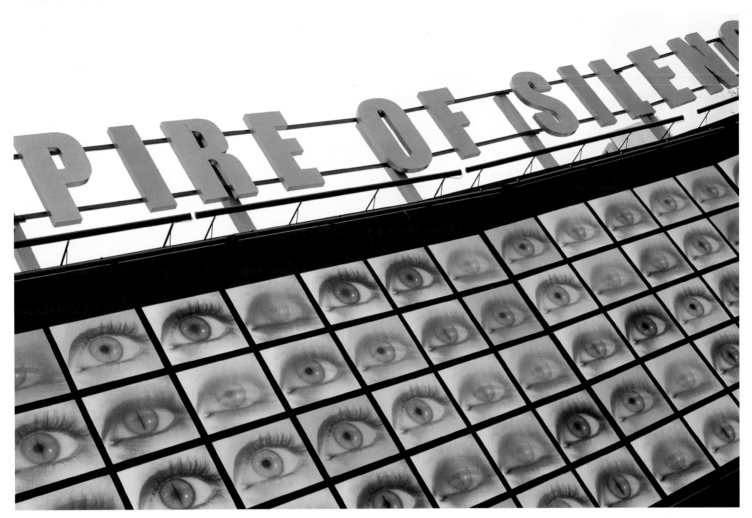

Hive Associates took a different approach to moving image when creating a facade for the Swisscom Pavilion, which housed the 'Empire of Silence' adventure at Expo.02 in Switzerland. The facade represents the most extensive use ever of lenticular images. The 40 metre by 5 metre wall was made up of 100 Dynamic Image tiles (an advanced form of lenticular imagery), in pink, purple, blue, red, orange, brown, yellow and green. Each 110cm x 88cm tile contained 22 frames which together showed a single eye opening and closing. Because the appearance of smooth movement depends on the changing angle of view while walking past the wall, the transition between frames had to be calculated according to the precise specifications of the site.

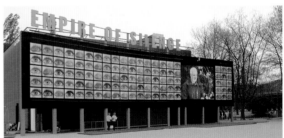

Lens-based lenticular technology was first developed in the early twentieth century, but more recently, advances in plastic lenses have allowed for both cheaper and more effective animation and image-making. As well as simulating movement, lenticular imagery can also be used to create the impression of a three-dimensional object. Several photographs, taken at slightly different angles, are woven into a single image which is coated with lenticular lenses.

FOOTNOTES

1 'Learning from Las Vegas', Robert Venturi, Denise Scott Brown, Steven Izenour. MIT Press, 1972.

2 'Critical way finding', Ellen Lupton and J. Abbott Miller. Originally published in 'The Edge of the Millennium: An International Critique of Architecture, Urban PLanning, Product and Communication Design'; ed, Susan Yelavich, Cooper-Hewitt National Design Museum and Whitney Library of Design, 1994. Republished in 'Looking Closer 2: Critical Writings on Graphic Design'; ed. Michael Beirut, William Drenttel, Steven Heller & DK Holland, Allworth Press, 1997.

3 'Drawing Support: Murals in the North of Ireland', Beyond the Pale Publications, 1992. 'Drawing Support 2': Murals of War and Peace', Beyond the Pale Publications, 1995.

4 'Wayfinding in Architecture'; Romedi Passini, Van Nostrand Reinhold; New York, New York; 1992. 'Wayfinding: People, Signs and Architecture'; Romedi Passini and Paul Arthur; McGraw Hill Text; 1992.

5 'Design Writing Research: Writing on Graphic Design'; Ellen Lupton and J. Abbott Miller, Phaidon Press, London, 1999.

6 'Lawrence Weiner', Phaidon Press, Alexander Alberro and Alice Zimmerman, Benjamin H. D. Buchloh, David Batchelor, 1998.

7 'Confessions of an Advertising Man', David Ogilvy, Ballantine Books, 1971

8 'The Sign User's Guide: A Marketing Aid'; Karen E. Claus and R. James Claus, ST Publications, 1974 (quoted by Bill Dundas, 'Can't You Read the Signs?', Signs of the Times magazine).

9 'Signs of the Times', Dan Bischoff. Metropolis magazine, February/March 1998.

10 Ibid.

11 'The View from the Road', Donald Appleyard, Kevin Lynch, John R. Myer. MIT Press, 1964.

IMAGE CREDITS

All photographs supplied by the design companies are credited in picture captions, except as stated below.

ACKNOWLEDGMENTS
A GENERAL THANKS TO ALL THOSE
WHO CONTRIBUTED WORK AND IDEAS
TO THIS BOOK, AND A PARTICULAR
THANK YOU TO ADRIAN CADDY FOR
THOUGHTS AND SUGGESTIONS.
THANKS ARE ALSO DUE TO
AMANDA BOWN FOR PICTURE
RESEARCH, NB: STUDIO FOR THE
DESIGN, AND KATE SHANAHAN, THE
EDITOR AT ROTOVISION.